The Uses of Images
Studies in the Social Function
of Art and Visual Communication

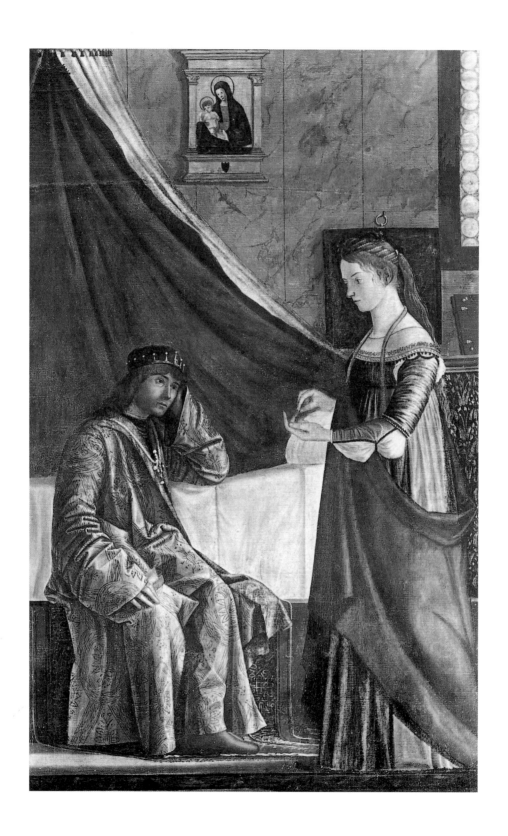

E. H. Gombrich

The Uses of Images

Studies in the Social Function
of Art and Visual Communication

Φ

Phaidon Press Limited
Regent's Wharf
All Saints Street
London N1 9PA

First published in volume
form 1999
© 1999 Phaidon Press
Limited
Text © 1999 E.H. Gombrich

ISBN 0 7148 3655 9

A CIP catalogue record for
this book is available from
the British Library

Library of Congress
Cataloging in Publication
Data available

Printed in Singapore

Frontispiece Vittore
Carpaccio, *Arrival of the
Ambassadors in Brittany*,
from the Saint Ursula Cycle,
detail showing room of
Saint Ursula's father,
*c.*1495–6. Accademia,
Venice (see p. 117)

Contents

Introduction

Heinrich Wölfflin tells us that that great student of civilization and of art, Jacob Burckhardt, on his seventy-fifth birthday, formulated, with a certain solemnity, what he wished to be his legacy to future art historians. Concise as ever, the words he used resist translation and call for a paraphrase. What he said in German was 'Die Kunst nach Aufgaben, das ist mein Vermächtnis' – approximately, 'Art as task is my legacy.'[1] He wanted his successors to study each work of art as meeting a demand. What he had in mind we can easily tell, considering his three posthumous papers on the Portrait, the Altarpiece, and the Collector in the period of the Italian Renaissance.[2] The word that Burckhardt used was 'Aufgabe', which literally means 'task' (as in 'Schulaufgabe', 'homework'), but might also be rendered as 'commission', except for the fact that a commission must come from outside, a task we may set ourselves.

Yet, confronted with the pressing problems of attribution, iconography, the sociology of art, and many others, twentieth-century art history has largely failed to meet the wishes of the great historian. What he perceived was that works of art, no less than other goods and services generally, owe their existence to what is now described as 'market forces' – the interaction of demand and supply. For even works which were not commissioned by any patron were mostly produced in the hope of arousing interest and finding a buyer – in other words, they hoped to meet an existing demand.

Thus we must not allow Burckhardt's insight to be obscured by the intensity with which so many artists of the last two centuries have striven to escape the entanglements of the market, their emphatic refusal to make concessions to the temptations of popular success. Even these noble spirits have harboured the hope that their creation would appeal to a kindred soul and that their work would ultimately create a demand, even if they might no longer be alive to benefit from this change of circumstances. By and large it is these artists who figure in our history of art, precisely because their works, rejected in their time, are enjoying popularity today.

This is true not only of the art market, but also of fashions in design, which has so often adopted shapes and styles that have puzzled earlier generations. The success of Cubist posters or wallpapers is a case in point: the formal experiments of Picasso and Braque created a demand subsequently exploited by manufacturers and commercial artists. It may be argued that what historians tend to describe as the influence of an artist generally comes about through such a change of demand. The impression made by Michelangelo's mastery of the human figure in motion led to that preference for contorted nudes that used to be described as the hallmark of Mannerism. Conversely, the fading of this interest on the part of patrons and public has led in our own century to a decline in the required skill; anatomy is no longer taught by most art schools, and many successful artists can get by without an accomplishment that used to be the foundation of any painter's training.

The way in which these movements of demand are subject to technical innovations need hardly be specified at length. As far as the demand for images is concerned, the invention and spread of photography offers the most dramatic example.[3] The requirement of a faithful visual record, that used to be met by specialists in portraiture, topography, or animal painting, was met more cheaply and efficiently by the camera, except in certain cases, such as the needs of medical illustration, where trained artists were, and possibly still are, employed in the operating theatre. The example highlights an element in the situation that must never be left out of account: the function an image is expected to serve. This important factor has been somewhat obscured by the critical creed of 'art for art's sake' that has dominated the art of our time. But if we leave the world of the galleries and look round in our own environment, the dependence makes itself felt all the more. So overriding is the 'demand for images' in Western society that a household which lacks a television set (preferably in colour) is often described as 'deprived', and so would be a child whose parents cannot afford to buy any toys. For good or ill, both the television programme and the child's dolls or soft animal toys are, of course, adapted to meet the function they are expected to serve. The programmes on the screen should not be too 'demanding', and the toy should be 'cuddly'. Here, as elsewhere, we can easily observe how the function assigned to an image will interact with its shape and appearance.

This insight, that 'form follows function', was first explicitly enunciated in the theory of architecture, when it served as the principle of a particular aesthetic programme.[4] But a moment's reflection will show that even the forms rejected by that creed served a function – if not a

technical one, then a social one. Columns are felt to enhance the dignity of a building, just as the 'conspicuous consumption' of decoration reveals the wealth and status of the owner or the institution who commissions it – a throne-room *demands* splendour.

As indicated above, similar factors can be observed to be at work in the genres and traditions of all the arts. To take an obvious example: a state portrait will differ in medium, format and posture from a portrait caricature; and that, in turn, will vary in form and spirit according to its social function. Having been interested in this last genre since my student days, I should like to present it as a paradigm of the approach I have in mind. I was tempted to include it in the following chapters, but found that the outlines of that story are by now so well known that I could not tell it without covering too much familiar ground.[5]

It seems that the term *caricatura*, and the light-hearted genre it signified, did not make its appearance in the history of art before the early seventeenth century.[6] We certainly know of earlier abusive and scurrilous representations of individuals (and some examples will be found in the following pages), but it was the Carracci brothers who must be credited with having created a new demand by their wit and skill (fig. 1). They had a knack of playing with the features of their fellow men which was later defined by Bellori: 'Portraits that aim at resembling the whole of the person portrayed as much as possible, but which, jokingly or sometimes mockingly, emphasize the portrayed features out of all proportion, in such a way that as a whole they appear to be a likeness, while the individual features are altered.'[7] Such drawings which he made of his intimates were circulated among his friends and admirers, imitated by other members of the Bolognese school, and taken up by the great sculptor Gianlorenzo

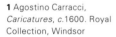

1 Agostino Carracci, *Caricatures, c.*1600. Royal Collection, Windsor

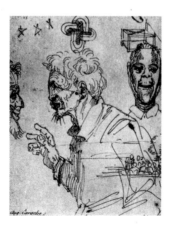

Bernini (fig. 267). By the turn of the century, the artist Pier Leone Ghezzi (fig. 2) specialized in the genre, and we know that travellers to Rome regarded it as an 'honour' to be included in his gallery of comic types.[8] In the enlightened society of literati and connoisseurs, gentle ridicule was obviously tolerated. The principal butts were actors and opera singers, whose stylized personalities could so easily be made to look farcical.

We are able to document step by step how the fashion of caricaturing was picked up by English artists visiting Italy, and popularized in their homeland. William Hogarth (fig. 3) still wished to dissociate his social satire from these modish jokes, but the demand spread in the coffee houses and clubs. Characteristically, it was an amateur, George Townshend, who enjoyed using his skill for comic likeness as a weapon to portray his opponents in funny scrawls (fig. 4), and soon the genre was adopted by professional artists who grafted comic likenesses on to their satirical portraits.[9] The new lease of life this gave to political imagery is briefly touched upon in one of the chapters that follow (p. 184). What still remains to be told is the story of the slow domestication of the genre in the pages of periodicals and daily papers. The satirical portrait was increasingly transformed into a convenient shorthand formula for the features of a politician, responding less to demands of polemics than of

2 Pier Leone Ghezzi, *Dr James Hay as Bear Leader, c.*1725. Drawing. British Museum, London

9

3 William Hogarth, *The Bench*, 1758. Engraving

4 George, Lord Townshend, caricature of Sir John Cope, 1751–8. National Portrait Gallery, London

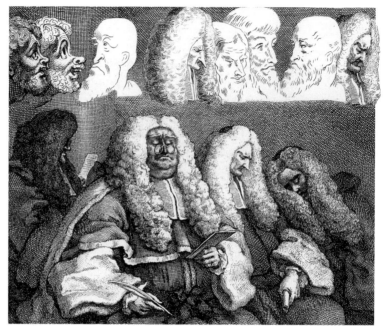

3 William Hogarth, *The Bench*, 1758. Engraving

4 George, Lord Townshend, caricature of Sir John Cope, 1751–8. National Portrait Gallery, London

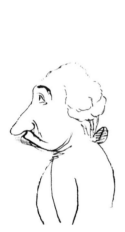

innocuous publicity. The photograph taken for the *New York Times* of President Truman surrounded by 'his' cartoonists sums up this development (fig. 5).

Thus, the birth of caricature in a milieu that appreciated artistic virtuosity, its efflorescence in a democratic society, and its survival as an innocent brand of journalism reflect the influence of social situation on a genre of art that owes its origin to an individual artist, and its survival to changing demands. Mark that in this reading, both the artistic invention and social pressure are given their due, for neither of these factors taken alone could have produced equal results. I have sometimes been tempted to compare this interplay of forces to the influence of the environment on the various forms of life. Biologists use the term *ecological niche* to describe the environment that favours a particular species of plant or animal. What is characteristic of these situations is again the constant interaction between the factors involved. The rainforests of Brazil could only have developed in a tropical climate, but they are known to influence the climate in their turn.

In the eleven chapters that follow, I have attempted to develop Burckhardt's programme, and to test its application against a variety of demands we encounter in the history of art.

10

5 President Truman
surrounded by his
caricaturists, October
1949

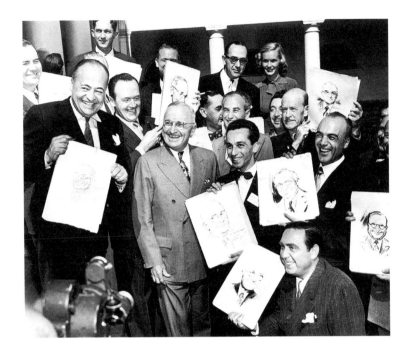

The first exemplifies the contrasting influences which the task of fresco painting is seen to exert on the means employed: while the Renaissance and the Baroque conjured up fictitious vistas, later critical opinion demanded that illusionism should be shunned, because the mural should 'assert the wall'.

The second, following more closely in Burckhardt's footsteps (without, of course, wishing to compete with his masterly essay on altar painting), takes its starting point from the demand for an altar frontal that arose from a change in liturgical practice, and proceeds to trace the conciliation of the conflicting aims – symbolic and narrative – that offered a challenge to the leading masters of the Renaissance, and finally deals with the diversion of these paintings from their original purposes when they became the prized possessions of princely collectors.

The third seeks explicitly to analyse the interaction of demand and supply in one period of art, that of 'International Gothic', when the wealthy courts of Europe set a trend for refined elegance in works of craftsmanship suitable for the *trésors* of the mighty.

The fourth chapter, entitled 'Pictures for the Home', concentrates on a demand that originated a century later, but can be observed in our own environment, that of pictures to place on the walls of our homes.

By way of contrast, the fifth, 'Sculpture for Outdoors', deals with the urge to erect monuments, and mainly concentrates on the hothouse atmosphere of sixteenth-century Italy, where the well-documented desire of artists and patrons to vie with each other resulted in the unique outdoor museum of the Piazza della Signoria, Florence.

The sixth chapter, on the political symbolism of the French Revolution, deals with the demands of a new ideology, not to say a new religion, to create its own imagery.

The seventh, entitled 'Magic, Myth and Metaphor', considers the needs and limitations of pictorial satire.

The eighth chapter, on 'Pictorial Instruction', draws attention to a use of visual imagery we all take for granted, which has been correspondingly neglected.

The ninth, entitled 'The Pleasures of Boredom', focuses on the opposite phenomenon: the idle penplay described as 'doodling' that corresponds to no requirement, and must be the result of a demand arising from within us.

I decided also to include in this volume my Reynolds Lecture at the Royal Academy of Art on 'Styles of Art and Styles of Life', because it looks at the relation of form and function from a greater distance and takes issue with the popular cliché of the 'Spirit of the Age'.

Finally, I have appended to these chapters the revised review of Francis Haskell's *History and its Images*, since this most important book enabled me to clarify my position on these issues.

I should like to reassure the reader, however, that the chapters concerned, mostly owing their existence to single lectures, can be read without reference to the theoretical points raised in this Introduction, though they may conceivably gain in interest when they are seen as a contribution to Jacob Burckhardt's programme.

It only remains for me to thank two kind helpers: Colin Harrison of the Ashmolean Museum in Oxford, who prepared these chapters for publication, and Bernard Dod of Phaidon, who saw them through the press.

Chapter 1 **Paintings on Walls**

Means and Ends in the
History of Fresco Painting

Given as the eighth Walter Neurath Memorial Lecture, and first published by Thames & Hudson (London, 1976).

In this chapter, I shall present some second thoughts on a topic I first discussed in my book *Art and Illusion*:[1] this was the idea, which is more familiar in the theory of architecture than in the criticism of painting, that form follows function, or that the end determines the means. Of course, slogans of this kind can never have more than heuristic value: they draw attention to the kind of question the historian should ask in confronting the monuments of the past. Admittedly, no human action and no human creation is likely to serve only one end; we often find a whole hierarchy of ends and of means. But we can also discern a dominant purpose without which the event would not have happened at all. Moreover, in human affairs, means can easily become ends, as is indicated in the formula 'Art for Art's Sake'. In trying to illustrate some aspects of this complex interaction by looking at the history of fresco painting, I must ask for indulgence on several scores. I shall be concerned with means, but shall not be pedantic about media. Figures 6 and 7 juxtapose two famous murals, both painted in the last decade of the quattrocento, Ghirlandaio's frescoes in Sta Maria Novella in Florence, and Leonardo's *Last Supper* in Sta Maria delle Grazie in Milan. I shall not enter into the question of the experimental technique allegedly used by Leonardo to avoid the need for rapidity connected with fresco painting;[2] in fact I shall use the term 'fresco' in a Pickwickian sense to stand for any mural or ceiling painting of an interior. I have obviously had to be ruthlessly selective in choosing examples culled from a few millennia; and often use familiar rather than unfamiliar landmarks without, alas, being able to dwell on them as they deserve. They serve here as evidence to support a thesis concerning means and ends, in the history not of art, but of image-making.

The end or dominant purpose of the two frescoes happens to be reasonably clear. The story of Ghirlandaio's cycle, as told by Vasari, was a

6 Domenico Ghirlandaio, *Life of Saint John the Baptist*, 1490. Sta Maria Novella, Florence, south wall of chancel

7 Leonardo da Vinci, *The Last Supper*, c.1495. Sta Maria delle Grazie, Milan, refectory

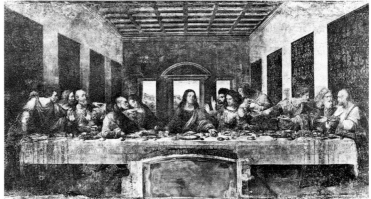

favourite example of Aby Warburg's which he used to break down the purely aesthetic approach of nineteenth-century art historians.[3] It was painted in the choir of one of the great preaching churches in Florence, of which the patronage belonged to the banker Francesco Sassetti, an associate of the Medici firm, who naturally wanted it decorated – if that is the word – with frescoes telling the story of his name saint, Saint Francis.

15

Alas, Sta Maria Novella is a Dominican, not a Franciscan church, and the suggestion was too much for the monks. In the end, Sassetti withdrew to Sta Trinità and ceded his rights at Sta Maria Novella to another member of the Medici circle whose Christian name was luckily Giovanni, Giovanni Tornabuoni. No objections were raised to the life of Saint John the Baptist being painted in the Dominican church. The main purpose of the other example, the *Last Supper* in the monastery of Sta Maria delle Grazie in Milan, is almost self-evident. It was the tradition to represent the Last Supper on the walls of refectories, and in this respect Leonardo conformed to usage, though his conception of the scene was less traditional.

My purpose in illustrating these examples, however, is not only to recall the social fabric in which image-making was embedded in Renaissance Italy, but to illustrate the text I have chosen for these reflections on ends and means. It is an important text, for it comes from Leonardo da Vinci's *Treatise on Painting*, a compilation of the master's thoughts made by his pupil Melzi. In it, Leonardo roundly attacks such frescoes as Ghirlandaio's in the Tornabuoni Chapel:

> *Why the arrangement of figures one on top of the other should be avoided:* there is a universal custom followed by those who paint on the walls of chapels which is much to be deplored. They depict one scene with its landscape and buildings on one level, then they go up and make another, varying the point of sight, and then on to the third and to the fourth in such a way that one wall is seen to be made with four points of sight, which is the height of stupidity ['somma stoltitia'] on the part of these masters. We know that the point of sight must correspond to the eye-level of the beholder of the scene.[4]

The principle which is laid down by Leonardo, and which he followed in Milan, may be formulated as 'one wall, one space, one scene'. It may remind the literary historian of the three unities demanded by Aristotle for tragedy – those of time, of place, and of action. And, like the Aristotelian critics who dismissed Shakespeare for his disregard of this principle, Leonardo is scathing about his colleagues who violate his unities, saying in another note that a painting with various horizons looks like a shop with merchandise displayed in various rectangular pigeonholes.[5]

Although Leonardo's prejudice led him to ridicule some of the greatest creations of Italian painting, such as Piero della Francesca's cycle in the

choir of S. Francesco in Arezzo, it must be said in his favour that the practice of art historians and art publishers has come round to his point of view. We are usually shown these paintings in isolation, on the principle of one picture, one space, one scene; indeed, in compiling this essay, it has come home to me how rare it is that frescoes are in fact shown in their setting, as they luckily are in Eve Borsook's book *Mural Painters of Tuscany.*[6]

But though isolation may serve the ends of the art historian and of the modern art-lover, the painter of a fresco cycle had to contend with different demands, and Leonardo knew it. For his note continues:

> If you ask me: how shall I paint on one wall the life of a saint which is divided into many incidents? My answer is that you must place the first plane at the eye-level of the beholder of the scene and on that plane represent the first scene in large size, and then diminishing the figures and buildings on the various hills and plains, as you go on, make the setting for the whole story. And as to the remainder of the wall, fill it with large trees in relation to the figures, or with angels, if they fit the story, or perhaps birds or clouds. If you do otherwise you will exert yourself in vain and all your work will go awry.[7]

Thus, the only concession which Leonardo was ready to make to the demands of the patron who wanted to have the whole life of his patron saint was to have one wall, one space, but several subsidiary scenes in that space: what may be described as a vague analogy to the eye-witness or messenger report in a unified drama. The kind of compromise he had in mind can be illustrated from the quattrocento frescoes in the Sistine Chapel in Rome, but only approximately so, because they are high up on the wall and have many compartments. Botticelli, for instance, represented seven episodes of the story of Moses in one unified landscape (fig. 8), with the meeting of Moses and Jethro's daughters at the well in the centre, the fiery bush in the background, and the Exodus squeezed into the corner – a compromise which makes one wonder whether the game of unity is worth the candle.

Not surprisingly, the most consistent application of Leonardo's demands was attempted by his pupil Bernardino Luini in the colossal fresco of *Golgotha* in Sta Maria degli Angioli in Lugano (fig. 9). This, too, is not on eye-level, and the relegation of the story of the Passion to a kind of background stage reminds us that there really was no future in this kind of compromise.

17

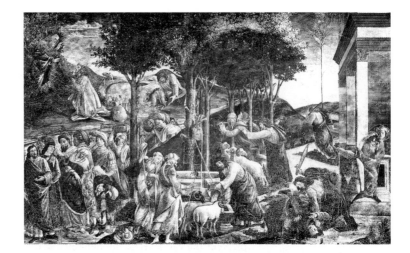

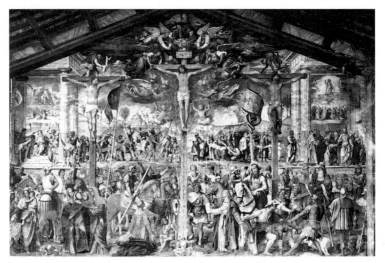

Why, then, did Leonardo go out of his way to recommend such an awkward expedient? Clearly because, for him, painting had one overriding aim, on which he insisted in countless notes:

> The elements of painted scenes must move those who look at them to experience the same emotions as those represented in the story, that is to feel terror, fear, fright or pain, grief and lamentation or pleasure, happiness and laughter … if they fail to do this the skill of the painter will have been in vain.[8]

18

This effect, which Leonardo considers the true purpose of the painter's skill, is known as empathy. In confronting his *Last Supper*, we should be troubled with the Apostles, defiant with Judas, resigned with Christ, who has just announced His impending betrayal and passion. It almost goes without saying that this experience also demands a special kind of looking. We must *concentrate*, as the wisdom of language has it, and we must focus on each of the figures in turn as we immerse ourselves in the event depicted. It is towards this end that all the painter's means must be mobilized. In order fully to appreciate the psychological relationship of the figures, we must also be made to sense the space in which they move and act. Vasari in his description of the work notoriously singles out for praise the convincing accuracy of the fabric of the tablecloth;[9] and even this minor detail must be understood as a visual aid, enhancing the immediacy of the beholder's experience as he is made to witness the momentous occasion of the Institution of the Eucharist. Unhappily, we have no better word for this feeling than the omnibus term 'illusion', though of course nobody can be under a genuine illusion that he is confronted with a frozen event. The word we would need would have to correspond with the term 'fiction' in literature. Fiction can be vivid and convincing in evoking an imaginary event without anyone taking it to describe a real happening. I shall argue that in art and in literature, this response depends on an inner coherence, a situational consistency. It was this coherence that Aristotle wanted to secure by his unities and Leonardo by his insistence on a consistent spatial setting. The idea of a succession of scenes showing the sky and then the floor on top of it was the height of stupidity because it lacked this elementary situational coherence.

At this point, I must hark back to a chapter of *Art and Illusion*, called 'Reflections on the Greek Revolution';[10] not to recant the hypothesis I presented there, but to articulate it a little more. What I argued was that we put the cart before the horse if we follow the authors of classical antiquity in recounting the growth of mimesis, the imitation of nature, as a merely formal development. The development can only be understood as a means to a new end, namely the visual evocation of a mythical event. In ancient Greece, the myths were not only recited in immutable sacred accounts; they were freely embroidered by poets and put on the stage so that the audience could experience the fear and pity that Aristotle considered the aim of tragedy. To do so, the playwright had to be given licence to imagine the event as it might have happened, as a full-blooded interpretation of a human situation with which we can empathize; hence the unities. I believe it was this same dominant aim, of showing not only the 'what' but the

'how' of an event, which also led Greek art to the observation of natural appearances, the rendering of expression, of anatomy, of space and of light. Form followed function. Whether or not the ancient Egyptians could have mastered these skills seems to me irrelevant, because they used the image for a different purpose. This brings us back to Leonardo's problem. The images in ancient Egyptian tombs are certainly arranged in registers (fig. 10), but their function is predominantly symbolic, almost pictographic, ranging from the hieroglyphic inscription to the enumeration of activities serving the dead and the trials awaiting the dead in the after-life. Such images must be read sequentially, more or less as we read a text, and for this process a division into registers is of almost indispensable help.

We have no Greek murals from the decisive period, but paintings on vases appear to confirm that the emancipation from episodic narrative in zones went hand in hand with the new psychological emphasis: contrast the François Vase of the sixth century, with its many incidents (fig. 11), and the fifth-century skyphos by the Brygos Painter showing the Homeric episode of Priam asking Achilles for Hector's body, where our eyes must surely linger on the actions of the participants in this moving scene (fig. 12).

10 Tomb of Sennedjem, 19th Dynasty, c.1292–1190 BC. Thebes, Egypt

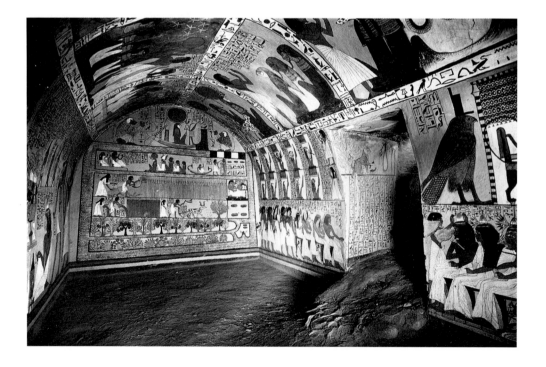

It seems that the painter Polygnotus, who was a contemporary of the great Greek tragedians of the fifth century, achieved the same psychological empathy, but was as yet unable to unify his scenes as completely.[11] So, at least, we are led to conclude by the descriptions of two murals at Delphi that we find in the ancient tourist guide by Pausanias.[12] Their subjects were episodes from the destruction of Troy and from Ulysses's descent into the Underworld, and it appears that Polygnotus adapted something like the compromise suggested by Leonardo, distributing his figures and groups loosely over a steep ground so that those further back were shown higher up on the wall, as is indicated in Goethe's diagrammatic reconstruction (fig. 14).[13] There is a famous Greek vase (of which the subject has been variously interpreted) which is generally believed to reflect the method of composition used by Polygnotus (fig. 13).

11 Kleitias, François Vase, c.570 BC. Museo archeologico, Florence

12 The Brygos Painter, *Priam and Achilles*, skyphos, 5th century BC. Kunsthistorisches Museum, Vienna

13 The Niobid Painter, *Herakles and Athena*, calyx-crater, c.455–450 BC. Louvre, Paris

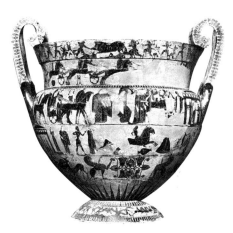

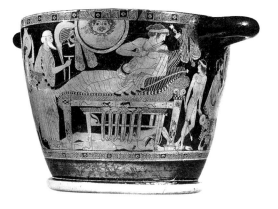

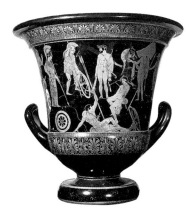

21

14 J.W. von Goethe, *Polygnotus's Paintings in the Lesche at Delphi*, diagram, 1803. From 'Polygnots Gemälde in der Lesche zu Delphi', *Gedenkausgabe der Werke*, vol. 13 (Zurich, 1953)

We do have a mural from a later period, the so-called Odyssey landscapes from the Esquiline in Rome, of the first century BC, which seem to be a perfect illustration of my hypothesis (fig. 15).[14] The demand that the artist allow us to visualize the 'how', rather than merely to tell us 'what' happened, has led by now to the creation of scenes bathed in light and atmosphere, which we witness from afar; and yet the Greeks and Laestrygonians are individuals realized with the deft skill of a great tradition.

Precisely because the means had been found to this end, a new problem had arisen in adapting this type of composition to the needs of a mural. To appreciate this new problem, we need only pause for a moment to consider what happens when we enter a room or any other environment. We first look around to see where we are; we notice the wall; we inspect a detail; all these, and many other varieties of perception, require different ways of scanning and of focusing. For the visual evocation of a dramatic painting to come to life, we must focus on it mentally and scan it in a controlled way so as to interpret its coherence. What F.C. Bartlett has called 'the effort after meaning'[15] makes us see the blue patch as water and the bright zone as a gap between the rocks. This may not take long, but it takes a measurable time. To perceive an interior also takes a moment, but here we look around in a sequence of roving eye-movements which soon completes our orientation. Now the decoration of a room, whether architectural or pictorial, need not slow down this

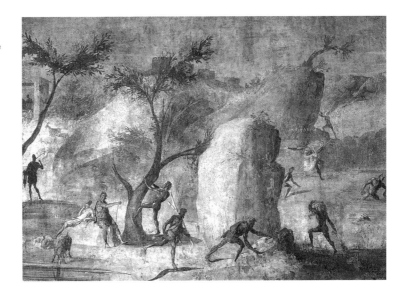

15 *The Laestrygonians Attacking the Ships*, 1st century BC. From a house on the Esquiline, Rome. Museo Profano, Vatican

alternative effort after meaning. On the contrary, by articulating the walls and the ceiling, the decoration may set accents for rapid scanning. We do not have to inspect every real or fictitious column or pilaster, because we quickly pick up correspondences and redundancies which allow us to take the individual element as read. Note that to do so, we also operate with an assumption of an expected coherence which enables us to accept whatever fiction the decorator may have introduced. He might, for instance, ask us to imagine that we look out of the room at various vistas, and he might use for this purpose the very means of so-called illusionism which were developed, if I am right, for the alternative purpose of dramatic evocation in paintings and probably also on the stage. Now, the Odyssey landscapes were originally part of a decorative scheme suggesting a series of openings through which we look at various episodes from the epic. It is clear that here, the two tests of coherence come into conflict – it is a curious room that appears to open on various different episodes separated in time and in place.

In abstract terms, there are two ways out of this artistic dilemma. The painter can turn the whole wall into the semblance of one scene; in fact, he can make the whole room a fictional setting of an imagined event. This is what the master of the Villa dei Misteri near Pompeii has done (fig. 16). He has created a shallow stage between us and the fictitious as distinct from the real wall, enlarging his figures to a scale which is easily taken in and which has enormous dramatic impact, even though we are not quite sure

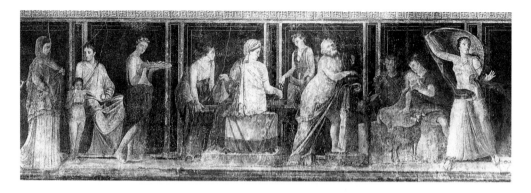

16 *The Initiation of Brides into the Dionysiac Mysteries,* 1st century BC. Villa dei Misteri, Pompeii

what ritual is being performed. Alternatively, the artist can save the coherence of his fiction by introducing the time-honoured device of a tale within a tale. Translated into visual terms, this means a representation within a representation. The decorators of Rome and Pompeii were past masters in ringing the changes of this sophisticated device: individual framed pictures, to be inspected by controlled scanning, are presented as part of the whole fictitious interior which may open out into vistas (fig. 17). Whether or not the Romans used the laws of perspective for these vistas is still an open question.[16] I think it matters less than the way they coped with the principle of coherence. Vitruvius, in the Age of Augustus, notoriously took the principle quite literally, insisting that in illusionistic murals the painter must keep strictly to forms which are architecturally viable and would stand up in reality. Playful and grotesque fictitious structures he rejected outright, without perceiving that their very flimsiness and their visual paradoxes enhanced their character as decorative fiction.[17] Be that as it may, the words in which this canonical authority condemned the painting of impossible situations had enormous influence on the history of criticism,[18] and may even have been at the back of Leonardo's mind when he attacked the mural painters of his time for their inconsistencies.

Soon the mural painter was to contend with a much more weighty kind of opposition, which was indeed to change the course of art. Christians could not ignore the Second Commandment, which enjoins them not to make 'any graven image, or any likeness of anything that is in heaven above, or that is in the earth below, or that is in the water under the earth' (Exodus 20:4). In the light of this text, the miracle is really that, unlike Judaism and most of Islam, the Christian Church in the West continued to tolerate the making of images in religious contexts. The concession which made this possible is best formulated in the pronouncement of Pope

24

17 Mural decoration,
1st century AD. Casa dei
Vettii, Pompeii

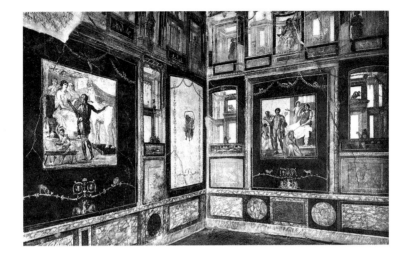

Gregory the Great which acknowledges the didactic purpose of images:
'Painting is to those who cannot read what letters are to those who can.' To
simplify but not, I hope, to falsify an immensely complex issue, we might
say that this restriction of the function of religious art redirected the
image-makers towards the exploration of those pictographic methods
which had never been entirely extinct.

The murals in the Roman catacombs illustrate to perfection the
difference between such a pictograph and what I have called dramatic
evocation. In SS. Pietro e Marcellino, we recognize at the back scenes of
the Adoration of the Magi, flanked by Moses Striking the Rock and Noah
Emerging from the Ark (fig. 18). This is a suitable example because
nobody can have thought that the Ark, which was after all made to
accommodate a pair of every species, could have been smaller than Noah
himself. It is a pictograph in the sense that the image of a floating box
marks the figure as Noah, and that the figure generates scarcely more
fictitious space around it than do the decorative scrolls. Once the image
has thus been reduced to a sign, Leonardo's problem of inconsistent spaces
disappears by itself.

In the murals from Vigna Magna (fig. 19), we can read off a large
number of examples of divine intervention arranged in various registers:
above, Moses Striking the Rock, the Miracle of the Loaves and Fishes, the
Adoration of the Magi, the figure of an *orans*, and the hieroglyph of Noah
once more; below, Daniel in the Lions' Den, Tobit with his fish, the healing
of the lame man who walks off with his bed, the Raising of Lazarus, and
poor Lazarus at the gates of Dives. Clearly what mattered here is the *what*,

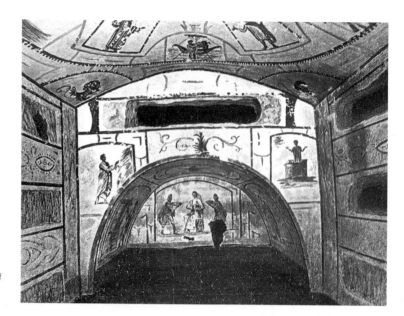

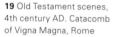

18 Adoration of the Magi,
4th century AD. Cubicle of
SS. Pietro e Marcellino,
Rome

19 Old Testament scenes,
4th century AD. Catacomb
of Vigna Magna, Rome

not the *how,* of the event. Think what a contemporary of the artists of the Laocoön group would have made of the scene of Daniel in the Lions' Den!

We know that the practice, censured by Leonardo, of telling a story sequentially in various registers was exemplified in the principal church of Christendom, the original Basilica of St Peter's, where there was a mural cycle of which we have at least a copy, made before the church was finally pulled down to make way for the present structure (fig. 20).[19] The exact date and state of this immensely influential cycle cannot be established with certainty; suffice it to say that here we again see what I have called the pictographic method. This is exemplified in the picture of Noah's Ark on

20 Jacopo Grimaldi, *Mural Decoration of Old St Peter's, Rome*, drawing, 1620. Vatican, Biblioteca Apostolica, MS. Barb. lat. 2733, fol. 108v

the left, fairly early in a long cycle which has to be read sequentially for its inner coherence to emerge.

We usually associate early Christian wall decoration with mosaics rather than with mural paintings. The durability of the medium has a lot to do with this, but there are other reasons more closely connected with the shift in the role of the image. Realistic painting is wedded to the observation of nature in all its variety; the pictograph stands in no need of such servitude. Just as the scribe is free to pen the sacred word in letters of gold on a purple page, to express his veneration and awe, so the designer of the pictorial narrative is free to enhance his message with all the resources of visual splendour. What he loses in terms of focused vision is amply made up by the gain for the roving eye. Whether or not those who could not read were able to take in the exact meaning of some of the figures on the mosaic of the triumphal arch of Sta Maria Maggiore, which still baffles the scholars (fig. 21),[20] may be a moot point, but that laity and clergy alike would feel the import of so much gold and solemnity we cannot doubt. As a result, the mural in the Middle Ages became something like a poor relation of the more splendid media such as the mosaic and the stained-glass window.

It was said of the lectures of a Harvard Professor of Art History, 'drop your pencil and you have missed a century'. My case is worse; I shall have to drop a handful of centuries in selecting just one of the better-preserved examples of the medieval mural – the apse of the Catalan church of S. Maria de Tahull (fig. 22), in which we see the Virgin enthroned, approached by the three Magi, marked with their names.[21] In the vault we see the figure of Abel with God accepting his sacrifice; no doubt there was the corresponding image of the rejection of Cain on the other side. In the apex there is the symbol of the Lamb of God, and beneath a row of Prophets there are fabulous animals which may be purely decorative. What such a Romanesque ensemble confirms is what I have been leading up to. There is no distinction in this style between the symbolic, the

27

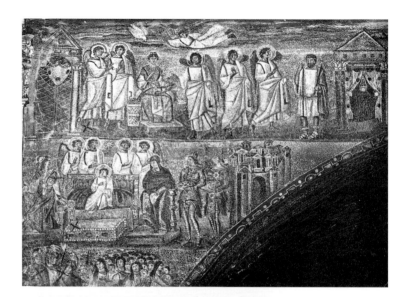

21 *The Adoration of the Magi*, mosaic, *c.*435 AD. Sta Maria Maggiore, Rome

22 *Virgin and Child Enthroned, Adored by the Magi*, 1123. From S. Maria de Tahull. Museo de Arte de Catalunya, Barcelona

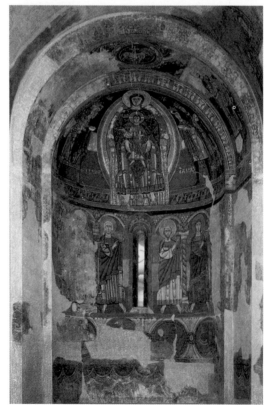

narrative and the decorative. What we call the Adoration of the Magi is really the Epiphany, the first homage by mighty rulers to the incarnate Word. It is no more the visualization of an earthly reality than is the Lamb of God in the centre. Nothing in his didactic and ritualistic purpose impeded the artist from making full use of the framework provided for him by the architect. The articulations of the building coincide with the grouping of the images.

When did this grand and consistent use of images disintegrate, and what were the pressures which led to that revival of the classical conception we call the Renaissance? It is a question which has engaged the minds of historians for generations, and one to which there is no clear-cut answer. One important element in the story seems to me to parallel the development in classical antiquity. This was the increasing demand for what I have called the dramatic evocation, the return to the desire not to be told only *what* happened according to the Scriptures, but also *how* it happened, what the events must have looked like to an eyewitness.

I agree with those who connect this decisive change with the new role of the popular preacher in the thirteenth century. It was the friars who took the Gospel story to the people and spared no effort to make the faithful relive and re-enact it in their minds. It is well known that Saint Francis celebrated Christmas at Greccio in this way, actually bringing an ox and an ass into the church, and perhaps also a live baby. It was in the Franciscan tradition also that there grew up that important technique of devotion which involves this kind of imaginative identification. The great historian of Christian iconography, Émile Mâle, stressed the crucial importance in this context of the *Meditations on the Life of Christ* by the Pseudo-Bonaventura, and of the miracle plays.[22] He has been accused of overstatement, and no doubt there were other factors, but I still think that he had the right intuition, and that the change of attitude to the sacred narrative engendered by the new conception of teaching and preaching cannot be left out of the history of art.

Let me here quote in evidence the description of the arrival of the Magi from Nicholas Love's English translation of the *Meditations on the Life of Christ*, made before 1400, which I have only slightly modernized:

> And so imagine we and set our mind and our thought as we were present in the place where this was done at Bethlehem, beholding how these three Kings comen with gret multitude … and how they alight down of the dromedars they had ridden upon, before that simple house and manner of stable in which our Lord Jesus was born. And

then, our Lady hearing great noise and stiring of people, anon took her sweet child into her armes, and they come into that house, and soon as they see the child they kneel adown and reverently and devoutly honoured him as a king … Now we take good heed, as to the manner of speaking of both parties, how our lady, with a manner of honest shamefastness, holding down her eyes towards the earth, speaketh and answereth sadly and shortly to their askings, for she has no liking to speak much …[23]

I need not elaborate on the clash between this account and the Romanesque fresco from Spain.

It could be argued that, at first, sculpture was more pliable to these new demands than was painting. The rendering of the individual figure, as it responded to any situation, achieved a dramatic intensity with Nicola and Giovanni Pisano which has never been surpassed (fig. 23). But once these protagonists were felt to be in need of a convincing stage, a consistent spatial setting, only painting could provide all the means to this end. It is at this point of the story that I would place the figure of Giotto (figs. 24, 25). He was the narrative genius who knew how to transform the traditional pictograph into a living presence, and the participants into beings with an inner life of inexhaustible intensity.

Thus my interpretation of the growth of representational mastery relies on the same basic principle that I have postulated for the development of illusionism in ancient art. It would indeed be possible to take up the story of Renaissance art from here and chronicle the progress towards this goal, in which, of course, the conquest of perspective and of anatomy play their part.[24] Leonardo's preparations for his *Adoration of the Magi* (figs. 26, 27) illustrate these increasing concerns, which bring in the resources of science and justify the role in the history of this development which historians have assigned to him since the days of Vasari. These sketches were made by Leonardo not for a fresco but for an altarpiece – another new area where the new aim of painting might clash with the traditional function of the visual image in the Christian Church.[25] Suffice it to say that, in a sense, Vasari's story would have to be supplemented and perhaps adjusted to describe the various means by which artists tried to extricate themselves from these conflicts of ends.

In the history of fresco painting, Giotto stands at the beginning of a long and complex series of problematic solutions. Remember that, in the tradition he inherited, the symbolic, narrative, and decorative elements could peacefully coexist within any fresco cycle. However, this coexistence

23 Nicola Pisano, *Adoration of the Magi*, relief, 1265–8. Siena Cathedral

24 Giotto, *Adoration of the Magi*, *c*.1306. Arena Chapel, Padua, section of south wall

25 Detail of fig. 24

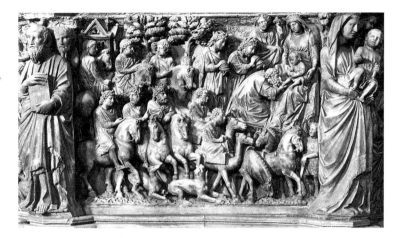

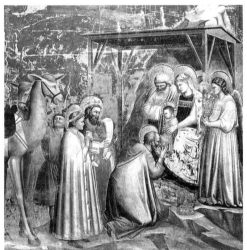

was inevitably threatened by the new demand for the convincing evocation of significant events. As if to acknowledge this new need for differentiation, Giotto introduced a visual distinction between symbolism and narration: the didactic images of the Virtues and Vices are distributed below in grisaille, suggesting fictitious statuary rather than living flesh; while the stories above are told with all the resources of his new realism. In thus introducing the device which the Swedish art historian Sven Sandström, in a thoughtful book, has called *Levels of Unreality*,[26] Giotto assigned a special status to those personifications which in the tradition of Western thought occupy a kind of no-man's-land between spiritual entities and mere abstractions. But the demands of a full narrative did not

31

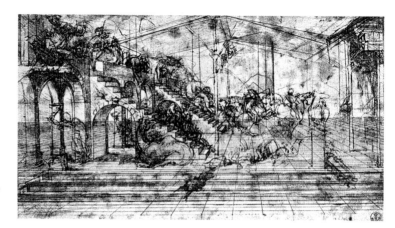

26 Leonardo da Vinci,
Study for *The Adoration of
the Magi, c.*1480. Uffizi,
Florence

27 Leonardo da Vinci,
*Figure Studies, c.*1480.
Louvre, Paris

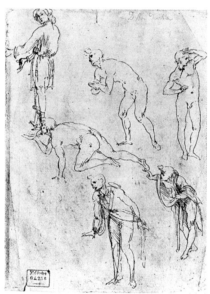

allow him at the same time to escape that stacked arrangement which
Leonardo described as the height of stupidity – for this effect was
inseparable from his achievement. As long as narrative was conceived as
writing on the wall, concentrating on the 'what' rather than the 'how',
there was no visual jump between the scenes; but when we are asked to
focus on the single frame which Alberti was to liken to a window opening
on to a scene, the multiple vistas carry within them the seeds of their own
destruction. This is so even before the introduction of perspective makes
the contradiction fully apparent.[27]

Art historians need no reminding that, in the early history of perspective, means and ends were sometimes out of phase. The first application of the new skill to fresco painting of which we know is Masaccio's majestic *Holy Trinity* from Sta Maria Novella, in Florence (fig. 28); but what it represents within this highly convincing fictitious chapel is not an imagined reality but a purely symbolic image, a reminder of a doctrine which cannot be visualized at all. The real presence in art of the First Person of the Trinity in so tangible a form is not easy to reconcile with the Decalogue, but it does not seem to have disturbed Masaccio's contemporaries.

In the Brancacci Chapel of Sta Maria del Carmine in Florence, Masaccio made use of the compartmentalized scheme; and so did any number of masters of the quattrocento elsewhere. But there are signs that in the course of the century the method began to look old-fashioned. Mantegna had used the traditional scheme in the Ovetari Chapel in the

28 Masaccio, *Holy Trinity with the Virgin, Saint John and Donors*, 1425. Sta Maria Novella, Florence

Church of the Eremitani in Padua, but in the Camera degli Sposi in the Palazzo Ducale in Mantua (fig. 29), he created an interior of astounding originality, applying the basic devices of the mural painters of antiquity in an entirely novel fashion, with its fictitious vistas and the famous open roundel in the ceiling through which people appear to look down into the room. Note the family group over the mantelpiece which confronts us almost bodily in the narrow zone before the fictitious wall or curtain. But in this extraordinary room, Mantegna did not have to contend with the narrative aims of Christian didactic art, which proved so hard to assimilate to the novel means of illusionistic painting. Where a sequence of scenes was demanded, the easiest way out of the dilemma was still provided by the real architectural articulation of a wall, the division into lunettes each of which could accommodate a scene with its own space, as with Domenico di Bartolo's room in the Ospedale della Scala in Siena (fig. 30). It is only a small step from this familiar scheme to Pinturicchio's solution, which completely conforms to Leonardo's demand for the unities of wall, space and scene, in the beautiful interior of a chapel in Sta Maria Maggiore at Spello (fig. 31). Here, there are three scenes on three walls: the *Annunciation*, the *Nativity*, and *Christ among the Doctors*. The artist did not find it all that easy to fill these walls with significant detail, but the general impression of these spacious scenes is much more pleasing than isolated illustrations might suggest. The chapel was completed in 1501, and we may regard it as a landmark. For, by the beginning of the sixteenth

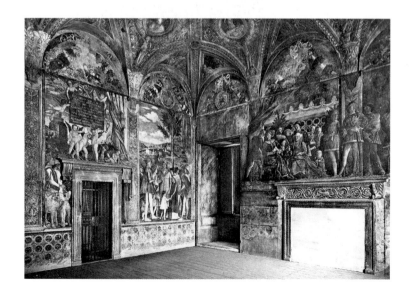

29 Andrea Mantegna, Camera degli Sposi, *c*.1464–74. Palazzo Ducale, Mantua

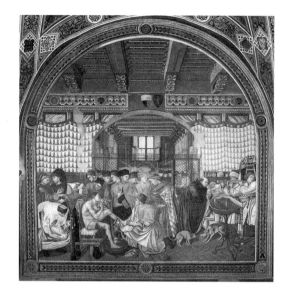

30 Domenico di Bartolo,
Activities of a Hospital,
1441–4. Ospedale della
Scala, Siena, west wall of
the Pellegrinaio

31 Pinturicchio,
Annunciation, 1501. Sta
Maria Maggiore, Spello

century, the old compartmentalized system was no longer acceptable. Others must have shared Leonardo's view.

There is one work, of course, which evades the problem and wholly defies categorization. This is Michelangelo's ceiling in the Sistine Chapel (fig. 32), in which the individual stories or scenes are not stacked on top of each other, precisely because they are in an unreal sphere on top of a

32 Michelangelo, vault of
the Sistine Chapel,
1508–12. Vatican

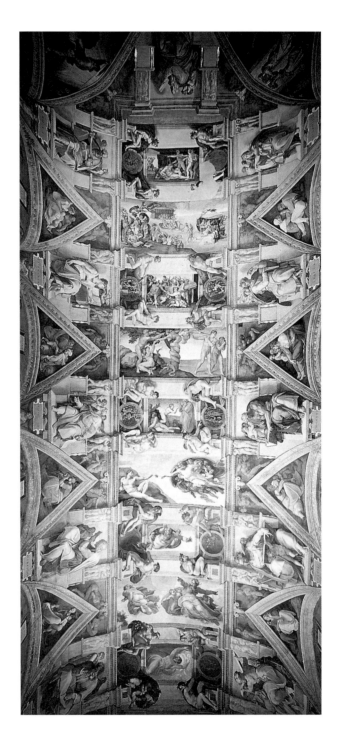

fictitious architecture. Whether Leonardo would have approved of this invention or regarded it as a dodge we shall never know. He would hardly have objected to Raphael's Stanze in the Vatican (figs. 33, 34), which have become the standard example of fresco decoration, with lunettes in each of the vaulted rooms corresponding to one space and one topic, if not one scene. Leonardo would have had no reason and no right to object to the fact that these scenes do not start at floor level but above the dado. He had

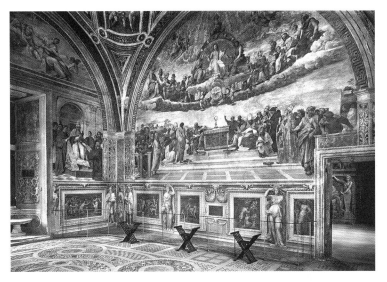

33 Raphael, Stanza della Segnatura, 1509–11. Vatican

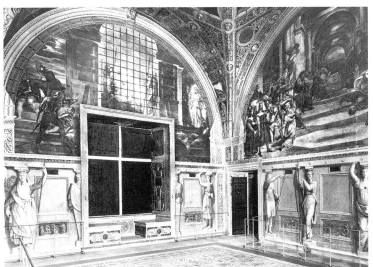

34 Raphael, Stanza d'Eliodoro, 1511–14. Vatican

done the same in Sta Maria delle Grazie; and indeed this is a practical precaution without which paintings on a wall soon succumb to the friction of crowds rubbing against them or fingering them.

The base in the Stanza della Segnatura is not original, except for the fictitious reliefs under the Parnassus, which indicate that Raphael resorted to those 'degrees of unreality' we remember from Giotto. The idea was used with conviction in the next stanza, the Stanza d'Eliodoro, where fictitious caryatids carry a kind of balustrade across which we look into the dramatic scenes which are, by themselves, far from simple. Indeed, if we analyse these first two Stanze, we may come to reflect that their harmonious appearance is partly a matter of luck – ours as well as Raphael's. His first commissions in Rome involved the decoration of relatively small rooms, which almost asked for this harmonious solution. It was different with the Sala di Costantino (fig. 35), for here he needed to organize much larger walls without resorting to that subdivision into registers which had become old-fashioned and unusable. Hence Raphael had recourse to the device of the tale within a tale. His dramatic scenes from the life of Constantine are represented as if they were woven hangings, suspended between niches with portraits of Popes, flanked by personifications who appear to be very much of our world of flesh, a strange reversal of Giotto's solution.

The variety of solutions to this problem of decoration, particularly among the pupils and followers of Raphael and other masters active in Rome, has recently been surveyed in a stimulating book by Catherine Dumont.[28] In turning its pages, we are introduced to the many variations played on themes introduced by Raphael and Michelangelo and carried to extremes by the next generation – such as the crowded walls of the Sala della Giustizia designed by Perino del Vaga in the Castel Sant'Angelo in Rome (fig. 36), which show us layer upon layer of fictitious fictions. You will rightly be reminded here of the ancient examples I have already illustrated, but Pompeii was of course undiscovered at that time. No doubt hints could be derived from fragments of ancient painting found elsewhere, but what interests me is rather the reason why they were studied with such eagerness. I would suggest that they can be interpreted as the response to an inevitable conflict between ends and means which arises from the fact that decoration, sequential narrative, and dramatic evocation each demand a different way of looking. If it was consistent with logic for Alberti to suggest that a painting representing a *historia* should be conceived as a window through which we look at the scene, it followed that a frescoed wall should be similarly treated as a fictitious opening, as

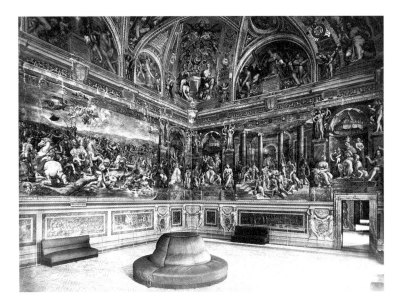

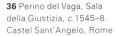

35 Raphael and Giulio Romano, Sala di Costantino, *c*.1520–4. Vatican

36 Perino del Vaga, Sala della Giustizia, *c*.1545–8. Castel Sant'Angelo, Rome

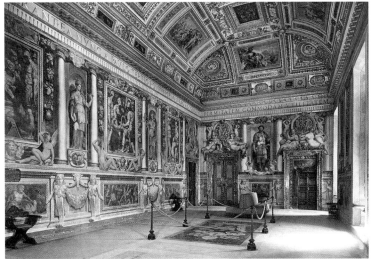

Peruzzi had done on Vitruvian principles in the Villa Farnesina (fig. 37), without, however, denying himself the privilege of introducing a fictitious frieze with Ovidian scenes above the opening and various fictitious reliefs and statues. But, in any case, why should the fiction of the opening be restricted to the separate walls? Taken to its logical extreme, the principle must in fact deny not only the wall but the room itself, which is what Giulio Romano did in Mantua, in a sensational showpiece which is not,

perhaps, the height of stupidity, but the height of folly, when regarded as a room – precisely because it is the ultimate in dramatic evocation, the equivalent of a 3-D horror film (fig. 38).

In the history of art, these various forms of organized confusion are generally discussed under the stylistic heading of Mannerism. When I was a young student of the subject, Mannerism was supposed to thrive on deliberate tensions, dilemmas and paradoxes. It seems to me now that these dilemmas were not so much contrived as real: they were the result of the means of illusion outrunning the ends of decoration and of evocation, and creating problems for the artist which made a harmonious solution

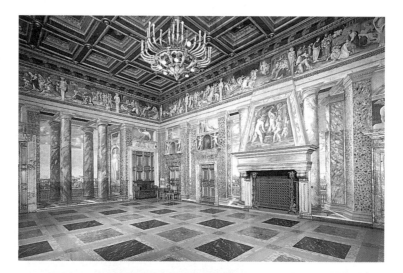

37 Baldassare Peruzzi, Sala delle Prospettive, c.1516. Villa Farnesina, Rome

38 Giulio Romano, Sala dei Giganti, 1532–5. Palazzo del Tè, Mantua

extremely difficult if not impossible. The richness, and indeed the visual wit, of some of these decorative schemes is not in doubt, but the imbalance between ends and means is unresolved, whether we look at Vasari's Sala dei Cento Giorni in the Cancelleria in Rome (fig. 39), with its fictitious steps leading to fictitious scenes; or at Francesco Salviati's Palazzo Sacchetti (fig. 40), with its panels uncomfortably superimposed on

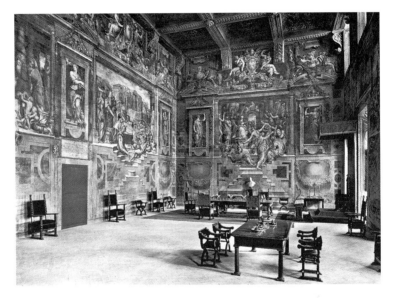

39 Giorgio Vasari, Sala dei Cento Giorni, 1546. Palazzo della Cancelleria, Rome

40 Franceso Salviati, Sala Grande, 1553–4. Palazzo Sacchetti, Rome

fictitious columns. I believe we cannot do justice to these complexities unless we supplement the purely formal and stylistic approach by the reconstruction of the problems facing the artist in the adjustment of means to ends and ends to means.[29]

I am emboldened to suggest this methodological rule because it may also help us in our appreciation of the next development in the history of fresco painting, the rise and proliferation of the so-called illusionistic ceiling, which we associate with the style of the Baroque, though we know it to have been started early in the sixteenth century, notably with Correggio's cupolas (fig. 41), derived, perhaps, from Mantegna's vault.[30] Now, this device can also be seen as a response to the dilemma which engaged our attention. For if there is one area in a large room to which Leonardo's unities can be applied without subterfuges and qualifications, it is the ceiling. Imagine it as a fictional pane, and you look straight into heaven. The example shows in a particularly striking way how means will

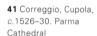

41 Correggio, Cupola, *c.*1526–30. Parma Cathedral

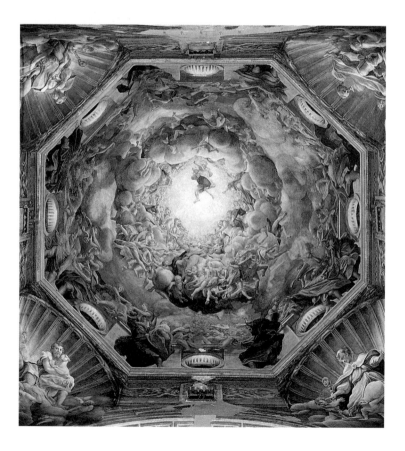

tend to generate ends. What looks like another purely formal or decorative device has the profoundest consequence on the resources of the image. It enabled the artist to recapture that unity of the symbolic, the narrative and the decorative, inherent in medieval art, which had disintegrated through those demands of dramatic evocation with which we have been concerned. In heaven, there is no distinction we can grasp between angels and those spiritual entities we call personifications.[31] Looking into heaven is in any case a visionary experience, where metaphors gain reality not as tangible representations but as the embodiment of the divine message. The light of heaven is not earthly light but divine radiance, which is seen in the famous ceiling of S. Ignazio to shine on the heart of the saint, whence it is reflected into all parts of the globe (fig. 42). To call such a composition, with all its attendant symbolic beings and signs, illusionistic seems to me again to be straining the meaning of the word; but we may call it an evocation which turns us into visionary eyewitnesses of that mystery which the Church desires to convey to the faithful. No doubt the possibility of transforming the ceiling into a unified vision also attracted the secular rulers, with their desire for apotheoses and mythological eulogies; but, as before, the system weakened and disintegrated with the coming of a new rationalism and literalism.

The eighteenth century Neoclassicists got tired of looking into heaven and shunned this form of illusionism. They argued that a wall is a wall and a ceiling a ceiling. The *Parnassus* by Anton Raphael Mengs in the Villa Albani in Rome (fig. 43) passes for one of the first symptoms of this attitude. You could not tell from the illustration that it was a ceiling painting and not a mural. In Neoclassicism the decorative picture became increasingly subservient to the aim of lucid organization, as exemplified in the Etruscan Room designed by Robert Adam at Osterley (fig. 44).

Lecturing to the students of the Royal Academy at the turn of the nineteenth century, Henry Fuseli came to speak of the lost murals by Polygnotus in Delphi which, by that time, had become the subject of much debate among classical scholars and artists, who attempted to reconstruct their appearance on the basis of the description by Pausanias. Remember that Goethe's diagram of the arrangement (fig. 14) shows the more remote figures higher up on the wall. Taking note of this compositional principle, Fuseli warned his hearers not 'to impute solely to ignorance or imbecility what might rest on the firm base of permanent principle':

At that summit, art shuns the rules prescribed to inferior excellence and … returns to its elements … Simplicity, parallelism, apposition,

take place of variety, contrast and composition … We must incline to
ascribe the primitive arrangement of the whole rather to the artist's
choice and lofty simplicity than want of comprehension.[32]

In the course of the nineteenth century this preference for primitive
methods of composition over illusionism in decorative painting was

44

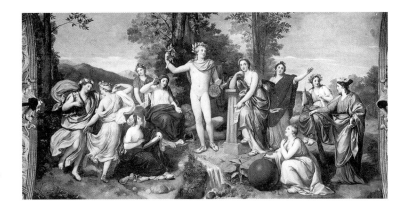

43 Anton Raphael Mengs,
Parnassus, 1761. Villa
Albani, Rome

44 Robert Adam, Etruscan
Room, 1775–7. Osterley
House, London

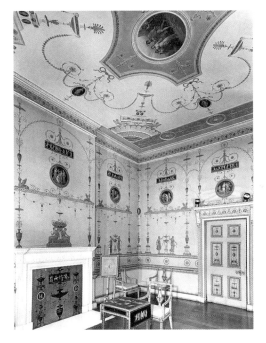

destined to become an article of faith among the reformers of design. Pugin emulated the tact of the medieval designer, who avoided the pitfalls of illusionistic motifs; he specifically mentioned that wallpapers should never show shadowed objects, because their painted shadow, when repeated all round the room, would come into conflict with the real shadows cast by the light from the windows.[33] Maybe the literal-minded Victorians underrated the capacity of the human mind to take fiction as fiction.

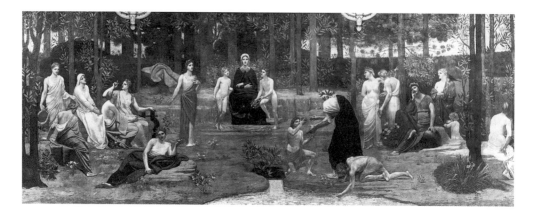

45 Pierre Puvis de Chavannes, *The Sciences and the Arts*, 1887. Grand Amphithéâtre, Sorbonne, Paris

46 Ferdinand Hodler, *The Retreat from Marignano*, 1896–1900. Schweizerisches Landesmuseum, Zurich

47 Gustav Klimt, Mosaic frieze, 1909–11. Dining room, Palais Stoclet, Brussels

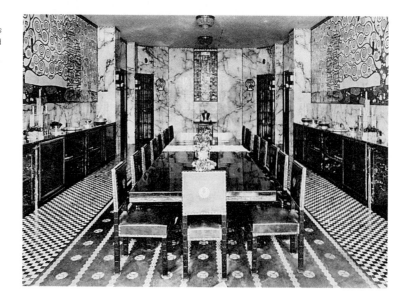

When, in 1852, the zealous reformer Sir Henry Cole arranged an exhibition at Marlborough House of visual atrocities which the cultivated designer should learn to shun, he did not fail to include paper hangings which are severely criticized in the catalogue for showing 'natural objects in unseemly positions, horses and ground floating in the air, objects much out of scale'.[34] Shades of Leonardo!

In the inevitable conflict between the means of illusion and the ends of decorative design, illusion was rapidly losing its hold on the visual image. The decorators were in the van of those who decried the vulgarity of illusionistic tricks, and leading masters of the mural came to adopt their dogma. Pierre Puvis de Chavannes said that if an artist failed to respect the wall, the wall would reject his work (fig. 45). The expression he used was more drastic, and is best left untranslated.[35] From Puvis the message was taken up by Ferdinand Hodler in Switzerland, who championed as the true principle of art the idea of 'parallelism'[36] – the very term Fuseli had used in his description of the lost murals by Polygnotus. But even Hodler's monumental murals (fig. 46) were too robust for the next generation of Art Nouveau, who much admired them but who had discovered in the East and in Byzantine art new sources of inspiration – witness Gustav Klimt's mosaic decoration of the dining room of the Palais Stoclet in Brussels, with its near-abstract play of flat shapes (fig. 47).

These designs date from 1905-9, and by this time the crisis which disrupted Leonardo's unities in mural decoration had also spread to easel painting. But that story must be accorded a separate chapter.

Chapter 2 Paintings for Altars

Their Evolution, Ancestry and Progeny

First published in *Evolution and its Influence*, ed. Alan Grafen (Oxford, Clarendon Press, 1989), pp. 107–25.

'Evolution in the Arts' is the title of a very learned book of 1963 in which Thomas Munro, a distinguished authority on aesthetics, surveyed the vast literature on the subject, including, of course, the theories of Herbert Spencer, in more than 500 double-columned pages.[1] In reviewing the book,[2] I ventured to criticize the author for his benevolent neutrality towards all varieties of this multi-faceted theory which left one wondering what he really thought. In this chapter, I shall present further thoughts on this elusive subject.

For to confess it without further ado, I myself have toyed with certain analogies I thought to perceive between evolution in nature and evolution in the arts. Indeed, when I was asked at pistol-point by my French publisher what to call a collection of my essays which he had already printed, I plumped for the title *L'Écologie des images*.[3] The title caused a certain flutter in the critical dovecots, particularly in France and in Italy, though I had meant nothing more sensational by it than the idea (which I had quite frequently put forward before) that what we call changes in style can be interpreted as adaptations, on the part of the working artists, to the functions assigned to the visual image by a given society. I say advisedly of the artists, not of art, because I am an individualist in such matters and prefer to see the history of art as the result of living people responding to certain expectations and demands which, in their turn, they may also help to stimulate, or at least to keep alive. In fact, the metaphor of the ecological niche appealed to me precisely because it does not imply a rigid social determinism. Indeed, the study of ecology has alerted us to the many forms of interaction between the organism and its environment which render the outcome quite unpredictable.[4]

Needless to say, these generalizations do not only apply to the arts of the image-makers. All the specialized skills that together make up the

fabric of civilization must have evolved in answer to demands which fed on their satisfaction. But in the history of technology and of science these demands are perhaps more easily specified than they are in the history of the arts. Whether we think of aviation or medicine, it is not difficult to explain the driving force behind their evolution.

To apply the term evolution to all the arts indiscriminately would seem to imply that, like the arts of flying or of healing, the arts of sculpture and of painting were always intended to serve a statable purpose. Up to a point, this was Spencer's view: he saw the arts as a means of producing 'aesthetic enjoyment'. I would not deny that there is such a thing, but it has always seemed to me one of the pitfalls of philosophical aesthetics that it so easily leads to tautologies. It might be said that neither cave paintings nor minimal art would have been produced if these products had never pleased anyone, reminding us of the saying, 'For those who like that kind of thing, it is the kind of thing they like.'

My book *Art and Illusion* contains a chapter entitled 'Reflections on the Greek Revolution', in which I tried to be a little more precise.[5] I there suggested that the slow but steady approximation of Greek art to natural appearances, the evolution of mimesis, might have been due to the same demands that also resulted in the development of the drama: the demand, or perhaps the craving, to see the events told by the poets and historians re-enacted as if they were happening in front of the audience, a demand I later condensed into the formula of the 'eye-witness principle'.[6] Applying this principle must ultimately have led to the mastery of foreshortening, the rendering of a unified space, and of light and shade. To illustrate these conquests, it is sufficient to contrast the famous mosaic of Alexander's victory over Darius (fig. 48) with an ancient Egyptian victory monument in which Tuthmosis III is seen holding and smiting a bundle of Asiatic prisoners (fig. 49). By way of radical simplification, I would call this style pictographic and that of the Hellenistic battle-piece photographic.

Admittedly this account of the function of the image in classical antiquity is very one-sided. The techniques of image-making never serve the same kind of statable purpose as does the technology of aviation or medicine. I still believe that dramatic narrative was a dominant aim of ancient art, but obviously the older and more persistent demand must have been for the creation of cult images. After all, the fame of Pheidias rested on his colossal statues of the Olympian Zeus and the Athena Parthenos. Both these works satisfied another demand: they must have been immediately recognizable as the divinities they represented, and this recognition also depended on their exhibiting the correct traditional

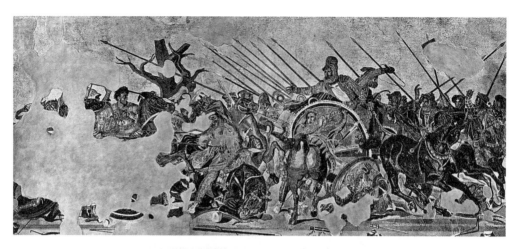

48 *Alexander's Victory over Darius*, mosaic after a Hellenistic painting, *c.*100 BC. Museo Nazionale, Naples

49 *Tuthmosis III Smiting the Asians*, 15th century BC. Temple of Amon, Karnak, seventh pylon

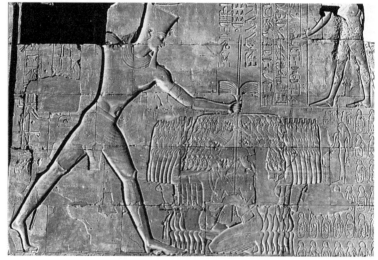

attributes. One copy of the cult image of Athena – artistically not the most attractive one – is at any rate complete, showing her traditional attributes as the Gorgoneion, the formidable trophy she wears around her neck, the shield and spear, and the statue of Nike her auspicious helpmate (fig. 50). Many ancient statues we see in our museums were found without their attributes, which were sometimes dubiously restored, but we can envisage them from other images, such as that of Poseidon with his trident and a fish on a fifth-century amphora (fig. 51).

In a sense these attributes are the distinguishing features which serve to identify the god; ultimately they, too, are often derived from a narrative

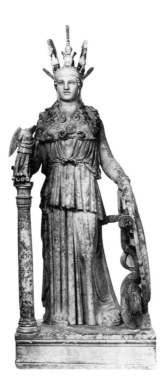

50 *Athena Parthenos*, Roman copy after a statue by Pheidias, *c.*447–432 BC. National Museum, Athens

51 *Poseidon*, 5th century BC, from the Panathenaic Amphora by the Kleophrades Painter. Antikensammlung, Berlin

context, from the role attributed to the God in mythology, where Poseidon shakes the earth with his trident, or Apollo plays the lyre. What history tells us, moreover, is that the increasing dominance of this narrative function also began to affect the isolated image. Praxiteles represented Aphrodite for her shrine at Knidos as emerging from her bath, and Lysippus may have invented the image of Herakles resting on his club from his labours, preserved in the Farnese Herakles.

When it comes to the discussion of Christian art in the Middle Ages, it is even more important to keep in mind the multiplicity of functions the image was expected to serve or, indeed, to avoid, and it is to the problem arising from these divided aims that this chapter is devoted. To consider the question schematically, it might be said that the Church had insisted on replacing the dramatic or evocative function by the pictographic one. According to Pope Gregory the Great, painting was to serve the illiterate laity for the same purpose for which the clerics used reading.[7]

Ever since Ruskin, this didactic purpose of the image in Christian art has been emphasized, and though one may doubt whether those who

could not read texts could in fact read the signs and symbols of ecclesiastical art, there is no denying the element of pictographic clarity of this tradition, which culminated in the imagery of the great cathedrals. I need only remind you of their porches where the sacred personages stand in serried ranks, as in the north transept of Chartres, begun in 1194, allowing us to read off their identities from these abbreviated symbols of their roles (fig. 52): Melchisedek, with his chalice and the censer of a priest, for he offered Abraham bread and wine; Abraham, whose sacrifice of his son Isaac is compressed into a pillar while he is looking up to the angel of deliverance; Moses, with the tables of the law and the pillar of the brazen serpent. Or remember the great stained-glass windows of the same cathedral, one of which shows the ancestry of Christ, the so-called Tree of Jesse, in almost diagrammatic form (fig. 53).

52 Melchisedek, Abraham and Moses, *c*.1194. Chartres Cathedral, north porch

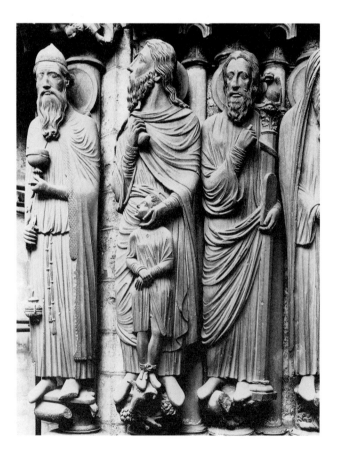

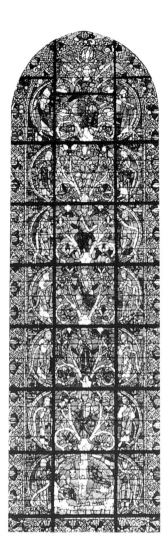

53 *Tree of Jesse,* stained glass, 12th century. Chartres Cathedral, west façade

In calling the style arising from this function 'pictographic', I am not, of course, making an aesthetic judgement, remembering how many great works of art testify to its artistic potential. Contrast two representations of the Last Supper, both taken from the screens of medieval cathedrals, one from Modena (fig. 54), dating from about 1184,[8] the other from Naumburg (fig. 55),[9] created about eighty years later by one of the greatest German masters. The earlier work is a lapidary illustration of the words of the Gospel of Saint John, where Christ says:

53

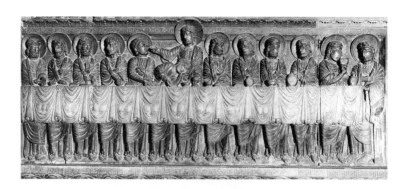

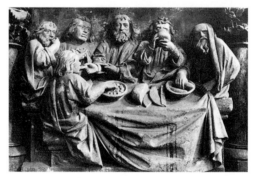

Verily, verily, I say unto you, that one of you shall betray me. Then the disciples looked one on another, doubting of whom He spake. Now there was leaning on Jesus' bosom one of his disciples, whom Jesus loved. Simon Peter therefore beckoned to him, that he should ask who it should be of whom He spake … Jesus answered, He it is, to whom I shall give a sop, when I have dipped it. And when he had dipped the sop, He gave it to Judas Iscariot … (John 13:21-6)

The text is illustrated with the utmost economy. The central group shows us the disciple leaning on Jesus's bosom, and the gesture of Jesus as he gives the sop to Judas. We must look a little more closely for Saint Peter who had beckoned that Christ should be asked, but there is only one of the disciples who has raised the hand in a speaking gesture, while all the others merely look at their neighbours. Remembering, as we all do, Leonardo's evocation of the scene, we may find this treatment hieratic, but it is all there.

In Naumburg, we are well on the way to Leonardo's dramatic evocation. Note the famous trait of Jesus holding his sleeve while handing Judas the sop, so that it should not get into the dish in front of him, not to

speak of the freedom with which each individual figure of the drama is realized. Here, as elsewhere, I use these works of art as an illustration of a theoretical point, that the difference between these two works cannot be expressed merely in terms of the evolution of formal means. I have often said that I believe that Émile Mâle[10] was fundamentally right when he reminded us of the new approach to the sacred story that can also be documented from popular sermons and miracle plays, all of which strove to evoke the events as vividly as possible, thus creating new expectations and a novel demand somewhat analogous to what I have called the Greek revolution.

The Naumburg group dates from about 1260, and it is worth recalling that this is also the period to which the first historian of art, Giorgio Vasari, assigned the beginning of the Renaissance. Knowing nothing of the North, he saw it embodied in the sculpture of Nicola Pisano, who had profited in his evocations from the study of ancient art.

If I am asked why painting lagged behind sculpture in meeting the demands which I have postulated, I would reply that certain media are less adaptable to certain requirements than others. It is far from obvious for the painter how to create the illusion of really looking into the room where the Last Supper is taking place. Even Giotto did not quite succeed. He lacked the scientific tool that had to be evolved by trial, error and scientific calculation in the slow progress that you find described in any history of Italian art from Giotto to Tintoretto.

Far from wanting to go over this ground again, I should like to concentrate instead on the inadequacy of the 'eye-witness principle' for the explanation of many paintings of the period, including some of the most famous ones. For, like their ancient predecessors, Italian artists also had to meet the demands of a very different task – the creation of cult images. Now it is true that the doctrine of the Latin Church excluded the worship of images, but it would not exclude the popularity of cults, the cult of saints and their relics and the development of a genre of art to which I should like to devote most of the remainder of this essay – the decoration of the altar.[11]

The emergence and evolution of this art form demonstrate to my mind the way a great variety of independent factors interact, ultimately to produce results which could never have been predicted at the outset. It is more than a pun if I refer back to the term of the 'ecological niche', because it allows me to explain why this niche had remained empty during the first millennium of the Christian era.

One of the reasons was purely liturgical: we have been reminded after the Second Vatican Council that in the early centuries the priest stood

behind the altar, facing the congregation, as we see on a famous Carolingian ivory in Frankfurt (fig. 56). While this practice persisted, the *mensa*, the altar, was really a table, and nothing could have been placed upon it without obscuring the officiating priest. All that could be done to decorate the altar was to adorn the front of the table, and indeed there were such altar frontals, the most famous being the golden *antependium*, from the early eleventh century, given by the German Emperor Henry II to the cathedral of Basle (fig. 57). It shows the diminutive figures of the imperial donors crouching at the foot of the majestic central figure of Christ who is accompanied by the three archangels, and Saint Benedict with his crozier and book. There are also less costly frontals or *antependia* with pictorial decorations, but the demand for pictorial images only became insistent when the priest changed his position to before the altar while celebrating mass, as shown in a fifteenth-century Flemish miniature (fig. 58), where the priest is seen elevating the host in front of a large altar structure. The type is still extant in the North – for instance the

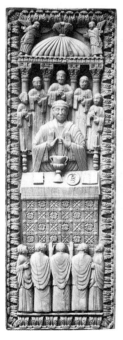

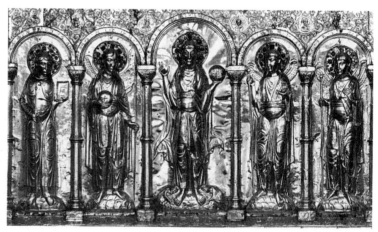

56 *Priest Celebrating Mass*, ivory, 9th–10th century. Stadt- und Universitätsbibliothek, Frankfurt-am-Main

57 *Antependium of Henry II*, early 11th century. Musée de Cluny, Paris

magnificent shrine by Hans Brüggeman, dating from 1521 (fig. 59). I trust no one will need persuading that such an elaborate work stands at the end of a long and complex evolution which I can only present in a radically simplified form, a kind of diagram which can only relate, at best, to the real course of events as the London Underground map relates to the actual network of lines.[12]

The wooden triptych represented as standing on the altar in the background of Sassetta's painting in the National Gallery in London illustrates the earlier form these church furnishings frequently took in the Italian South (fig. 60). They offered a visual display for the congregation during the service and made the altar into the focus of devotion for anyone entering the church. But while the change in the position of the priest made this development possible, it can hardly be described as a sole cause.

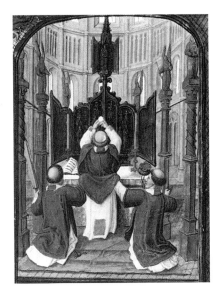

58 *Priest Celebrating Mass*, Flemish miniature, 15th century. British Library, London, Add. MS. 35313, fol. 40

59 Hans Brüggeman, carved polyptych made at Bordesholm, 1521. Schleswig Cathedral

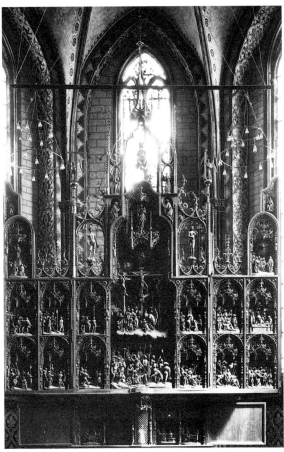

60 Stefano di Giovanni, called Sassetta, *The Funeral of Saint Francis*, from an altarpiece of 1444. National Gallery, London

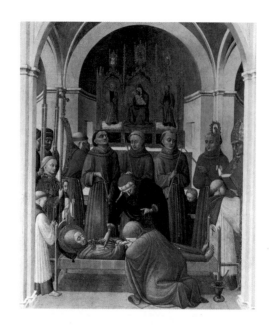

60 Stefano di Giovanni, called Sassetta, *The Funeral of Saint Francis*, from an altarpiece of 1444. National Gallery, London

Another element enters this momentous development, which brings it home to us that evolution in the arts can never be studied in isolation from geographical and historical factors. This was the role of the image in the neighbouring lands dominated by the Eastern, or Byzantine, Church.

It is desirable to steer clear of the complexities and horrors of that issue, horrors because of the bloodshed it caused when the iconoclastic movement nearly tore the Byzantine Empire to shreds. Suffice it to say that after that terrible crisis the image or icon was accorded a special status in the Greek Church which largely removed it from the innovations and experimentations which characterize developments in the Latin West.

But what is important in our context is that the icon is not an altar painting. Its place is on the *iconostasis*, the screen that separates the laity from the choir. Now the history of the *iconostasis* may in some respect run parallel to that of the Latin altar,[13] but this need not concern us. What concerns us is a historical event which marks an important point in my diagram, the conquest of Constantinople by Latin crusaders in 1204.

The exact significance of this event may be a matter for learned debate,[14] but it can hardly be an accident that this temporary removal of the political barrier between East and West coincided with a vogue for panel paintings in Italy which can only be described as imitation icons. The great seaport of Pisa seems to have been one of the main centres of import and soon also of the production of such easily portable images as

the painting of the Madonna now in Santa Maria del Carmine in Siena (fig. 61), which was probably painted in Pisa and which clearly reflects a Byzantine type. Indeed, seen from Byzantium, these incunables of Italian panel painting must have looked like provincial or even folk art.

It was this type of painting derived from Byzantium which Vasari had in mind when, in the sixteenth century, he looked back on the evolution of painting in Italy and described what he called the crude and ugly manner of the Greeks.[15] He thought that this style had dominated all the centuries since the decline of antiquity and that it was only due to his compatriot, the almost legendary painter Cimabue, mentioned by Dante, that Italian painting began to bestir itself, after which Giotto set it on its path of unbroken progress leading to the perfection of Raphael.

It is a neat story, but the events can also be read somewhat differently. It may be no less correct to say that Raphael's Madonnas, like the statue of Aphrodite by Praxiteles, testify to the triumph of the narrative mode over the tradition of the symbolic cult image, with further consequences to which I shall turn at the end of this chapter.

61 *Madonna*, probably painted at Pisa, 13th century. Sta Maria del Carmine, Siena

Not that the duality of pictographic symbolism and narrative representation can only be found in Western art. A twelfth-century icon from Mount Sinai shows Saint George with his attributes surrounded by narrative scenes from his life (fig. 62).[16] One of the earliest Italian panel paintings devoted to Saint Francis of Assisi, the panel by Berlinghieri at Pescia near Pisa, likewise shows the saint with his emblematic stigmata surrounded by episodes from his legend (fig. 63). Art historians like to contrast the scene of the *Sermon to the Birds* (fig. 65) with the same scene from the fresco cycle at Assisi (fig. 64). Whether or not the latter is by Giotto, it again illustrates to perfection the gulf between realistic evocation and an almost pictographic rendering.

But such a comparison almost begs the question of the purpose and function of these images. We learn more about this clash of tendencies by looking at a wing of an altar, also attributed to Giotto (fig. 66). It represents Saint Stephen in the garb of a deacon, and at the back of his tonsured head a small stone which serves as a reminder of his martyrdom by being stoned to death. A typical altar by Giotto's follower Taddeo Gaddi (fig. 67), of about 1340, illustrates the context of this conventional form, a series of panels, no longer quite in their original setting, with the Holy Virgin in the centre, flanked by the Baptist, with his pointing gesture, 'ecce

62 *Icon of Saint George,* before 1200. Monastery of St Catherine, Mount Sinai

63 Bonaventura Berlinghieri, *Saint Francis,* 1235. S. Francesco, Pescia

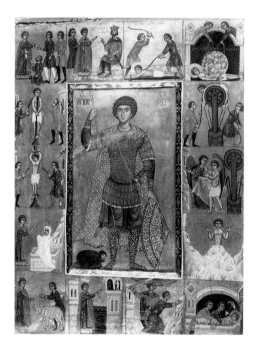

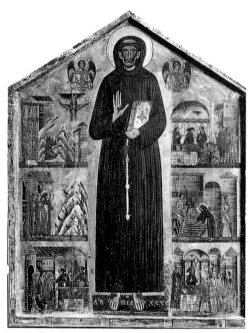

64 Attributed to Giotto, *Sermon to the Birds*, *c*.1300. Basilica of St Francis, Assisi

65 Bonaventura Berlinghieri, *Sermon to the Birds* (detail of fig. 63)

66 Attributed to Giotto, *Saint Stephen*, *c*.1300. Casa Horne, Florence

67 Taddeo Gaddi, *Madonna and Child Enthroned with Saints*, *c*.1340. Metropolitan Museum of Art, New York

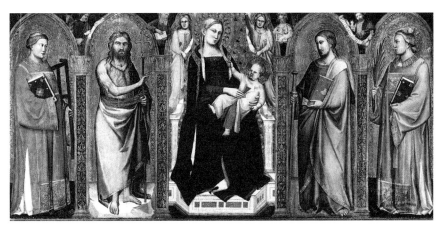

Agnus Dei', Saint Lawrence with the gridiron, and on the opposite side again Saint Stephen, and Saint James. We are so used to these divergent modes of painting that we sometimes forget that to ignore these inherent tensions can cause us to misunderstand the meaning of certain images.

There is a charming panel in Edinburgh attributed to the fourteenth-century master Vitale da Bologna (fig. 68), which is described in the catalogue as representing the Adoration of the Magi.[17] To be sure, we see the three kings of legend representing, as they traditionally do, three ages of man. The old king has deposited his gift of gold in the form of a chalice on to the seat of the Virgin; the second, in his prime, who points to the star, holds the censer; and the youth presumably carries myrrh in his box or coffer. Below, in the right-hand corner, we see the horses from which the travellers have dismounted, with their grooms. They wear exotic headgear to show that they have come from distant lands, though one of them is only visible behind the horse. But if this part of the panel justifies the interpretation of the catalogue as a narrative, the two female figures on the other side do not. They are two female saints, and again, if we look closely, we discover other figures presumably of further saints recognizable only by their haloes and the crown on one of their heads. Whoever they are, they are not part of the narrative; the artist did not imagine or envisage them standing by the side of the scene when the Magi arrived from the East. The one holding the wheel is of course Saint

68 Vitale da Bologna, *The Adoration of the Magi and Saints, c.*1350–9. National Gallery of Scotland, Edinburgh

Catherine, the one with the sword in all probability Saint Ursula. They are again marked by their attributes or emblems which remind the faithful of their characteristic martyrdom. Should we then really describe the panel in Edinburgh as *The Adoration of the Magi*? Is it not rather to be interpreted as an assembly of saints, namely Caspar, Melchior, and Balthasar, together with female saints? The question may be an idle one, except that it brings home to us that what may have mattered to the faithful was the presence of these intercessors rather than their role in a particular sacred episode.

In nature, hybrids often prove infertile, and in the history of art too, this rather confusing mixture of modes was not granted a long life. What we observe instead in the history of altar painting is a tendency to separate the two modes, assigning one part of the altar to the symbolic composition and another subsidiary one to the narrative. Thus the great altarpiece by Orcagna dedicated by the Strozzi to Santa Maria Novella exemplifies this solution (fig. 69). On the main panel we see Christ enthroned within a mandorla of angels handing the keys to Saint Peter and a book to Saint Thomas Aquinas. Needless to say, this is not the evocation of a scene which was imagined to have taken place in a here and now, but a purely

69 Andrea di Cione, called Orcagna, Strozzi Altarpiece, 1357. Strozzi Chapel, Sta Maria Novella, Florence

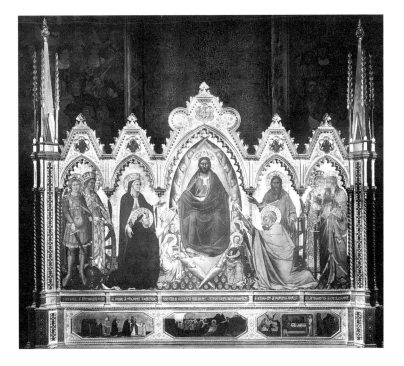

symbolic visualization of the role assigned to these saints, just as the other sacred personages, all of them not only marked with their emblems but labelled with their names, are here assembled as if they were witnesses to the solemn act, the Virgin protecting Saint Thomas, Saint Catherine with her wheel and Saint Michael with the dragon on one side, and opposite the Baptist behind Saint Peter, Saint Lawrence with the gridiron, and Saint Paul with his epistle to the Romans neatly sealed.

In his book *Painting in Florence and Siena after the Black Death*,[18] Millard Meiss sensitively analysed this great composition, which for him represented a departure from the realistic tendencies of the earlier generation of Giotto and a return to a more medieval and hieratic style. I would not contradict him, but we must not overlook the functional aspect of the altar painting, for underneath, in the predella, the artist has given narrative its full scope with legends of the saints represented above (fig. 70). Thus the scene of Christ and Saint Peter on Lake Genezareth is rendered with great dramatic intensity – remember the moment in the gospels when St Peter, having left the boat and walked on the water, finds himself sinking and cries out, 'Lord save me', and Christ replies, 'O thou of little faith' (Matthew 14:30–1).

In the next century, in the art of the quattrocento, the story-telling conception gains even more ascendancy over the symbolic or pictographic one. It was this shift in emphasis which led to a new form of altar painting as exemplified in Domenico Veneziano's wonderful Saint Lucy Altarpiece (fig. 71), so typical of the second quarter of the fifteenth century. The arcading of the hall still reflects the earlier tradition, but Saint Francis, Saint John the Baptist, Saint Zenobius the bishop, and Saint Lucy are shown together in the airy chapel into which light is streaming, where they seem to be paying homage to the Virgin on her throne. The togetherness of the sacred personages has led to this type of composition

70 Andrea di Cione, called Orcagna, *Christ in the Storm*, detail from predella in fig. 69

71 Domenico Veneziano,
Saint Lucy Altarpiece,
*c.*1440. Uffizi, Florence

71 Domenico Veneziano, Saint Lucy Altarpiece, *c.*1440. Uffizi, Florence

being referred to as a *Sacra Conversazione*, a term of the nineteenth century,[19] but of course there is no conversation in any earthly sense going on, not an event but a symbolic assembly. Here too the narratives of events were confined to the predella. I say were, because such small panels were easily taken away and two are now in Washington and two at the Fitzwilliam Museum in Cambridge. Each shows a miracle from the life of the saint represented above, such as the miracle of Saint Zenobius restoring a child to life after an accident (fig. 72), and I need not enlarge again on the dramatic character of this narrative, which seems to be laid in a typical Florentine street rendered with convincing perspectival skill, perspective being the form most suited to what I have called the evocative function.

The feature of altar painting which was most strikingly affected by the novel demands of a unified spatial setting was the place of the donor in the composition. This can be illustrated in the contrast between an altar painting by Jacopo del Casentino (fig. 73) from the early fourteenth century, with Lorenzo Costa's altar of 1488 (fig. 74). Both are dedicated to the Holy Virgin enthroned in the centre, but in the early work the donors who paid for the altar and hoped for reward in heaven are shown diminutively small in comparison with the holy personages, as on the altar frontal from Basle. In Costa's painting, the whole family or clan of the Bentivoglios is crowding in, no different in scale from the Madonna. It is

72 Domenico Veneziano,
Miracle of Saint Zenobius,
predella from the Saint
Lucy Altarpiece, *c*.1440.
Fitzwilliam Museum,
Cambridge

73 Jacopo del Casentino,
Madonna and Donors,
early-14th century.
Gemäldegalerie, Berlin

74 Lorenzo Costa,
Bentivoglio Madonna,
1488. S. Giacomo
Maggiore, Bologna

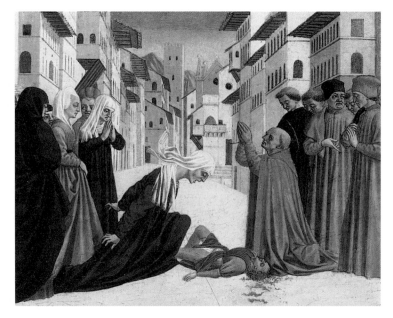

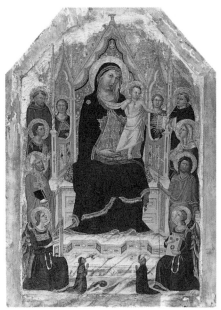

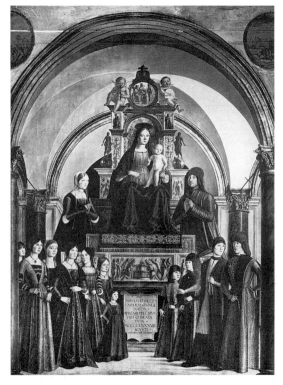

tempting in all such cases to regard this change as a symptom of a changed mentality, the 'self-assertiveness of Renaissance man' as compared to the humility of the medieval donor. But I am not sure that such an inference would be justified. Costa worked within a different pictorial tradition which excluded a disregard of scale, and we can only admire the skill with which he managed nevertheless to respect proprieties and to preserve some kind of psychological distance between the heavenly and the mundane spheres by purely compositional means.

For there is no denying that the expectations aroused by the novel achievements of realistic painting confronted the producers of altar paintings with special problems. Just as Costa no longer felt free to manipulate the size of the figures to express their humility or grandeur, so the needs of the genre could get into conflict with other progressive achievements. The ends always influence the appropriate means and the function of the altar painting demands that it should be clearly visible from afar.

In an earlier volume of essays[20] I juxtaposed the illustrations of two Florentine quattrocento altars, both representing the Coronation of the Virgin, one by Lorenzo Monaco dating from 1414 (fig. 75), the other by Fra Filippo Lippi dating from 1441 (fig. 76). My purpose was to show how Fra Filippo's mastery of realistic skills had to some extent jeopardized the spiritual quality of the earlier Gothic evocation of the heavenly ceremony. In addition, it also resulted in a painting that must be inspected at close

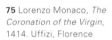

75 Lorenzo Monaco, *The Coronation of the Virgin*, 1414. Uffizi, Florence

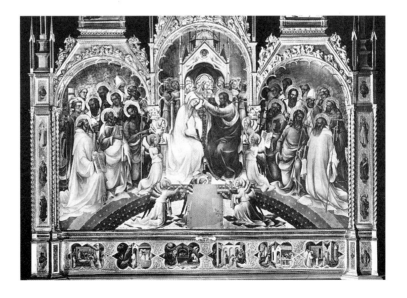

76 Fra Filippo Lippi, *The Coronation of the Virgin*, 1441. Uffizi, Florence

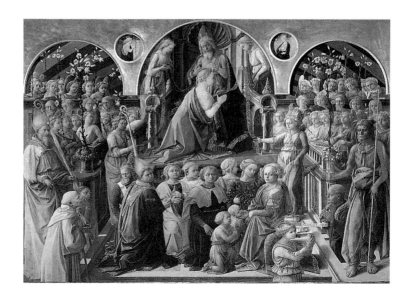

77 Rogier van der Weyden, *The Virgin and Saint John*, wing of an altarpiece, c.1445. Philadephia Museum of Art, John G. Johnson Collection

quarters to reveal all its subtlety and beauty, while the Lorenzo Monaco proclaims its meaning at one glance from a distance. Two Florentine painters of the next generation, Piero Pollaiuolo (fig. 78) and Sandro Botticelli (fig. 79), showed in their altar paintings of the same subject that they had absorbed the lesson and adjusted their means to the specific task. Though they could no longer work with a golden background, they still achieved that lucidity of composition which the genre of the altar painting demands.

That the problem is not one we construct from hindsight, but is inherent in the task, can be shown by its very fertility. Both the artists of Italy and those of northern Europe sensed its urgency and worked out ways to resolve these tensions.

Rogier van der Weyden's great *Deposition* (fig. 80) dates roughly from the same period as Filippo Lippi's *Coronation of the Virgin*, but it combines the most moving psychological realism with the refusal to create a pictorial illusion of reality, his group being assembled in a simulated sculptural shrine. Or take his panels of about 1445, now in Philadelphia, in which the golden background is confined to an upper zone (fig. 77). Before that we find a stone wall draped with what may be called a cloth of honour to set off the figures of the Saviour, of the Virgin and Saint John, again painted realistically without destroying the sense of distance. It needs the tact and inspiration of a great master to achieve this balance between conflicting demands.

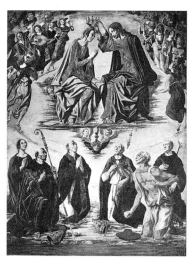

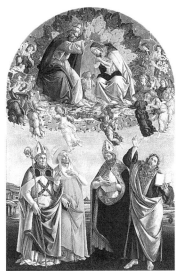

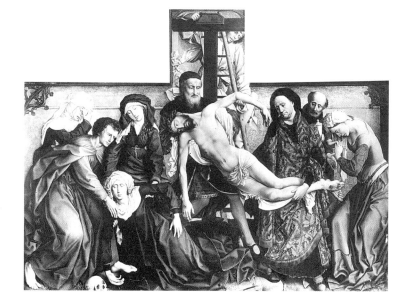

78 Piero Pollaiuolo, *The Coronation of the Virgin*, 1483. S. Agostino, San Gimignano

79 Sandro Botticelli, *The Coronation of the Virgin*, 1490. Uffizi, Florence

80 Rogier van der Weyden, *The Deposition*, c.1435. Prado, Madrid

Towards the end of the century the German Master of the St Bartholomew Altarpiece also used the device of a cloth of honour to set off the donor and saints (fig. 82), but he could not refrain from showing the peaks of mountains behind the cloth, a touching display of illusionistic skill, but slightly incongruous.

I hope to have shown that it might be fruitful to look at the evolution of altar painting in the light of the problem inherent in the task, the need of harmonizing the requirements of traditional didactic symbolism with the means of realism. I know no more telling example of these inherent tensions than the painting by Geertgen tot Sint Jans from the late fifteenth century (fig. 81). We see a large group of realistic, modishly dressed figures balancing on the branches of a tree like acrobats. It is of course a representation of the Tree of Jesse, the family tree of Christ, with David playing the harp in the centre and other ancestors precariously perched aloft. When we remember the twelfth-century stained-glass window from Chartres cathedral illustrating the same theme (fig. 53), we appreciate the ease with which a non-realistic mode of representation could present this visual symbol.

81 Geertgen tot Sint Jans, *Tree of Jesse*, c.1480. Rijksmuseum, Amsterdam

82 Master of the Saint Bartholomew Altar, altar wing, 1505–10. National Gallery, London

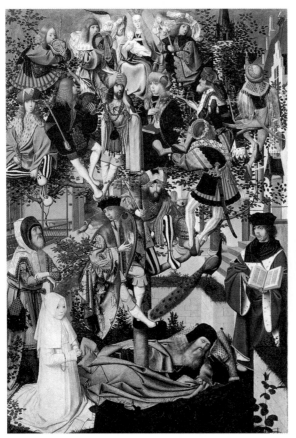

This is an extreme example, but its lesson has a bearing on one of the great altar paintings which is now housed in the Louvre, Leonardo's *Saint Anne* (fig. 84). I have suggested in *Symbolic Images*[21] that the problem confronting Leonardo can only be explained in terms of these two conflicting traditions or functions. A polyptych of the trecento by Luca di Tommè illustrates what I mean (fig. 83). Here there is no doubt in anybody's mind what we are supposed to see. Each of the saints is marked by their symbolic attribute, and Saint Anne is also so marked by having on her lap the Holy Virgin. How do we know she is the Holy Virgin? Because she holds on her lap the Christ Child; the picture is in fact a diagrammatic family tree. But with the coming of realism the conflict of which I have spoken made itself felt. In Gozzoli's version of the theme, the inconsistency of scale reflects the inconsistency of aims (fig. 85). Leonardo could not possibly have been satisfied with such a half-hearted solution, and we know from his sketches and his versions how hard he worked to reconcile the irreconcilable and to weld the whole into a group which is both an evocation and a symbolic presentation.

The cartoon in the National Gallery is unintelligible except as an attempt to solve this problem (fig. 86). Why is the Virgin seen half sitting on the lap of her mother? Clearly because if she were to slide down and sit beside her, the older woman would be taken for the mother of little Saint John, that is, for Saint Elizabeth, not Saint Anne. Leonardo later eliminated Saint John, the cause of this extra complication. He, if anyone, conceived of the art of painting as an evocation and re-creation of reality, and so great was his fame as a painter that when Filippino Lippi, who had been commissioned to execute an altar painting of Saint Anne, heard that Leonardo, just back from Milan, was ready to undertake it, he stood down to make way for the renowned artist. Vasari, who tells us this story, also relates that when the cartoon for that composition was ready in Leonardo's studio, 'not only were artists astonished, but the room where it stood was crowded with men and women for two days, all hastening to behold the wonders produced by Leonardo; and with reason', Vasari adds, for in the face of the Virgin is all the simplicity and loveliness which can be conceived as giving grace to the Mother of Christ as she contemplates the beauty of her son whom she holds in her lap. Saint Anne looks upon the group with a smile of happiness, rejoicing to see her earthly offspring become divine.[22]

It seems that Leonardo himself was not satisfied with this generalized evocation, and that he gave visitors a more detailed theological explanation of the symbolic interaction of the figures, with the Virgin

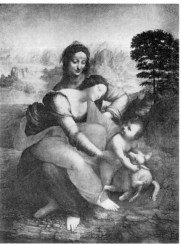

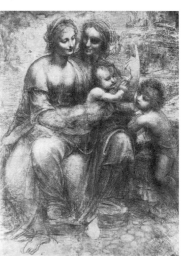

83 Luca di Tommè, *Virgin and Child with Saint Anne*, *c*.1370–5. Pinocateca Nazionale, Siena

84 Leonardo da Vinci, *Saint Anne*, *c*.1508. Louvre, Paris

85 Benozzo Gozzoli, *Madonna and Child with Saint Anne and Donors*, *c*.1470. Museo Civico, Pisa

86 Leonardo da Vinci, *Saint Anne*, cartoon, *c*.1502. National Gallery, London

wishing to remove the Child from the lamb, the sacrificial animal, and her mother restraining her so as not to hinder his sacrifice for the salvation of mankind.

What matters to me in this historical account is another step in the evolution from the cult image to a work admired for its own sake as a work of art. There is no evidence that Leonardo's painting, which he took with him to France and which is now in the Louvre, ever stood on an altar.

I do not want to overstate my case: I do not claim that earlier works of art, whether Western or Eastern, had not also aroused admiration and that

their masters were not also intent on displaying their skill for its own sake or to give aesthetic pleasure. But I believe it is significant that in the early sixteenth century, the period we call the High Renaissance, the general interest in the work of the artist had grown to such a pitch that even altar paintings were predominantly seen as opportunities for the display of mastery. When, around 1517, Giulio de' Medici commissioned two altar paintings for his cathedral at Narbonne from two famous painters in Rome, Raphael and Sebastiano del Piombo, the occasion was watched as a competition between two rival cliques. Sebastiano was the protégé of none other than Michelangelo, and no love was lost between his friends and those of Raphael, the darling of Pope Leo X. In order to secure Sebastiano's chances to outshine his rival, Michelangelo even supplied him with drawings for the *Raising of Lazarus* (fig. 87), the picture which is now in the National Gallery in London. Raphael's composition was to be the *Transfiguration of Christ on Mount Tabor* (fig. 88), which was left unfinished at his death and placed by his bier before his burial. I need not emphasize the extent to which these two altar painters had been drawn into the tradition of dramatic evocation, in Sebastiano's case almost at the expense of their religious function, while Raphael achieved a marvellous balance between the two, with the miraculous scene on the mountain and the despair of the disciples below who, in the absence of Saint Peter, were unable to cure a boy possessed by a demon.

87 Sebastiano del Piombo, *The Raising of Lazarus*, 1517–19. National Gallery, London

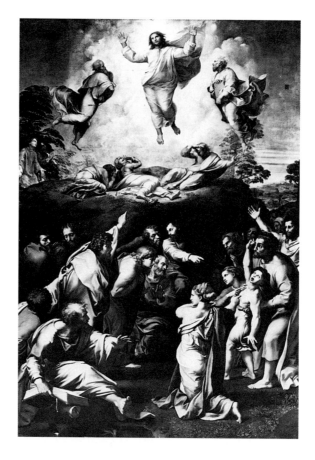

88 Raphael, *The Transfiguration of Christ on Mount Tabor*, 1518–20. Pinacoteca Vaticana, Rome

From the very year of this momentous competition in Rome, which was muted by Raphael's death in 1520, another incident can be documented which illustrates even more sharply the emergence of the altar painting as a work of art in its own right.[23] It involved the greatest of the Venetian masters, Titian, and one of his principal patrons, Duke Alfonso d'Este of Ferrara. Titian had been commissioned to paint an altar painting for the high altar of the church of St Nazaro and St Celso in the North Italian city of Brescia. It is still in that church (fig. 89). Titian painted in the centre the risen Christ, and on the wings above, in half-length figures, the Annunciation, with the Angel on one side and the Virgin on the other. Below he painted the donor, the papal legate Bishop Altobello Averoldo, who is seen kneeling in prayer under the protection of the two saints to whom the church is dedicated. One is Saint Celso, the soldier saint who points to the hope of salvation embodied in the risen

89 Titian, Polyptych with the *Resurrection*, 1522. SS. Nazaro e Celso, Brescia, high altar

Christ. On the wing opposite we see Saint Sebastian, a saint whose intercession was thought to be particularly powerful against the omnipresent perils of the plague.

Some nine years earlier Titian had also included Saint Sebastian in an altar painting specifically dedicated as a prayer against the plague (fig. 90). It shows Saint Mark, the patron saint of Venice, flanked by the two medical saints, Cosmas and Damian, holding medicine boxes, Saint Roch who points to the wound which is his emblem, and Saint Sebastian having suffered martyrdom tied to a tree as a target for the arrows of his torturers. It goes without saying that here the arrow sticking in the body of the young man is indeed an attribute, a pictographic sign as in Giotto's picture of Saint Stephen. Nor need I enlarge on the contrast with the way the martyrdom is visualized in the Brescia altarpiece. The change from symbolic rendering to dramatic evocation was not lost on the Venetians. In fact the master's new version and new vision of the event caused an equally dramatic reaction.

My final story starts with a letter of December 1520 from Venice to Ferrara addressed to Duke Alfonso by the duke's agent, one Tebaldi. The agent had been to Titian's studio where he had seen the Saint Sebastian on an easel (fig. 91). He tells his master that all visitors praised it as the best thing Titian had ever done. And to give the Duke an idea, he appended a description which is worth quoting in full, for we do not have many such

90 Titian, *Saint Mark Enthroned*, *c*.1511. Sta Maria della Salute, Venice

91 Titian, *Saint Sebastian* (detail of fig. 89)

opportunities of hearing what a sixteenth-century layman thought of a particular work of art:

> The aforementioned figure is attached to a column with one arm up and the other down and the whole body twists, in such a way that one can see the whole scene before one's eye, for his is shown to suffer in all parts of his person from an arrow which has lodged in the middle of the body. I have no judgement in these matters because I am no connoisseur of art, but looking at all the features and muscles of the figure it seems to me that it resembles most closely to a real body created by Nature, which only lacks life.

Nor did Tebaldi hide from us or the duke what conclusions he drew from this display of mastery. He reports that he waited until the crowd had left and then told the painter to send this painting not to Brescia but to the duke, because, as he candidly and significantly put it, 'that painting was thrown away if he gave it to the priest and to Brescia'. The original function, the purpose for which it was demanded and painted, to stand on an altar, was irrelevant in the eyes of the duke's agent. The days of the collector had arrived. It was simply too good for a liturgical role and should be treasured simply as a work of art.

76

The agent reinforced his plea with a strong economic argument. Titian had been promised 200 ducats for the whole altar, but the duke would pay 60 for the Sebastian alone. Titian replied that to yield to this request would be an act of robbery, though there are indications that he was not altogether disinclined to commit this act. In the end it was the duke who got cold feet, for he found it diplomatically inadvisable to offend a powerful bishop and legate of the Pope. The painting was left to serve its original function.

And yet, we may feel that it is no accident that it was over this painting that Titian had become involved in a momentous conflict of loyalties. For in a sense it was he who had courted this reaction precisely by the change from symbolism to narrative. He had discarded the last remnant of the medieval heritage for the tradition rediscovered and valued by the Renaissance, the demand for dramatic evocation. His drawings bear witness to the fact that he, like Leonardo before him, was aiming at a masterly solution (figs. 92-3).

Art historians have linked these drawings with what was then the most famous statue of antiquity, the Laocoön group recently discovered in Rome in which the beholder is made to witness the agony of the innocent victim and his two sons. The most admired artist of the age, Michelangelo, had taken up the challenge of this group in his images of the dying slaves intended for the tomb of Julius II (fig. 94). It is with such works of intense

92 Titian, *Saint Sebastian*, drawing, 1522. Kupferstichkabinett, Berlin

93 Titian, *Saint Sebastian*, drawing, 1522. Städelsches Kunstinstitut, Frankfurt-am-Main

94 Michelangelo, *Slave*, destined for the Tomb of Julius II, *c.*1516. Louvre, Paris

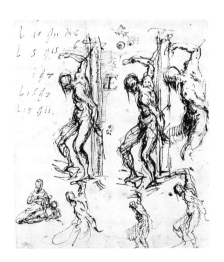

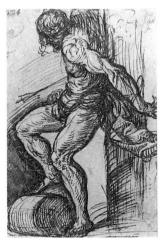

dramatic evocation that Titian evidently entered into competition, indeed one might say that the dominant demand which the image was now expected to meet, was to stand up to comparison with that canon of excellence. In other words, art had created its own context, its own ecological niche, once more, as it had done in the ancient world, and it was this autonomy, this emancipation, which led in turn to its survival in a new and hostile climate.

For consider the dates. The year is 1520 – the time of the Reformation in Germany and the Netherlands which was to sweep the images from the altars as merely serving idolatrous heresy. The blocking of this outlet, which had provided so many artistic workshops with their livelihood, might well have led to the decline and extinction of the image-maker's skill, and there are regions such as Germany where this came close to happening. If it did not happen where the tradition of artistic production was as vigorous as it was in the Netherlands, this was due to the fact to which I have alluded, namely that art had lodged itself in a new ecological niche, the painter's skill was admired for its own sake

95 David Teniers the Younger, *The Collection of Archduke Leopold Wilhelm*, c.1650. Kunsthistorisches Museum, Vienna

and the admired specialists in mimesis had begun to supply an eager export market.

There is a famous painting from the collection of the Regent of the Netherlands Archduke Leopold Wilhelm (fig. 95) in which we recognize many of the treasures which are now in the Kunsthistorisches Museum in Vienna. Quite a number of these paintings were originally intended for altars and private devotion. They had now become Art with a capital A, as it were, they had been cut loose from their roots and flourished in a new environment. And yet the historian remains aware of those roots I have briefly traced in this lecture. Most of them, of course, are easel paintings, a form of art which is peculiar to our Western tradition. If we visit in our mind some of the great national galleries of the world which have extended their chronological span beyond the works collected by the seventeenth-century collector, we discover that the earlier rooms are also devoted to easel paintings, including a number of panels on golden backgrounds dating from the thirteenth, or more probably the fourteenth, century. They were of course intended to stand on altars in churches or in the home, and it is from the moment of their production that we can trace the unbroken evolution of painting in the West to the present day. To quote the words of Otto Demus from his book *Byzantine Art and the West*: 'Had it not been for the transformation of Hellenistic panel painting into Byzantine icon painting, and the transfer of this art form to the West, the chief vehicle of Western pictorial development would not have existed …'[24] Thus, I believe, it is true to say that even the artist today who is, as the saying goes, facing the challenge of the empty canvas or hardboard on his easel, owes his predicament and his joy to the demands made on his predecessors some 700 years ago.

Chapter 3 Images as Luxury Objects
Supply and Demand in the Evolution
of the International Gothic Style

First published in *Three Cultures*, ed. M. Bal *et al.* (The Hague, 1989), pp. 127-60.

If you go to almost any museum in Europe or in America, you will find the paintings there arranged according to so-called 'schools', the Low Countries, the German, the Venetian or the Spanish. I believe it was the first director of the Uffizi in Florence, the eighteenth-century art historian the Abate Lanzi, who introduced this convenient device which has also carried over into the writing and teaching of the history of art. Even non-professionals will generally have no difficulty in distinguishing the Italian seventeenth-century style of painting from the Flemish one.

But there is one period where this ease of recognition breaks down, and it is about this period that I propose to speak. The very difficulty to which I have alluded has given rise to the name of the style: we call it the International Style, or more specifically the International Gothic Style. The great art historian Erwin Panofsky, who devoted a chapter of his important book *Early Netherlandish Painting* to this style, characterizes with his usual precision the difficulties with which it confronts art historians:

> Art historians tend to shift important works of the 'International Period' back and forth between Paris and either Vienna or Prague, between Bourges and Venice, between France and England, and often finally agree they are Catalan.[1]

Needless to say, the fascination and the complexities of this exceptional period in the history of European art have attracted the attentions of many of our leading art historians: apart from Panofsky himself, there were Otto Pächt, Millard Meiss, and Robert Scheller.[2] In any case, rather than present a survey of their results in this short chapter, I must somewhat step back from the rich tapestry of events and reflect on some of the general questions they pose to the historian. Clearly I cannot do so, however,

without giving you at least a brief account of the style and the problems it raises.

Let me start with a convenient example which epitomizes the character of the style and also the perplexity it has caused to connoisseurs, namely that exquisite work in the National Gallery in London known as the *Wilton Diptych* (fig. 96). Its open wings show King Richard II of England kneeling in prayer in front of Saint John the Baptist and two of the patron saints of the Royal Family, Saint Edward the Confessor and Saint Edmund, who commend him to the Holy Virgin shown on the opposite wing, or perhaps rather to the Christ Child in her arms who extends His little hand in greeting, while the angels of Paradise on the flowering meadow assist in drawing attention to the supplicating sovereign.

It fits my purpose that this quintessential example of the International Gothic Style, with its delicate display of fair maidens and delightful flowers, of precious jewellery and gold, has been the subject of much debate: is it English, as its subject might suggest, or was it perhaps painted by a French master? Does it date from the life-time of Richard II, who died in 1399 and would have destined it as a devout donation to the Virgin to secure his salvation in the hereafter; or should we take its representation literally, that is as an image of the King received in Paradise and being welcomed by the angels who wear his badge, the stag with the golden chain? Personally, I am inclined to the latter hypothesis developed by the late Francis Wormald,[3] but what must concern me at present is the

96 *Wilton Diptych, c.*1400. National Gallery, London

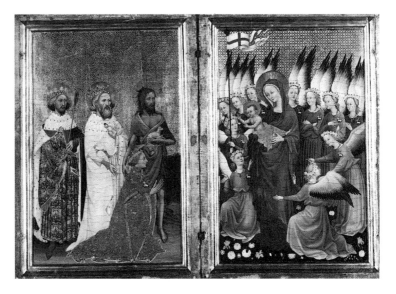

international character of the style used by the master.[4] There is a certain kinship between a detail of the *Wilton Diptych* of the Virgin and Child (fig. 97) and one of another painting which depicts the Madonna and the Christ Child with equal delicacy and beauty (fig. 98). Now, this detail is neither English nor French, but comes from a painting completed in Florence in 1423 by the great master Gentile da Fabriano for the powerful merchant Palla Strozzi (fig. 99).[5] Coming as it does at the end of our period, it may be regarded as the epitome or summing up of all the features dear to the period. The theme of the Adoration of the Kings gave the painter welcome opportunities for the display of splendour and variety in the sumptuous robes of the Magi and the pomp of their train, the festive throng, not to forget the elegant greyhound. Gentile, of course, was not the only painter of the period to relish the chances afforded by the biblical story for a display of glittering pageantry. Less than ten years earlier the Limbourg brothers had shown their mastery in covering the pages of a splendid book of hours for their wealthy patron. The so-called *Très Riches Heures du duc de Berry*, which remained unfinished when the duke died in 1417, is one of the most famous monuments of our style.[6] Here, the train of the kings is, if anything, more sparkling and various than that of the Florentine altarpiece (fig. 100).

This wonderful book of hours has lodged itself in our memory for its evocation of courtly life in the period, represented in the opening calendar cycle, one of the best-known pages being that devoted to the month of May, with the ladies enjoying their excursion in the balmy spring, preceded by trumpeters and festively attired gentlemen, all wreathed and

97 Detail of the Madonna and Child, from fig. 96

98 Detail of the Madonna and Child, from fig. 99

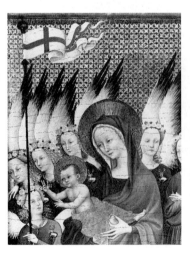

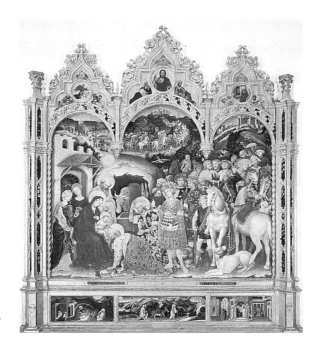

99 Gentile da Fabriano,
The Adoration of the Magi,
*c.*1423. Uffizi, Florence

100 The Limbourg
brothers, *The Adoration*
of the Magi, from the *Très*
Riches Heures du duc de
*Berry, c.*1410. Musée
Condé, Chantilly

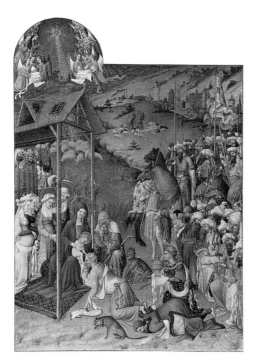

garlanded with fresh leaves (fig. 101). No less endearing is the outdoor scene of April, with the elegant group in conversation and two of the pretty maidens picking flowers (fig. 102).

Nothing could demonstrate the international character of the style more clearly than a comparison of these enchanting visions with a cycle of murals, also devoted to the occupations of the months and happily preserved in a castle outside the South Tyrolean city of Trento, the Torre dell'Aquila. In that beautiful cycle,[7] we encounter a similar taste for the pleasures of a carefree life, celebrating youth, beauty and love, not only in the jolly month of May when the ladies crown their faithful swains with flowers (fig. 103), but also in June when the older couples join the outing into the lovely countryside (fig. 104).

As if to prove again the international character of the style, it turns out that this room in a castle situated near the frontiers of Italian- and German-speaking lands was commissioned by a Bishop of Trento, John of

101 *The Month of May,* from the *Très Riches Heures du duc de Berry,* *c.*1410. Musée Condé, Chantilly

102 *The Month of April,* from the *Très Riches Heures du duc de Berry,* *c.*1410. Musée Condé, Chantilly

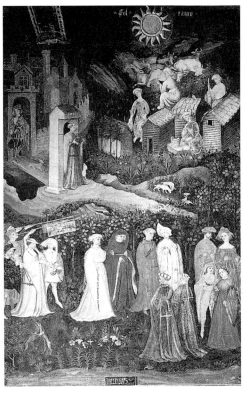

103 *The Month of May,* *c.*1400. Torre dell'Aquila, Trento

104 *The Month of June,* *c.*1400. Torre dell'Aquila, Trento

Liechtenstein, who hailed from Prague in the present Czech Republic, and that it was painted in all probability by a native of Bohemia, possibly the painter Wenzeslav mentioned in a document.[8]

It is tempting to regard these paintings as a mirror of life of the period and to see them – in the facile phrase – as an expression of the 'spirit of the age', a golden age of sweetness and light, of refined pleasures and unalloyed joy. Alas, this is not what historians tell us of the years in which these cheerful scenes were painted. Every age has its share of tensions and of horror, but the years which saw the rise and efflorescence of the International Gothic style may have had more than their due share. They are described, for example, in Johan Huizinga's classic on *The Waning of the Middle Ages,*[9] or the more recent book by the American historian Barbara Tuchman, *A Distant Mirror*, which is very aptly subtitled *The Calamitous Fourteenth Century.*[10] In the latter, the author follows the fortunes of the French nobleman Enguerrand VII de Coucy through all their ups and downs to the bitter end against the background of the wars and strifes of

the period, and in the process paints a gloomy picture of the passions, follies and cruelties that contrast only too sharply with the image of the age reflected in its art.

Of course, it is legitimate to wonder whether it was not precisely these tragic events which may explain the demand for such visions of untroubled bliss? Could not the International Gothic style have arisen as a dream of wish-fulfilment or what is nowadays called 'escapism'?

Frankly, I have never been impressed by any kind of argument that treats whole periods of societies as if they had a collective mind, a spirit of their own.[11] I believe that if we want to make progress in historical explanations we must resist the temptation to mythologize. The ancient world thought of nature in terms of personified forces such as the wind or the seasons. Progress in science only began when this tendency was left behind. It is for the same reason that I have become so sceptical of those romantic philosophies of history that personify ages, peoples or classes. We must learn to think in terms of individual human beings who were admittedly interacting with each other and responding to situations which were not of their own making. What Popper has called 'the logic of situations' must always be in the historian's mind.[12] This includes, of course, invariant human traits which enable us to understand and reconstruct the reactions of people in the past as well as today, and the modifications of these traits due to learning and cultural influences.

Some of the features of the International Gothic style are likely to yield to this analysis without much difficulty. We can say, without fear of contradiction, that the society depicted here was a refined society fond of the display of luxury. This surely is a fairly universal trait though it needs special conditions to be brought out into the open as it were. I have spoken in this connection of the logic of Vanity Fair,[13] the effects of competition in showing off wealth and superior taste. The fashions worn by the men and women at court must have been as expensive as those in vogue in any other age in which the mighty could afford to impress the populace and each other. Moreover, they were real fashions which must have been doubly costly for being relatively short-lived. Perhaps this period was one of the first to witness such vogues of exaggerated displays which any self-respecting courtier had to adopt if he was to hold his own among his social peers. There are products of the International Style, such as a drawing in Uppsala (fig. 105), which really remind us of fashion plates. Such extremes of fashion reflect what Veblen[14] has called 'conspicuous waste': witness the extended sleeves worn by both men and women in the scene of the snowball fight at Trento (fig. 106) – these are typical features which serve

86

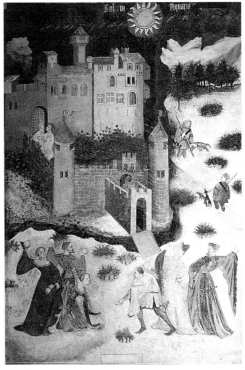

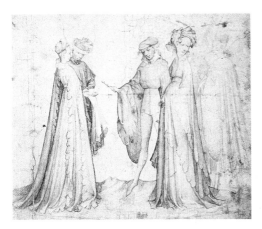

105 *Elegant Couple*, anonymous drawing, early 15th century. Uppsala University Library

106 Detail of *The Month of January*, *c.*1400. Torre dell'Aquila, Trento

no purpose but that of showing off and they can serve this purpose only for the brief time when they attract attention for their extravagance, after which another feature may take over.

No doubt the artists and craftsmen who catered for these courts must have taken account of similar demands. Their most typical work may also be described as *objets de luxe*, none more so than the *Très Riches Heures*, which are described by this telling designation in the duke's inventories.

Turning to the first page of the calendar cycle, we see the duke himself feasting at the well-laid table in a hall richly adorned with tapestries (fig. 107). The master of ceremonies hospitably calls out to the court 'Aproche, aproche', and we can be sure that there is enough for everyone, including the dog who is fed in the corner. But look at the table-ware such as the large golden boat, described in the inventories as 'la salière du Pavillon', and all the golden vessels on the sideboard. Where are they now? Alas, these products of the goldsmith's skill have nearly all been melted down to pay for the wars and the conflicts that beset the life of that age. Only a very few escaped this fate because they found permanent shelter in the treasuries of

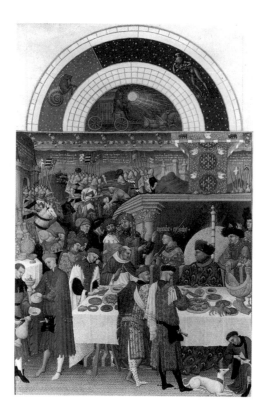

churches – none more famous than the *Goldene Rössel*, the Golden Horse of Alt-Ötting in Bavaria, the gift of the king of France to his spouse on New Year's Day, 1404 (fig. 108).[15] The exquisite craftsmanship of this enchanting piece proves, if proof were needed, that the patrons of the period made no distinction between what we have come to call fine art and applied art. The goldsmiths were certainly as respected as the illuminators or fresco painters, if not more so. After all, it was to them that the most precious metals were entrusted.

Looking at this precious masterpiece, the enchanting Madonna surrounded by pearls, the figure of the king with his sumptuous garb of enamel and the realistic groom holding the king's horse, can we be surprised that such pieces were in demand? Can we wonder that such a combination of skill and of splendour found favour with the mighty? After all, it is not so long ago that the courts of Europe presented each other with the precious trinkets made by the goldsmith Fabergé, showing perhaps less discrimination than the erstwhile King of France, but an equal love of luxury.

108 *The Golden Horse of Alt-Ötting, c.*1404. Church of St Philip and St Jacob, Alt-Ötting, Treasury

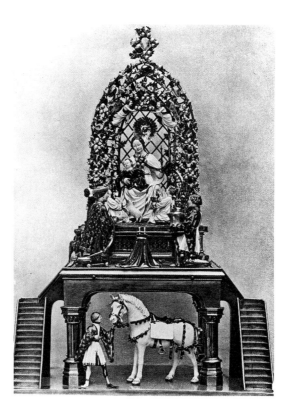

Indeed, if anything can be called a universal human trait, it is this delight in splendour and glitter. The proverb reminds us that not all that glitters is gold, but if it is gold so much the better, because then it combines the visual attraction of sparkle with the value of rarity. Hence power has always sought to surround itself with overwhelming and overawing visual pomp, whether one thinks of the treasures of Tutankhamun or those of the Indian Moguls. It is for this very reason that such a taste for gold and finery cannot serve the art historian as an adequate principle of explanation; at the most he may want to consult the logic of the situation where he finds that taste to be absent – a question to which I must return.

We certainly know that it was nothing new for the International Style to adorn manuscripts and paintings with a lavish dose of gold leaf and precious pigments. Examples of this tendency could be quoted from almost any period. The exhibition in London some years ago entitled *The Age of Chivalry* enabled us to feast our eyes on many such shining pages from the thirteenth or early fourteenth century. And if the testimony of the monuments does not suffice, the art historian can turn to the study of

literature to support and refine his observations. He will find that we have the words of none other than Dante telling us that the illuminators of his time, the early trecento, sought to compete with each other in satisfying this universal demand. In a famous episode in *Purgatorio*[16] Dante encounters a miniature painter of his time, one Oderisi da Gubbio, and addresses him with the words: 'Art thou not Oderisi, the master of that art that is called *illumination* in Paris?' But since the encounter is taking place in Purgatory, where the souls are purged of their sin of pride, Oderis rejects the compliment: 'The pages painted by Franco Bolognese smile more,' he says: 'Più ridon le carte che pennelleggia Franco Bolognese.' 'The honour is all his, and mine only in part; though I would never have admitted this while I dwelt among the living.'

To paint the most smiling, the most cheerful page was obviously the subject of competition among the miniature painters of Dante's time (fig. 109). Who can doubt that at least in Purgatory they would have had to admit that a few generations later the competition was won by the Limbourg brothers (fig. 110)? I say 'Who can doubt?', but generally art historians do not approve of such apodictic assertions. After all, we know that tastes vary and what seems smiling to one generation might have seemed gloomy to another. I confess that I do not hold with these extremes of relativism which are *de rigueur* in academic life. At least I would find it amusing to put my assertion to an experimental test in the manner of psychologists asking a number of subjects which of two pages

109 *The Coronation of the Virgin, c.*1337. Biblioteca Trivulziana, Milan

110 *The Coronation of the Virgin,* from the *Très Riches Heures du duc de Berry, c.*1410. Musée Condé, Chantilly

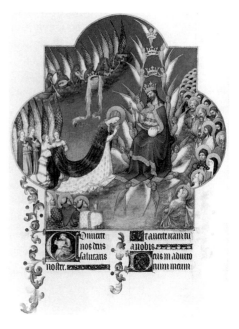

they would describe as more smiling, in the way Charles Osgood has described in his book on *The Measurement of Meaning*.[17] In the absence of such tests, I like to consult my own reactions, which is admittedly not a very scientific procedure. In any case, what my own reactions tell me is that the masters of the International Style had added another strong attraction to their smiling pages, that is the richness and skill with which they mirrored the variety of the visual world. A competition in this skill was possibly a new element in the situation, the effort to satisfy a novel demand. What was required now was not only splendour but also naturalism, if the word is taken in its most general sense as the rendering of reality in all its aspects.

It so happens that we have another text from a great Italian of the trecento in praise of this novel standard. In a famous passage in his *Decameron* praising the achievement of the great Giotto,[18] Boccaccio attributes to Giotto such gifts that he was able with his brush to depict anything created by nature to the point of deception. 'He thus', says Boccaccio, 'recovered that art that had lain buried for many centuries because of the errors of some who painted more for the sake of delighting the eyes of the ignorant than of satisfying the judgement of the knowledgeable.'

Note that Boccaccio here makes the vulgar taste for visual pleasures responsible for the decline of art – there are passages in ancient authors such as Pliny which may have given him this idea. There is much in the famous remark that is formulaic and purely rhetorical but what matters to us is that it contrasts the naïve taste with the preference of the wise who will understand the new and superior achievements of Giotto's brush in rendering nature in all its variety. Naturalism, to put it briefly, is even better than splendour.

The growth of naturalism in the fourteenth century and the transition from the Gothic to the Early Renaissance is clearly not a topic that lends itself to demonstration in a short essay, but it so happens that its growing popularity can be illustrated in another literary text. The most famous anecdote about Giotto is the story told by Ghiberti and Vasari of how he was discovered by Cimabue as a shepherd's boy drawing sheep on a rock.[19] Otto Pächt has shown[20] that this same story was told earlier of a master of the International Gothic style, Michelino da Besozzo, who worked in Milan around 1400.

In his seminal article, Pächt shows that the story makes more sense when applied to this once famous though largely forgotten master, because he obviously continued to excel in the drawing of animals, something that

can hardly be said of Giotto. Pächt has convincingly attributed to Michelino a drawing now in the Albertina in Vienna (fig. 111) which shows sketches for an *Adoration of the Virgin* including cheetahs, one of the exotic creatures in earlier representations of the trains of the Magi. The types of graceful young women in this composition also have cousins in earlier drawings.

Boccaccio contrasted the superior achievement of Giotto with the inferior art of pleasing the ignorant by offering them visual delights. But in a way the contrast was overdrawn, at least in the eyes of the artists working in Boccaccio's period. After all, there are plenty of things in nature which delight the eye both of the knowledgeable and the ignorant and why not concentrate on those pleasing everybody? Naturally, I construct this attitude from hindsight, but I think it can be argued that in the late fourteenth century something I should like to call 'selective naturalism' won the day. There was no effort to emulate the astounding displays of near *trompe l'oeil* like those Giotto created in the simulated chambers on either side of the triumphal arch of the Arena Chapel. Instead we find an increasing concentration on the rendering of individual motifs from nature such as beautiful flowers or exotic animals displayed in some of my

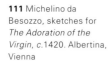

111 Michelino da Besozzo, sketches for *The Adoration of the Virgin, c.*1420. Albertina, Vienna

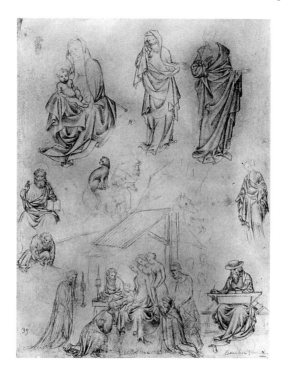

earlier examples. I know no easier way of illustrating this type of selective naturalism than by referring to a genre of art that was immensely popular among the wealthy of the period, though regrettably few examples have survived. I am thinking of the tapestries and wall-hangings which rendered the interiors of the castle more cheerful and more habitable. Among the most precious of those which have survived are the Duke of Devonshire's tapestries in the Victoria and Albert Museum in London, which admittedly date from the end of the period of the International Style, around 1440.

Like so may secular works of the period, they depict the main enjoyment of the nobility – the killing of animals (fig. 112). I need not enlarge on the contrast between the schematic background of plants and buildings and the marvellous observation with which the hounds and their quarry are rendered, with the elegant members of the hunt standing somewhat in between the degrees of realism. Or take the pair of courtly lovers (fig. 113) in a wood, even more typical of the International Style, and mark the contrast between the trees and the representations of the rabbits, one of which is shown in perfect foreshortening from behind.

A famous manuscript from the middle of our period, about 1400, the first part of the *Visconti Hours*, painted for Giangaleazzo Visconti by Giovannino de Grassi, a contemporary of Michelino da Besozzo,[21] shows another aspect of selective naturalism (fig. 114). There is a striking contrast between the sacred figures of the biblical narrative, such as Joachim, a typical Gothic type, and the naturalistic rendering of the two shepherds who seem to come from another world altogether. The cattle and the dog are rendered with the same keen observation, but even more telling for my purpose is the use of naturalistic motifs in the service of decoration in the borders, notably the cheetahs in four different positions.

Surely we cannot be surprised that such works reminding the mighty of their favourite pleasures were in demand at their courts. But there is an important difference between the demand for gold and splendour on the one hand and that for naturalistic images, however selective, on the other. To satisfy the one, not much more is needed than wealth and the willingness to spend it; the other is not so easily had for the asking. The special skill that is required was rightly the pride of the prominent masters. We are fortunate in having another testimony to this skill of the master of the *Visconti Hours*, Giovannino de Grassi's sketchbook in Bergamo, which contains other pictures of exotic animals (fig. 115). We know that these characteristic creations of the International Style represented a novelty in this period.

112 *Hunting*, from a
tapestry of *c*.1430.
Victoria and Albert
Museum, London

113 *Courtly Lovers*, from a
tapestry of *c*.1400.
Louvre, Paris

114 Giovannino de Grassi,
The Story of Joachim,
from the *Visconti Hours*,
c.1430. Biblioteca
Nazionale, Florence

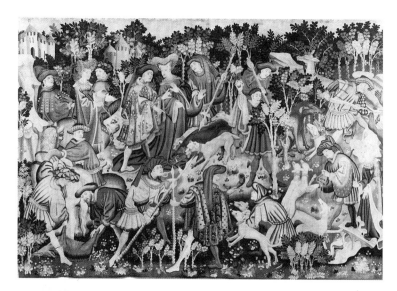

115 Giovannino de Grassi, page from a sketchbook, *c.*1395. Biblioteca Civica, Bergamo

If proof were needed that they testify to a widespread demand, it could be found again in one of the pages of the *Très Riches Heures du duc de Berry*. The month of December is here represented by the picture of a hunt in which the pack of hounds is besetting the boar brought to bay (fig. 116), and this group is derived from a similar composition in the Bergamo sketchbook made some ten or fifteen years earlier (fig. 117). Or let me hark back to the *Wilton Diptych* with which I began: the reverse of the wings (fig. 119) shows a lovely heraldic stag with the King's emblem, and this stag also has a close precedent in the Bergamo sketchbook (fig. 118), though the drawing is much faded.

If the existence of such a demand is relatively easy to establish, can we also explain that there was a corresponding supply of these creations of selective naturalism? The question may seem an idle one, for why should not artists have drawn naturalistic animals if their patrons wanted them? It is at this point that I must refer to my book *Art and Illusion*,[22] which deals precisely with this question. I tried to show in that book that it is naïve to think that all that is needed for the convincing imitation of nature is a good eye, a skilled hand and the wish to copy appearances. What the history of art demonstrates is that the skilled rendering of nature cannot be acquired overnight, as it were. In that book I discussed the famous instance of the lion drawn by the Gothic thirteenth-century French artist, Villard

116 *The Month of December*, from the *Très Riches Heures du duc de Berry*, *c.*1410. Musée Condé, Chantilly

117 *Hounds Attacking a Boar*, from Giovannino de Grassi's sketchbook, *c.*1395. Biblioteca Civica, Bergamo

118 *Stag*, from Giovannino de Grassi's sketchbook, *c.*1395. Biblioteca Civica, Bergamo

119 *Stag*, from an outer wing of the *Wilton Diptych*, *c.*1400. National Gallery, London

de Honnecourt, which bears the startling inscription 'and know that it was drawn from the life' (fig. 120). He had seen a lion, not a frequent occurrence of course, and had somehow checked it against the heraldic formula for a lion he had learned and applied. But before you smile about the naïvety of the medieval craftsman, let me remind you of my thesis that it is far from obvious that an artist can reproduce the appearance of such a creature. If there was one artist who had both the inherited skill to do this and the surpassing gift of portraiture, it was surely Rembrandt, and indeed his portrait of a lion is most convincing (fig. 121). But would it satisfy a zoologist? I am not sure. For if you isolate the head of the creature (fig. 122), it looks suspiciously as if Rembrandt had applied what I call a schema, in this case the schema of the human head, and projected it on to the lion. I cannot prove that there are no such lions, or that the photograph I select for confrontation (fig. 123) is not biased, but I wonder.

Of course, I did not bring in this observation to debunk Rembrandt, but merely to remind you of the argument of my book that any naturalistic

120 *Lion*, from Villard de Honnecourt's sketchbook, *c.*1235. Bibliothèque Nationale, Paris

121 Rembrandt, *Lion*, *c.*1640. Louvre, Paris, Collection Léon Bonnat

122 Detail of fig. 121

123 Photograph of a lion's head

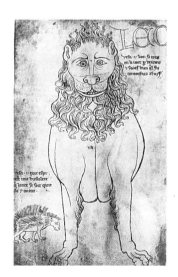

style stands in need of an acquired vocabulary which must be mastered and modified, perhaps by generations of craftsmen.

I believe that this observation is particularly relevant for the explanation of the growth of the so-called International Style. It has been known for a long time that these artists and craftsmen made a good deal of use of pattern books. Not that pattern books were an innovation in this period: medieval craftsmen had certainly relied on such collections from very early on, though few of them have been preserved. An early example of the period around 1200 is the so-called *Model Book of Reun* (fig. 124), with its pages of real beasts and fabulous animals. But during the period of the International Style the number of these pattern books appears to have increased considerably. This may be partly due to the accident of preservation but there is little doubt, as you will see, that such collections were increasingly in demand among craftsmen, who in their turn hoped to satisfy the demands of their patrons. One of the earlier collections of such pictures which enabled the artist to lay up a store of images is a pattern book in the Pepysian Library in Cambridge with animals and birds. Figure 125 shows a page with two lions, which obviously contrasts with the picture of a cow and the famous pages of birds (fig. 126), which were also often used in decorative borders. Who can tell how many of these birds the artist had actually seen and how many he had taken over from another model book?

That not all realistic details in works of this style were taken from life can easily be demonstrated. There is a model book from our period in the

124 *Animals*, from the Model Book of Reun, *c.*1200. National-bibliothek, Vienna

125, 126 *Animals* and *Birds*, from a pattern book, 14th–15th century. Pepys Library, Magdalene College, Cambridge

125, 126 *Animals* and *Birds*, from a pattern book, 14th–15th century. Pepys Library, Magdalene College, Cambridge

Vienna Museum which serves as a convenient starting point for this demonstration. My teacher Julius von Schlosser, who first published it more than eighty years ago,[23] called it the *vade mecum* of a migrant painter's apprentice. Its unusual form would make it suitable for carrying in a knapsack: it consists of tablets with green prepared paper and can conveniently be folded and fitted into a little leather pouch (fig. 127).

Thanks to the industry of a whole team of art historians, we can see how these formulas were used by the same or by other artists, how for instance the bearded old man (fig. 128) is fitted to a richly draped body to become a worthy apostle (fig. 129). Clearly the artists noted down artistic inventions that might come in usefully in overcoming difficulties. It has been shown how close his picture of a man looking down (fig. 130) comes to a formula which was later used by Gentile da Fabriano in the *Adoration of the Magi* (fig. 131), for a page loosening the king's spurs. These inventions certainly had an international market. We know moreover that pattern books such as our *vade mecum* were not in themselves unique. The heads of an angel and of the Virgin that would fit an Annunciation exist not only in Vienna (figs. 132, 134); another version of them has turned up and is now in the Fogg Museum (figs. 133, 135); they are more subtly drawn and may be the originals in so far as we are entitled in this context to speak of original drawings.

This *vade mecum* was probably made in Bohemia, but the type of the Virgin recalls a painting of the Annunciation generally thought to be Burgundian, of around 1400. It is not hard to guess why these heads were

127 Model book with
case, early 15th century.
Kunsthistorisches
Museum, Vienna

128 *Bearded Man*, from
the Vienna model book,
fig. 127

129 *Saint Thomas*, *c*.1420.
Albertina, Vienna

130 *Head Looking Down*,
from the Vienna model
book, fig. 127

131 Detail of fig. 99

132 *Head of an Angel*,
from the Vienna model
book, fig. 127

133 *Head of an Angel*,
c.1400. Fogg Art
Museum, Cambridge,
Mass. (Alpheus Hyatt
Fund)

134 *Head of the Virgin*,
from the Vienna model
book, fig. 127

135 Head of the Virgin,
c.1400. Fogg Art
Museum, Cambridge,
Mass. (Alpheus Hyatt
Fund)

copied and passed on: they represent types of beauty, of loveliness which the artists of the period required no less than they required models for foreshortened heads or rare animals. Art historians have become somewhat shy in talking about beauty. They are too much aware of changes in taste and standards and they have never quite overcome the trauma of the Romantic Revolution when the classical ideals of beauty were dethroned. Even so, I have ventured to argue elsewhere that one can also go too far in relativizing beauty.[24] Granted that human reactions to golden glitter are more universal and more basic than the reaction to a pretty young face, we need not forget that this response also has its biological roots and that youth and health are generally found more attractive than sickness and decay. A demand for prettiness or loveliness in images sacred or profane may now be considered rather primitive, but if such a demand had never been felt, the charming visions, angels and damsels of the International Style could never have been created in such splendid profusion. Surely their presence belonged to those 'smiling pages' which were an object of competition in Dante's time.

My emphasis in this chapter on skill and on methods of production may jar with those who do not think of the creation of images in such technological terms. But there is at least one aspect of art or of craftsmanship where nobody can deny the role of technology: this was the recipes used by the masters of the period for their pigments and their media. We have a collection of such recipes copied out by one Jean le Begue from an earlier manuscript by one Johannes Alcherius in 1431.[25] It is worth studying for what it reveals of the way the inventions of craftsmen were diffused throughout Europe, because the compiler usually noted where he got his recipes. In 1382 he left Milan for Paris taking with him a recipe for writing-ink given him by Alberto Porzello, a writing master who kept a school at Milan. In 1398 he was in Paris where he received a treatise on colour from a Flemish painter, Jacob Cona, who lived in Paris. In the next year he wrote another treatise on colours from the dictation of Antonio di Compendio, 'an illuminator of books and an old man'. In 1409 he was again in Milan where he copied recipes from a book lent him by Fra Dionisio, a Servite. In 1410 he wrote a description of the process of preparing ultramarine given him by one Master Johannes, a Norman residing in the house of Pietro da Verona.

In 1410, Alcherius was in Bologna where he met one Theodore, a native of Flanders and an embroiderer who had been employed in Pavia by Giangaleazzo Visconti. Some of the recipes Theodore had procured in London, though they were written in French. Further in 1410, Alcherius

copied recipes from a book lent him by 'Johannes da Modena, a painter living in Bologna', and had them translated into Latin. Still in 1410, Alcherius went to Venice where he received a recipe for preparing ultramarine from Michelino da Besozzo, 'the most excellent painter among all the painters of the world'; which brings us back to our point of departure.

This document not only throws a vivid light on the intensity of the search by eager craftsmen for techniques to satisfy and surpass the demands of their customers or clients, it also opens up fresh vistas on the conditions which enabled the International Style to emerge, and shows the relative ease of communication between the cultural centres of Europe. Ideas and procedures invented in Paris or in Milan would easily reach England and Flanders in a short time. Patrick de Winter, in his study of the library of Duke Philip the Bold of Burgundy,[26] has rightly insisted on the role of the Italian merchants in this development and on the importance of Avignon during the time when it was the enforced residence of the Popes. Despite the wars and deprivations, the markets expanded and traffic in luxuries moved without much hindrance across the frontiers of states and dominions. Without this increased mobility the demands of the mighty for visual delights could not have been supplied by busy craftsmen.

But are we not in grave danger here in offering too simple an answer? To be sure we cannot go quite wrong in postulating that so rich a supply of splendid images must reflect an eager demand, but we must never forget that the causal chain is more complex than that. If demand elicits supply, supply also tends to stimulate demand. Engineers have come to speak of 'feedback' when they wish to describe such a mutual interaction, and when it comes to the market in luxuries we need only open our eyes today to find this dual relationship constantly at work. Only recently nobody seemed to be aware of a craving to walk about the streets with headphones piping pop-music into their ears, but once technology had offered them this possibility, the desire to enjoy this dubious luxury seemed to arise everywhere.

I trust we can easily agree that the appetite for fine books of hours or murals is somewhat more noble, but surely it could also increase with the possibility of its satisfaction. It is here, in other words, that the historian will want to add some elementary sociological insights to his toolkit. The most unassailable law of sociology I know is contained in the proverb that 'nothing succeeds like success'. The admiration for certain achievements results in an upwards spiral which manifests itself in a craze, a fashion or even a dominant style.

Looking at our phenomenon, I would go so far as to suggest that the success of new technical means would lead also to a search for new areas where they could be employed. Without being too schematic here, it may well be argued that the new style which proved so successful in glorifying the joys of life might also have been turned to the glorification of paradise. The wings of the Wilton Diptych with which I began offer such an example. They have been compared by Wormald[27] with a page painted by Michelino da Besozzo in 1403 representing the reception of Giangaleazzo Visconti in paradise (fig. 136). New forms of devotional images were being created that offered full opportunity to these new skills – most of all the theme of the Virgin in the rose garden which was so memorably visualized by Stefano da Verona (fig. 138), or the *Paradiesgärtlein* (fig. 140), an exquisite painting from Germany which has all the marks of the International Style. On the other end of the scale even more down-to-earth scenes were exploited for the same opportunities they might offer. I have in mind the herbals of the period, a traditional genre reaching back to classical antiquity but now enriched and expanded in such manuals as the *Tacuinum sanitatis*, one of which belonged to the bishop who commissioned the calendar cycle in Trento.[28] It not only shows us how spinach is grown (fig. 137) but also the joys of spring (fig. 139).

But the historian must never be carried away in his eagerness to explain such phenomena as the International Style, for if he explains it too well you might wonder why it is not still with us. Why, in fact, did it give way to other stylistic movements within a very few years?

136 Michelino da Besozzo, *The Reception of Giangaleazzo Visconti in Paradise*, c.1403. Bibliothèque Nationale, Paris

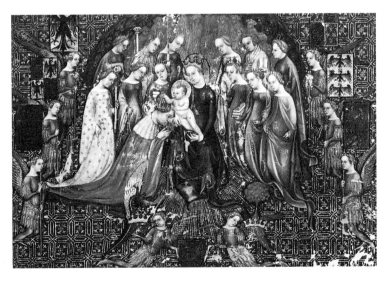

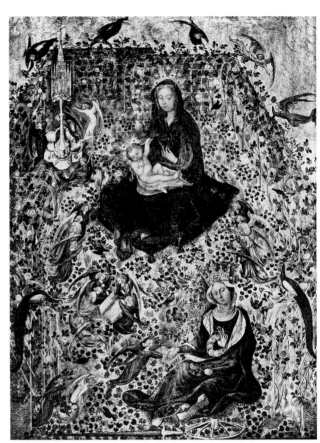

137 *Spinach*, illustration from the *Tacuinum sanitatis*, late 14th century. Österreichische Nationalbibliothek, Vienna

138 Stefano da Verona, *The Virgin in the Rosebower*, *c.*1420. Museo di Castelvecchio, Verona

139 *The Joys of Spring*, from the *Tacuinum sanitatis*

140 *Paradiesgärtlein*, *c.*1400. Städelsches Kunstinstitut, Frankfurt

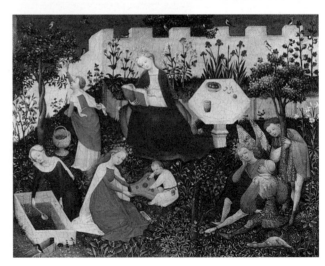

To deal properly with this question would again demand an application of what Popper has called the logic of the situation. One of the factors to be considered would again be psychological, the speed with which the satisfaction of certain cravings can produce a reaction caused by a surfeit. Too much sweetness results in a desire for more astringent fare.[29] In the game of competition, new stimulants are always found and exploited. Remember that Boccaccio contrasted the naïve delights of splendour with the more intellectual satisfaction offered by Giotto's mastery in deceiving the eye. I have suggested that the International Style struck a balance between these two types of satisfaction in what I call its selective naturalism. But the balance could only be an unstable one. The mastery of space represented by Giotto's school could not but appeal to the craftsmen elsewhere in Europe. Once more this can be demonstrated by another borrowing found in the pages of the *Très Riches Heures*, where the edifice of the temple in the story of the Virgin (fig. 141) is modelled on a fresco by Giotto's successor Taddeo Gaddi in Santa Croce in Florence (fig. 142). The interest which this intricate building aroused is suggested by a drawing in which it is copied (fig. 143), and we may assume that the

141 *The Presentation of the Virgin*, from the *Très Riches Heures du duc de Berry, c.*1410. Musée Condé, Chantilly

142 Taddeo Gaddi, *The Presentation of the Virgin*, *c*.1328. Santa Croce, Florence

143 *The Presentation of the Virgin*, drawing after Taddeo Gaddi. Louvre, Paris

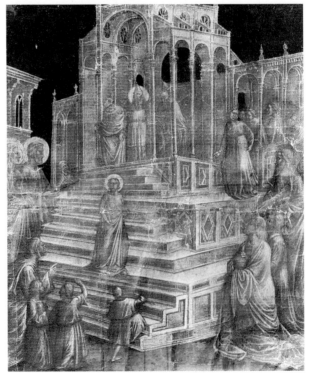

Limbourg brothers could have seen a similar copy. Nor must we forget that what I have called selective naturalism did not only concentrate on visual delights. It extended to motifs found interesting or amusing, including the appearance and the behaviour of yokels and clowns, using the term in Shakespeare's sense (fig. 144). Clearly there were always new motifs to be found and new worlds to be conquered, and the development of the next decades suggests that these new conquests acquired increasing prestige, eclipsing the earlier admiration for cheerful splendour.

Shortly after 1430, less than ten years after the completion of Gentile da Fabriano's *Adoration* in Florence, the humanist Leon Battista Alberti expressed this novel scale of values in his treatise on painting where he scorned the use of gold since it was a much greater achievement by the artist to depict gold rather than to apply it.[30] Erwin Panofsky observed that 'much of what enchants the eye in the work of Jan van Eyck is due to his attempt to capture in a different medium some of that splendour and meticulous workmanship which must have delighted him in the treasuries of his patrons and in the workshops of their patient artisans'.[31] He was right, of course. But here a new spiral or feedback was initiated. It was the artists who by their novel technical inventions, such as the development of oil painting in the north and the invention of perspective in the south, made the charms of the International Style look old-fashioned and created new standards of artistic excellence.

144 *Month of July,* *c.*1400. Torre dell'Aquila, Trento

Chapter 4 Pictures for the Home

Originally given as a lecture at the Courtauld Institute of Art, London, December 1977, and incorporated in a series of lectures given at the University of California at Berkeley, October 1978.

Much has been written on the history of the great collections and on such depictions of them as Teniers's famous painted catalogue of the collection of Archduke Leopold Wilhelm, much of which ultimately landed in the Habsburg collections in Vienna (fig. 95). The same cannot be said, however, of the habits of humble people who decorated their rooms with paintings, as can be seen in Brekelenkam's view of a tailor's shop with a still life on the wall (fig. 145). This is because what may be called the 'domestication' of the easel painting is much harder to document than the story of collecting, and the evidence is largely found in studies of interior decoration.[1] While such works provide invaluable illustrations, they do not always answer the questions I wish to ask.

145 Quiringh van Brekelenkam, *A Tailor's Shop, c.*1655–60. National Gallery, London

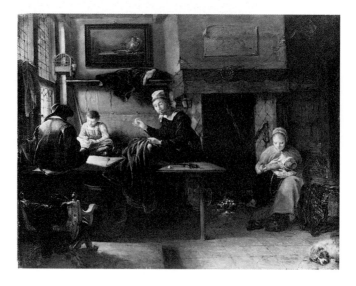

108

My own interest in this type of demand for images was first aroused years ago when I found myself in the company of a high-minded lady who was, I suppose, a teacher of art appreciation. She was railing against the Philistines, and one of her grievances stuck in my mind. 'They want a picture to go over the sofa,' she said, with a sense of outrage perhaps worthy of a better cause. Maybe it was this sense of righteous indignation which aroused my spirit of contradiction, for I was and am only too keenly aware of worse crimes being committed all around us than the selection of a picture to go over the sofa. Moreover, as an inveterate historian, I reacted less emotionally and more analytically. I began to wonder when the Philistines had adopted these evil ways. I cannot, unfortunately, give a date for this disaster, but it is worth noting that one of the most famous paintings in the history of art is first recorded as having suffered this indignity: Botticelli's *Primavera*. In the earliest inventory of the city palace of Lorenzo di Pierfrancesco de' Medici – a family not renowned for their Philistinism – the painting is listed as being placed over the bedstead, 'sopra il lettuccio'.[2] Admittedly the 'sofa' only came later into the story – the word is Arabic and did not come into English before the eighteenth century. Maybe it is the connotation of opulent ease that aroused the wrath of my acquaintance. At any rate, the piece of furniture in the painting by Lancret in figure 146 may qualify for this description, and there you see not one but two paintings hanging over the sofa in a luxurious boudoir.

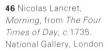

46 Nicolas Lancret, *Morning*, from *The Four Times of Day*, c.1735. National Gallery, London

But why over the sofa? Surely whoever sits on it cannot see the painting, and if he wants to have a closer look must adopt a strenuous kneeling position, as in a charming painting by Moritz von Schwind, though actually the lady is not poking her finger at a painting but pointing at a map (fig. 147). Indeed, one of the advantages of placing a painting over a sofa must be that of protecting it from the poking fingers of children and adults.

But this can only be one of the elements of the tradition according to which this kind of furniture, whether you call it a sofa, a bedstead, a settee or a couch, appears to demand a picture as a crowning feature. Clearly here, as so often in history, any number of motivations or demands interact. So, before sneering at the inhabitants of the simple interior painted by Georg Achen at the beginning of this century (fig. 148), it is wise to remember that the choice in arrangement of these homely and glazed pictures – whether paintings, prints or photographs – must have been the fruit of aesthetic deliberation: which place needs a picture, and which picture should go to a given place. Placing the picture or pictures over the sofa or anywhere on the wall in an interior might be called minimal art, the setting of visual accents. In this respect, this topic might have formed a chapter in my book *The Sense of Order*, which deals with

147 Moritz von Schwind, *The Visit*, *c*.1860. Neue Pinakothek, Munich

148 Georg Nicolaj Achen, *Interior*, 1901. Musée d'Orsay, Paris

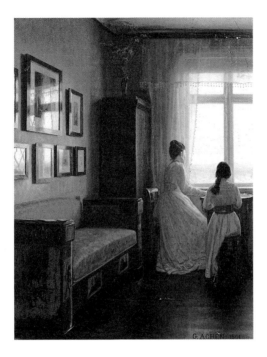

149 Pyramid with one irregular step

the psychology of decorative designs.[3] Let me just show you one illustration from that large and somewhat complex study to explain how visual accents come about and how they affect us (fig. 149). Briefly, it turns out that any break in continuity is experienced as an accent. We expect things to go on as they are and we are alerted when they change. In this pyramid, for example, every step is a little narrower than the one below, except in the middle, when two are the same, and even this slight deviation alerts us to notice the change or break. For our senses are very economical: we do not inspect what we can take for granted. And so any break serves as a magnet to the eye. There is thus a constant interaction in our perception between regularity and deviation. Without the regularity we could not speak of a break or interruption. If there is one thing that is constant in the art of decoration, it is this interplay between order and disturbance.

Our concern with changes of style often blinds us to continuities, yet even the most revolutionary art lover will be forced to respect them. In the photograph of Gertrude Stein's room in Paris in the winter of 1914–15 (fig. 150), we notice her portrait by Picasso and other works of the French avant-garde, but her unorthodox taste has not prevented her from neatly aligning the paintings on the wall, just as these wild artists never thought

111

150 The studio of
Gertrude Stein, 27 rue
de Fleurus, Paris. Winter,
1914–15. Photograph
in the Cone Archives,
Baltimore Museum of Art

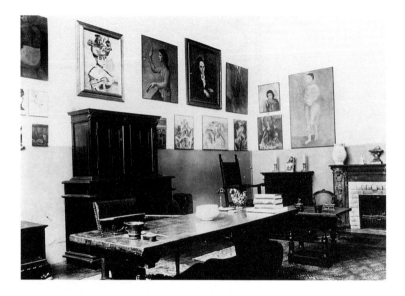

150 The studio of
Gertrude Stein, 27 rue
de Fleurus, Paris. Winter,
1914–15. Photograph
in the Cone Archives,
Baltimore Museum of Art

of abandoning the rectangular canvas for their creations, unlike some of the Surrealists. Comparison with a painted interior from Pompeii (fig. 17) shows that the force of tradition is powerful indeed. But is it only tradition? We all know that the demand for alignment is so strong that most of us cannot bear it if a painting hangs askew. Indeed it might be a refined form of torture to lock us into a room where we cannot adjust them. It is true that the German painter Georg Baselitz wants his paintings to be displayed upside down, but to the best of my knowledge, even he wants them to hang straight.[4]

To safeguard the alignment, decorators of the past sometimes turned paintings into fixtures, set into the wall, though not all of them had the kind of material to work with as had Inigo Jones when he created the Double Cube room at Wilton House in the seventeenth century – for some of the paintings in this magnificent interior are by Van Dyck (fig. 151). Not everything in the room dates from the original period,[5] but it still shows the interaction of painting and decoration to perfection, with the standardized size of the main canvases spaced out on the wall at an even distance from each other. There are two traditional features: the picture over the mantelpiece, and those over the doors, the *sopraporte*, which were almost *de rigueur* in the stately homes of the seventeenth and eighteenth centuries. From this point of view, the picture over the sofa might be called a *soprasofa*, for just as the door or the chimney breaks into the wall and creates a disturbance which might be mitigated, so does any piece of

151 The Double Cube
Room, Wilton House,
Wiltshire, *c.*1647

152 Diagram to illustrate
the principle of 'filling in'

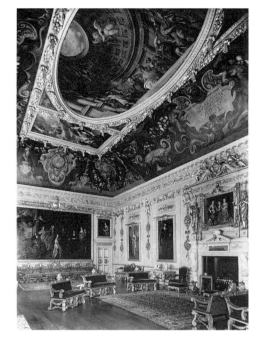

furniture. We always demand the reassurance of continuity. So, when we see a void, we want to fill it in, and this desire is aroused all the more easily when the process appears to have started. The space left blank after the first intrusion appears to have assumed the character of a frame which asks to be filled as if an operation has been left incomplete. Elsewhere,[6] I have described one of the basic operations of decorators as 'framing, filling and linking': the empty field asks to be filled by a design which may, in its turn, create a fresh form to be filled and so on *ad infinitum* (fig. 152). What the architect has created in the Double Cube might thus be described as a number of frames to be filled by pictures which are framed in their turn.[7]

The linking of pictures vertically or horizontally is generally achieved by aligning them along a common axis. This applies equally to the sumptuous interior of Queen Isabella of Naples at Capodimonte (fig. 153) and the room of a poor lace-maker in twentieth-century Sweden (fig. 154): the majordomo of the former would no more have thought of breaking the line of the pictures on the wall than the seamstress would have placed the oval picture anywhere but under the clock. It is only when extreme emphasis is desired that the picture is likely to be isolated or placed by the architect between symmetrical converging features: pictures hung in a row

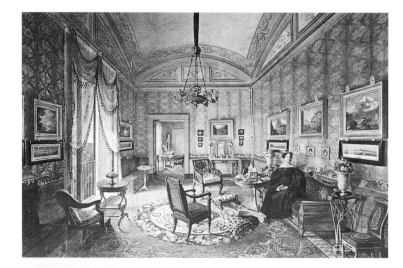

153 Attributed to Carlo de Falco, *Queen Isabella in the Palace of Capodimonte, Naples*, c.1831–2. Mario Praz Collection, Rome

154 Hanna Glas making lace; photograph of a Swedish interior of the early 20th century. From S. Jonsson, *Bilder av Nådens Barn* (Stockholm, 1963)

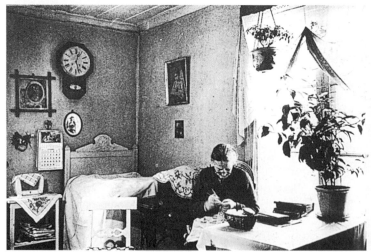

tend to lose their individual identities. Marco Ricci, like other eighteenth-century painters and later society photographers, appears to have used stock interiors for some of his conversation pieces (figs. 155, 156). Needless to say, he did not want them to be shown side by side, which would not only give away his compositional tricks, but also upset the internal balance of the room.

This basic play with accents must recur whenever pictures are displayed together, whether in a museum or on the wall of Ricci's interior. The same applies to the hanging of pictures in exhibitions and the

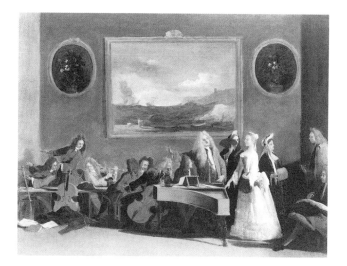

155 Marco Ricci, *A Rehearsal of an Opera*, *c*.1709. Yale Center for British Art, New Haven

156 Marco Ricci, *A Rehearsal of an Opera*, *c*.1709. Yale Center for British Art, New Haven

arrangement of illustrations in books: designers should be aware of the slight visual degradation of the individual picture and, perhaps, also of the pictures represented on the walls; where there is not one centre but two, this de-emphasizes the individual item.

It is far from easy to find out how the art of picture hanging was really exercised in the past. There are plenty of period rooms in our museums and showplaces which purport to give us the exact appearance of domestic interiors in various ages, but, useful as they are, figure 155 indicates that they must not be considered as conclusive evidence.[8] Nothing is easier

115

than to take a picture off a wall and hang it elsewhere, and so we can rarely be sure that what we see is authentic. Before the nineteenth century we rarely find a developed interest in documentation, which was to be so much helped by photographic journalism. In a sketch by that gifted amateur, the composer Felix Mendelssohn, of his sister's room at Leipzig (fig. 157), we can be sure that he wanted to record a particular setting and note the alignment with the residual *sopraporta*. On the other hand, Cazin's painting of the humble room in a Paris suburb where Gambetta died after an accident in 1882 was probably made after a photograph (fig. 158). Of course, interiors had been painted before, but painters may have had their own reasons when representing a picture or pictures in an interior. For example, this print by David Vinckboons (fig. 159) is a

157 Felix Mendelssohn, drawing of Rebekka Mendelssohn's room in the house at Liepzigerstrasse 3, *c.*1830. Mendelssohn Archiv, Staatsbibliothek, Berlin

158 Stanislas-Henri-Jean-Charles Cazin, *Gambetta's Death Chamber*, 1883. Musée National du Château de Versailles

159 David Vinckboons, *Vanitas*, 1620. Rijksmuseum, Amsterdam

Vanitas, and so we are meant to see not only the amorous couple but also the threat of retribution on the wall; we need not conclude that there ever was such a dining room.

There is a natural transition from the devotional painting in a church or chapel to the museum piece, and there is a similar transition from the devotional image to the picture in the home. In the room of St Ursula's father in Carpaccio's beautiful cycle in Venice (fig. 160), there is such an image of the Virgin on the wall, just as the studious man in a woodcut (fig. 161) in that strange romance the *Hypnerotomachia Poliphili*, published in 1499, has on the wall one of those half-length figures then popular in Venice, perhaps Christ or Saint Peter.

In Italian art, glimpses into a domestic interior are indeed rare; it was different north of the Alps. In the *Annunciation* by Joos van Cleve of the early sixteenth century (fig. 162), we see the Virgin in her chamber at prayer, and in the background a domestic altar shrine and an unframed sheet pinned to the wall near the bed. A similar devotional image, this time framed, can be seen next to the window in Lucas Cranach's *Portrait of Cardinal Albrecht of Brandenburg* (fig. 163).

160 Vittore Carpaccio, *Arrival of the Ambassadors in Brittany*, from the Saint Ursula Cycle, detail showing room of Saint Ursula's father, *c.*1495–6. Accademia, Venice

161 Woodcut from the *Hypnerotomachia Poliphili*, Venice, 1499, showing a man in his study

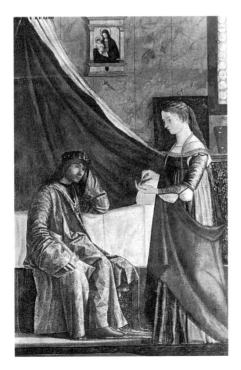

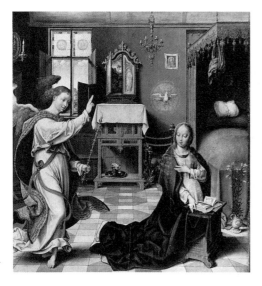

162 Joos van Cleve, *The Annunciation*, c.1525. Metropolitan Museum, New York, Friedsam Collection

163 Lucas Cranach, *Portrait of Cardinal Albrecht of Brandenburg*, 1525. John and Mable Ringling Museum, Sarasota

It is to this love of realistic detail characteristic of Northern painting that we owe the convincing depiction of an interior by Ludger Tom Ring of the second half of the sixteenth century (fig. 164), showing Christ and His disciples in the background and the preparation of the meal in the foreground. There are two things to be noted here: first, the relegation of the larger paintings to the upper zone below the ceiling; and second, the careful alignment of even the small pictures, a portrait among them, with the lines of furniture, something we might not have expected but which looks quite authentic.

There is a good deal of evidence that in the late sixteenth and early seventeenth centuries, paintings generally hugged the ceiling. Among the more surprising pieces of evidence is an engraving after Claes Janszoon Visscher, dated 1609, showing *Grace before a Meal*, with a triptych high over the mantlepiece (fig. 165). It might seem that the artist here took liberties for the sake of his subject, but there is one class of evidence which cannot be suspected of such ulterior motives. This is the dolls' house, a delightful type of toy of which production began some time in the early

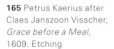

164 Ludger Tom Ring the Younger, *Marriage Feast at Cana*, 1562. Formerly Berlin, Kaiser Friedrich Museum

165 Petrus Kaerius after Claes Janszoon Visscher, *Grace before a Meal*, 1609. Etching

seventeenth century at the latest.[9] One from Nuremberg, dated 1639 (fig. 166), indicates very clearly how pictures were displayed in a burgher's home. Inspection of individual rooms explains very clearly why the wall lower down was considered unsuitable for paintings: the panelling was not to be damaged by hooks and nails, so the pictures remained above the wainscot, to fill the gap between panelling and ceiling, and be somewhat out of reach. We find basically the same arrangement in the much grander

119

166 Dolls' house, 1639.
Germanisches Museum,
Nuremberg

interiors painted by the seventeenth-century Dutch artist Bartholomaeus van Bassen (fig. 167). These are no doubt largely architectural fantasies, but the documents tell the same story even about certain collectors. One of them, Phillips van Valckenisse, who died in Antwerp in 1614, owned some 450 paintings, of which nearly a third were copies. In the ground-floor room he had, above the line of the doors, as the inventory says, eight landscapes by Joos de Momper, and two by Sebastian Francken let into the wall.[10] Another room was similarly fitted out with nine landscapes, and a small room with two marine paintings and two further landscapes by de Momper.

We must expect many of the northern paintings of the period to have been destined for this kind of frieze below the ceiling, and the question must arise whether the artist ever took account of this viewpoint from which they were to be seen. The question is less abstruse than it may sound, for there is a famous passage in Plato, surely known to Netherlandish humanists, in which we hear that sculptors took account of the positioning of their work high up on the temples by changing the proportions.[11] Even so, we need not ask our museums to 'sky' their Bruegels from now on. I had one of these famous paintings, *The Peasant and the Bird Nester*, photographed obliquely from below, and it does not result in an improvement (fig. 168). If the painter really wanted to produce what is called an anamorphosis – a picture which rights itself when seen from the side, usually through a peephole – he would have had to paint the head larger than the feet, for it is more distant. But he had every reason to

120

167 Bartholomaeus van Bassen, *Flemish Interior*, *c.*1620–30. Rijksmuseum, Amsterdam

168 Pieter Bruegel the Elder, *The Peasant and the Bird Nester*, 1568 (photographed from below). Kunsthistorisches Museum, Vienna

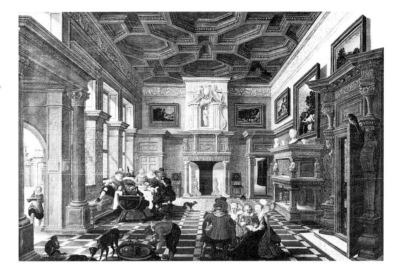

stick to the true proportions, for when we look at a picture, whether sideways or up, we automatically make allowance for such perspectival change through what is technically known as the perceptual mechanism of the constancies, so happily we can forget about this possibility of having viewed these pictures from the wrong angle.

In any case, the history of the domestication of the easel painting in the Netherlands in the seventeenth century is also the history of the descent into the living room and the increasing self-assertion of the painting itself. Here, evidence is plentiful, though we may never be able to trace the individual steps and the share of various cities and classes in that process.

Among many examples are two paintings of cheerful companies, one by Palamedesz. (fig. 169), in which the pictures are still above the doorline, though they could just as well have been hung lower down on the unpanelled wall; the other by Dirck Hals (fig. 170), showing a resplendent image much lower down, but this represents a decorative hanging suspended from a curtain rail.

The transition, if we should call it this, from the upper to the lower zone, may be exemplified by an interesting painting by Jan Steen showing a peasant wedding (fig. 171). I am not sure it is completely reliable, for it looks a little like a stage setting, but it combines the two phases I have described. There is a row of large paintings, still hugging the ceiling, a monumental landscape and a genre head in the style of Frans Hals (which

169 Anthonie Palamedesz., *Merry Company in a Room*, 1633. Rijksmuseum, Amsterdam

170 Dirck Hals, *A Party at Table,* 1626. National Gallery, London

171 Jan Steen, *Peasant Wedding, c.*1663. Gemäldegalerie, Berlin

Steen used more than once). Underneath is another row, this time in the line of sight, of smaller cabinet pictures. Fully authentic or not, the impression one gains from Dutch interiors is certainly that there was great demand for pictures in the home. The observation is given an unexpected slant by a famous entry in the diary of John Evelyn, dated 13 August 1641:

> We arrived late at Rotterdam, where there was their annual mart or fair, so furnished with pictures (especially landscapes and drolleries, as they call their clownish representations) that I was amazed. Some of these I bought and sent to England. The reason of this store of pictures, and their cheapness, proceeds from their want of land to employ their stock, so that it is an ordinary thing to find a common farmer lay out two or three thousand pounds in this commodity. Their houses are full of them, and they vend them at their fairs to very great gain.[12]

Of course, there is a paradox in this account which I must leave the economists to explain. We hear that pictures are cheap, but that there is a great demand for them for the purpose of investment when great gains can be made. One thing is pretty certain, the gains were rarely made by the painters. We know that Jan Steen had to supplement his earnings from painting by keeping an inn. Perhaps here, as so often, it was the middle men who made most of the money.

Still, there is internal evidence that the picture in the home has become a treasured commodity. As it was moved further down, it was often provided with a curtain for better protection against dust and light and, as you see in this other painting by Jan Steen, it was now frequently shown in a sumptuous gilded frame (fig. 172). We can see this as another manifestation of the more opulent style of life adopted by the prosperous citizens of the Netherlands, who increasingly wished to keep up with their wealthy neighbours in Catholic Europe. For, little as we know of the way the Italians arranged their interiors, there is no doubt that the heavy golden frame had been adopted there long before it became the fashion in the Netherlands.[13]

There exists a tantalizing document from the court of Mantua dating from 1531, a letter by the majordomo about fitting out the apartments of the spouse-to-be of Duke Federigo Gonzaga.[14] One of the large rooms there was to be hung with paintings in golden frames selected for the purpose by the Duke's formidable mother, Isabella d'Este. It is a mouth-watering list of the possessions of a great family, with works by Mantegna, Raphael, Titian, Leonardo and others, but only two can be indentified with some certainty: the portrait of Leo X believed at Mantua to be by Raphael, though it was only a copy by Andrea del Sarto; and Mantegna's *Dead Christ with Angels*. In one respect, however, the letter only teases our

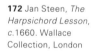

172 Jan Steen, *The Harpsichord Lesson,* *c.*1660. Wallace Collection, London

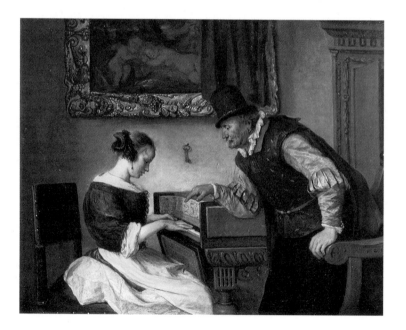

curiosity without satisfying it, for it turns out that this splendid gallery was intended as an emergency measure; the rooms were not ready and Giulio Romano had promised to fresco them the following summer. It is worth remembering, though, that in that period there was plenty of give and take between the fresco and the framed painting: the device known as the *quadro riportato*, the fictitious picture in the decorative setting, would deserve a special study. Such fictitious frames can be seen in Perino del Vaga's splendid hall in the Castel Sant'Angelo in Rome (fig. 173) and, of course, on the ceiling of the Galleria Farnese by Annibale Carracci. In France, the golden frame seems to have been adopted quite early: at least the foolish virgins in Abraham Bosse's engraving (fig. 174) seem to have been foolish enough to hang paintings in such frames over the precious

173 Interior of Hall of Castel Sant'Angelo, painted by Perino del Vaga, 1545–8

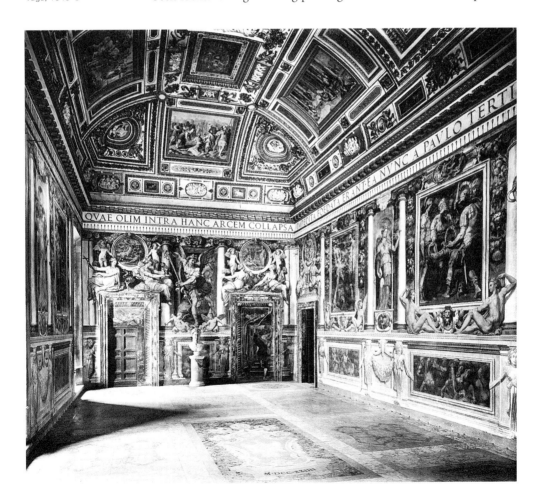

174 Abraham Bosse,
The Foolish Virgins,
1640s. Engraving

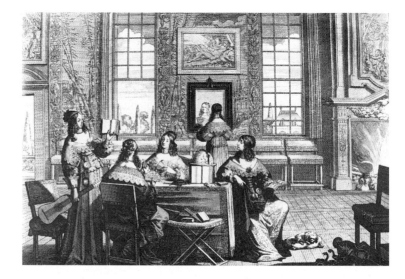

tapestries. In England, the choice seems to have depended very much on class and wealth. Hogarth, in his series *Marriage à la Mode* (figs. 175, 176) clearly draws a distinction between the house of the wealthy upstart who sells his daughter to a worthless aristocrat, in a room hung with emblematic pictures in heavy gilded frames, and the interior where the heroine dies which is not devoid of pictures, to be sure, but is devoid of gold.

Watteau's wonderful *Enseigne de Gersaint* (fig. 177), the sign of a picture dealer, is a more pleasant reminder of the social context of these paintings in their rich setting. One would dearly like to know who these customers are imagined to be, and what their criteria are for selecting their purchases. One of them I have not even mentioned yet: the destination of the painting not within the room, but within the house. Some paintings would have been considered more suitable for the boudoir, others for the salon or dining room. I do not think, however, that we should regard this type of attention to subject-matter as very widespread or very firm. Where there was a choice, you may have preferred to put the picture of the nude in the bedroom and the still life with enticing fruit or game in the dining room, but if subject-matter had always counted for so much, the painters of landscapes or animals would have had an even harder time, for where should the painting of cattle go in the house?[15] There must always have been members of the middle classes who simply wanted a painting to place over a sofa or in an equivalent gap, irrespective of any moral or message they contained.

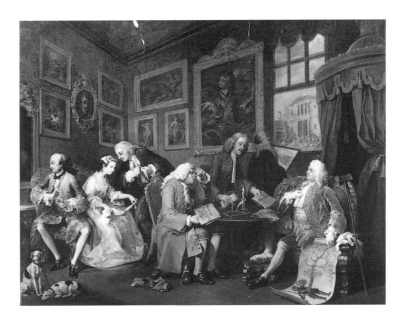

175 William Hogarth, *The Marriage Contract*, from *Marriage à la Mode*, 1743. National Gallery, London

176 William Hogarth, *The Suicide of the Countess*, from *Marriage à la Mode*, 1743. National Gallery, London

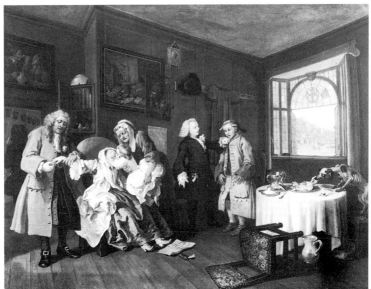

It is here that the demand for paintings in the home suffered a formidable setback through the competition of the cheaper medium, the print.[16] The threat, if I may call it so, had been slow in developing, for though prints were cheap, they were also inconspicuous and somewhat messy when pinned up on a wall, if this loose print in a tavern painted by

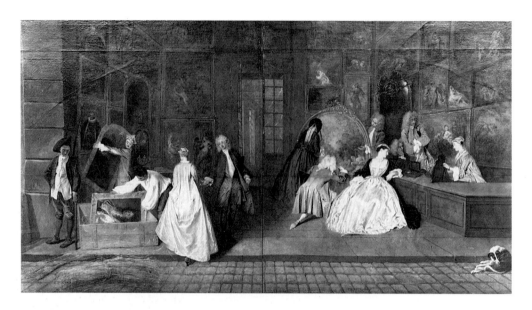

Teniers is indeed a print and not a drawing (figs. 178, 179). It was not before the eighteenth century, I believe, that prints were accorded the dignity of a golden frame and of glazing as can be seen in the background of a Venetian conversation piece by Longhi, a portrait of Gherardo Sagredo, one of the procurators of San Marco, a choice which is unlikely to be devoid of significance (fig. 180).

This promotion of the print among the pictures for the home would not have been possible without the ease of framing and glazing connected with the development of rolled glass. The popularity of framed prints is attested by the dealer Joullain, who in 1786 warned the public never to buy a print under glass, but always to take it out of the frame first.[17]

When Hogarth introduced the copyright act, he may not have realized that he changed the relation between painting and public.[18] He was known to hate the collectors of Old Masters, whom he accused of snobbery and ignorance, but now contemporary work began to take on the function of an archetype to be spread and made known in the form of reproductions. The inventions of the masters had of course always been spread by engravers, but these prints usually went into the folders of connoisseurs or artists. It is characteristic of the changes to which I refer in the eighteenth century that the printmakers in their turn produced the splendid mezzotints after paintings by Reynolds which were regularly disseminated after the exhibitions of the Royal Academy.[19]

I believe there is a subtle but important change here in the function of

128

the picture on the wall. It is intended to serve as a reminder, a souvenir, and to rival the book as a source of knowledge. We know from Goethe's childhood recollections that his father had brought back from his Italian journey a number of engraved views of Rome which were hung in the entrance hall of their spacious house in Frankfurt.[20] They were, as he says, engraved by skilful forerunners of Piranesi, one of whom we know to have been Giovanni Battista Falda, and they made a lasting impression on the

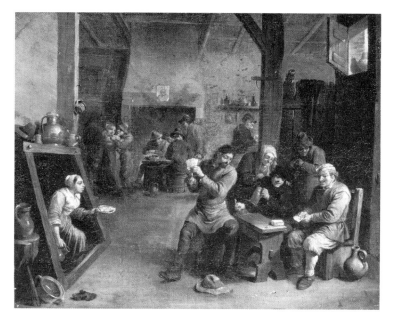

178 David Teniers the Younger, *The Card Players*, *c*.1633. Musée des Beaux-Arts, Le Havre

179 Detail of fig. 178

180 Pietro Longhi,
*Gherardo Sagredo and
other Figures in an
Interior, c.*1750–60.
National Gallery, London

child. What matters to me is that this style of living set the key for the educated classes in Germany and elsewhere. Those who could afford it had a full-sized copy of an admired masterpiece; those who could not afford a painted copy bought a reproduction. A charming painting of a musician's family in Basle in 1849 surely shows us mainly prints under glass, including, right in the centre between the windows, Leonardo's *Last Supper*, probably in the famous engraving by Morghen that Goethe recommended (figs. 181, 182).

To meet this demand, the advent of photography came almost as a god-send, for photographs can reproduce a painting both accurately and cheaply. My final example is a photograph taken by Byron in 1905 of a bedroom in a New York conservatory of music (fig. 183). Some may recognize the detail from Botticelli's *Pallas and the Centaur*, but the reason I show it is that it is not a print, but very probably one of Alinari's photographs bought in Florence, Botticelli having by this date graduated into the ranks of the most famous masters. The coming of the photographic reproduction, of the Arundel Society, of Alinari, Anderson,

Giraudon and so on, completed the process I have described, the demand not for pictures but for reminders of great pictures, the greatest if possible.[21]

When that great and idiosyncratic student of English literature C.S. Lewis was asked to give his inaugural lecture, he introduced himself to his audience as a prehistoric animal, a dinosaur.[22] He wanted to make the point that what a survivor of a bygone age can tell present-day students is what things were like in previous geological epochs. In my old age, I have

181 Sebastian Gutzwiller, *Family Concert in Basle*, 1849. Kunstmuseum, Basle

182 Detail of fig. 181

acquired the right to the title dinosaur. There may be few authentic records
of what a middle-class apartment looked like in Vienna at the time when I
grew up (fig. 184), but I can briefly describe it. My mother taught the
piano, and in the room where she had two concert grands, there hung over
one a large print of the wedding procession from Giotto's *Life of the Virgin*
in Padua (fig. 185). Chronologically, it was the earliest of the paintings, and
I remember my mother saying how consoling she found it, when a pupil
played badly, to look at these serene music makers. Not surprisingly,
perhaps, there were also the music-making angels from the Ghent altar-
piece, both wings united in a golden frame; and the central panel of
Bellini's *Frari Madonna*, with more music-making angels. But it was not
all music by any means. I grew up knowing as a matter of course
Michelangelo's *Creation of Adam*, Raphael's *Alba Madonna*, and the *Mona
Lisa*. Luini's *St Catherine* (fig. 186) was, I think, if not over the sofa, at least
over the settee, and a large reproduction of Palma Vecchio's *St Barbara*
(fig. 187) flanked the door. I do not pretend that this was all you would
have seen if you had visited us, but though my father was a modest
collector of prints, some of which he put on the walls, the emphasis was
overwhelmingly on photographic reproductions.

All this must sound pretty horrific, but I tell it in no satirical or
repentant frame of mind. The generation to which my parents belonged
looked at pictures as they looked at books and listened to music, as a
means of making contact with the great minds of the past. They surely felt
that no contemporary painting they could afford would be as good as

184 Photograph of E. H. Gombrich's mother in her music room in Vienna

185 Giotto, *The Wedding Procession*, detail from *The Life of the Virgin*, 1304–6. Scrovegni Chapel, Padua

186 Bernardino Luini, *Saint Catherine being Carried up to Heaven*, detail from *The Life of St Catherine*, 1530. Besozzi Chapel, S. Maurizio, Milan

187 Palma Vecchio, *St Barbara*, c.1509. Sta Maria Formosa, Venice

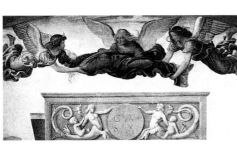

Michelangelo's Sistine Chapel. And they had no more ambition to be collectors of original paintings than of autograph poetry or music. It was as reminders of loveliness and power that they selected the photographs, and since they were reminders only, they did not hanker after faithful colour reproductions either. I remember a wonderful old lady I was occasionally allowed to visit when I was still a schoolboy. Over her sofa was a black and white photograph of Titian's *Tribute Money* (fig. 188). She mentioned that she had seen the painting in Dresden but had actually found that the colours detracted or distracted from the spiritual content of the masterpiece. Here is change for you.

133

188 Titian, *The Tribute Money*, *c*.1518. Gemäldegalerie, Dresden

I admit that, even seventy years ago, her remark shocked and outraged me. But do not jump to the conclusion that she was a stuffy old Philistine. She, if anyone, belonged to the avant-garde of her time. She had been an emancipated woman who had walked out of her marriage with a famous philosopher; Gustav Mahler attached particular importance to her opinions of his music; and in her old age, men such as Furtwängler and Bruno Walter made their pilgrimage to her whenever they came to Vienna. Things are more complicated than they seem.

Even so, I am sure that the violence of the reaction against the cult of the past which characterized the modern movement in painting cannot be fully understood without this background. On the face of it, the revolt against the display of photographic reproductions of masterpieces in the home should have benefited the contemporary painters enormously. If it did not quite as much as one might have hoped and expected, this was due to the concomitant revolution in taste. I mean the rise of modern architecture, which is subsumed, however superficially, in the term functionalism. For what the new taste abhorred above all was the cluttered room, the upholstery and knicknacks no less than the pictures we connect with this style of life. Now, the architect wanted to articulate the room himself, and left little place for pictures in the home. In the Art Nouveau interior by Voysey in England, such pictures as can be discerned have returned to the zone below the ceiling (fig. 189).

This movement away from the cluttered interior is brilliantly caught by the splendid architectural satirist Osbert Lancaster. He made two contrasting drawings of cottages, one entitled *Ordinary Cottage* and the other *Cultured Cottage* (figs. 190, 191). One wonders which he preferred. Over the mantlepiece of the cultured cottage, one has, almost as a matter of course, a large reproduction of Van Gogh's *Sunflowers*, a new sign of allegiance to modernism and probably a coloured print. For the coming of the large, inexpensive colour print would be the next chapter in this story.

189 C.F.A. Voysey, New Place, Haslemere, Surrey, 1897, view of hall

190, 191 Osbert Lancaster, *Ordinary Cottage* and *Cultured Cottage*, from *Homes, Sweet Homes* (London, 1939), pp. 60–1, 62–3

Chapter 5 Sculpture for Outdoors

Originally delivered as part of a series of lectures at the University of California at Berkeley, October 1978.

Looking into the shop of a seventeenth-century picture dealer, one Jan Snellincks (fig. 192), it is not too difficult to imagine what these well-dressed men have in mind as they are scrutinizing the available pictures. Whether or not they are collectors as well as householders, they know what to do with a painting if they decide to purchase it. The engraving of a sculptor's workshop by Abraham Bosse in figure 193, dated 1642, shows a rather different situation. The elegant pair stand in front of a more than life-size group of Venus and Cupid of which the sculptor holds a small replica. He is obviously trying to persuade them to buy either of them; one hopes for his sake that it will be the large group, but one could not be surprised if the pair hesitated. Venus and Cupid may be very nice to have around, but where are they going to put them? Unless they are the owners

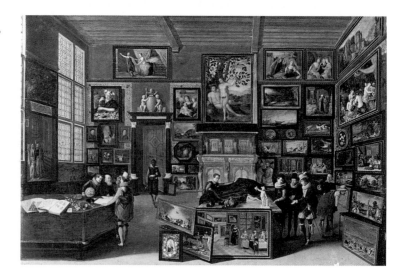

192 Hieronymus Franken II, *The Shop of the Picture Dealer Jan Snellincks*, 1621. Musées Royaux, Brussels

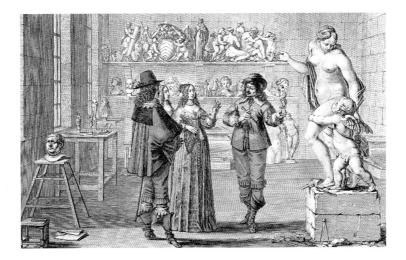

of a house with large grounds, they will have to be satisfied with the small statuette. For monumental sculpture almost demands to be placed outdoors, and the demand for such works must of necessity be more limited than that for pictures in the home.

In fact, I remember being in a somewhat similar situation when I visited the studio of a very good sculptor and expressed my sincere admiration for a very large reclining nude suitably transformed from an irregular hunk of a block. It suddenly crossed my mind that I had better stop praising it, for what if the artist had said, 'I am so glad you like it, have it'? What would I do with such a stumbling block, even though I have a small patch of garden? In a volume devoted to the demand for images, the existence and role of monumental sculpture points to a problem, indeed to an embarrassment for any neat theory of supply and demand.

There is a provocative chapter in Charles Baudelaire's review of the Paris Salon of 1846, which is entitled quite bluntly 'Pourquoi la sculpture est ennuyeuse' – 'Why sculpture is such a bore'.[1] For all their bias, these pages are so full of insights that I chose them as the starting point for this essay. 'The origins of sculpture', Baudelaire began, 'are lost in the mists of time. It is in fact a Carib art.' By Carib, Baudelaire meant what we would call a primitive or tribal art, for he goes on to say that all races bring real skill to the carving of fetishes long before they embark on painting which, as he claims, demands deep thought and a special kind of initiation. In his view, sculpture is so much easier to make and to understand because it is solid like the objects of nature. Any peasant can understand a piece of sculpture, but a painting will baffle him, because he cannot touch the

objects represented. But because sculpture is what Baudelaire called brutal and positive, he thought it as difficult to be a connoisseur of sculpture as it is to create a really bad piece of sculpture. Once it had emerged from the ages of savagery, he maintained, sculpture lost this brutal independence, it became what he called a complementary art. It was able to thrive only in association with architecture and with painting. He was probably thinking of the statuary decorating the porches of Gothic cathedrals (fig. 52), which were once painted, or of the fountains of Versailles (fig. 194).

Much has changed since Baudelaire's day. We no longer speak of fetishes, except in the context of pathology, and we do not use the terms savages or even primitives with a good conscience. Moreover, we do not claim that sculpture is really older than painting, for unlike Baudelaire, we have seen the art of the caves. But it is not for their historical insight that I have quoted Baudelaire's opinions on sculpture, but rather for the psychological truth they may contain. Whether or not sculpture preceded painting in history, and whether or not there really are peasants who cannot understand a picture because it lacks solidity may be doubted. But if one forgets about the alleged savages of the past, and remembers the little savages in our nurseries, some of Baudelaire's distinctions between the solid and the flat no longer seem far-fetched.

Although I do not mention this distinction in my piece entitled 'Meditations on a Hobby Horse',[2] I would claim that there really is all the difference to the child between a real three-dimensional hobby horse and a painted one, say in the illustrations of a picture book. It is not that the child would not recognize the picture; of course it would. But the picture would not be a toy, he could not handle it, let alone ride on it, and so it would lack that peculiar charge which belongs to a three-dimensional

194 The Fountain of Neptune in the gardens of Versailles, 1735–40

195 A Steiff Teddy bear

image. If you have heard too much of hobby horses, remember that other inmate of the nursery, the Teddy bear (fig. 195).³ Surely it would be misusing language to say that the function of the Teddy bear is to represent a bear. It does not. It is a new kind of bear, a creation of this century and maybe one of its few lovable ones. I do not think that Christopher Robin ever wondered who had made his dear Winnie whom he called the Pooh, but with the distance of time, scholarly curiosity and the greed of the market have also invaded the nursery. The Teddy can now confidently be attributed to two independent artists: the German toy maker Margarete Steiff with her product, but the inventor of the name Teddy bear and thus of the toy was an American called Morris Milton, who in all sincerity wrote to President Theodore Roosevelt in about 1902 asking for permission to call one of his stuffed toys after him, which was graciously granted. But Milton was not swollen-headed; he obviously felt that his bear lacked a certain *je ne sais quoi* and when, on a visit to Leipzig, he saw a bear called Petz made by Mrs Steiff, he at once ordered 3,000 copies, much to her amazement, and so began Teddy's career in earnest. I say began, but it is only in the last few years that this creation has received the accolade of being auctioned at Christie's, where, on 5 December 1994, £110,000 was paid for a specimen from around 1904.

But what may be called the aestheticization or sterilization of the Teddy bear happened a few centuries after the aestheticization of paintings of saints. Surely the original demand for the bear was not the demand for a work of art but for a creature to play with, a companion to share the child's pillow or plate, in other words to become vested with something like a soul. It is difficult to find a word to describe this capacity of three-dimensional images to be drawn into the world of the living, to become not representations of something else but almost individuals in their own right. 'Personalized' might have fitted, if it had not been so horribly abused. Perhaps animation is the best I can do. For the child, the image is charged with a life of its own, not a dangerous life, but a fictitious life of make-believe. Watch children in our parks or playgrounds reacting to sculpture: how they touch it or clamber on it. One is reminded of one of Aby Warburg's cryptic but profound remarks about the image: 'you are alive but will not harm me,' 'Du lebst und tust mir nichts.'⁴ I believe that this strange duality is always potentially present in any outdoor three-dimensional sculpture that has not yet been aestheticized. Indeed, without this background, we cannot understand the demand for what I call sculpture for outdoors, any more than we can understand the demand for dolls indoors in the nursery.

Let me now follow Baudelaire's literal meaning and descend into the mists of time, to remind you of that archetypal image, the Great Sphinx of Giza, carved from the living rock in front of the tomb of the deified Pharaoh (fig. 196). The exact function of this sculpture can only be surmised, but it certainly is not simply a representation of that mythical monster the Greeks called the Sphinx. It, or rather he, has the head-dress of the Pharaoh. But we need not doubt that it was charged with life. There is an inscription near the image, dating, it is true, from a much later period, in which the Sphinx is made to speak: 'I protect the chapel of this tomb ... I ward off the intruding stranger. I hurl its foes to the ground and their weapons with them.'[5] Whether or not it was thought to be able to harm us innocent visitors, it was surely thought to be able to harm any hostile force.

Here we can see that the idea of outdoors acquires a literal meaning. You can use such a presence to guard your gates or doors against any intruders, and this practice is so widespread that it may well have originated independently in various parts of the world. I do not think many would be tempted to attribute to these Hittite lions of the thirteenth century BC a purely decorative aesthetic function (fig. 197). The same guardian function exists in the Far East, in China and Japan where the four main directions of the compass at a temple precinct are regularly guarded by such fierce images which are indeed by now also a triumph of the sculptor's art, like this guardian from a temple at Nara of the eighth century (fig. 198). So, too, is one of the most astounding archaeological

196 Great Sphinx at Giza, Egypt, *c.*2500 BC

finds of our time, the so-called Terracotta Army guarding the tomb of the great Emperor Qin Shi Huangdi of the second century BC (fig. 199). The very fact that they were found underground rules out any idea of a purely aesthetic purpose, though we are free now to enjoy their high artistic quality as we enjoy the various figures from the Tang period which are displayed in our collections (fig. 200).

What was it that permitted the image to leave its site and turn from a numinous presence into an object for collectors? I briefly discussed this change of function in my essay on altar painting, where I described the case of a painting by Titian destined for a particular altar which was considered more suitable for the collection of a prince. In stepping into this role of the purveyor of art for collectors, the Renaissance artist was seen and saw himself as the successor to the ancients, the Greeks and Romans whose achievements in the fields of sculpture were legendary. I

197 Hittite Lions standing guard, *c.*1300 BC. Hattusa, Boğasköy, Turkey

198 Guardian deity, Tòdaiji Temple, Nara, Japan, 8th century

199 Terracotta army, China, *c.*210 BC. Hsian, northern China

200 Kneeling female musician, from an imperial tomb, China, Tang Dynasty (618–906 AD)

have sometimes trailed my coat by claiming that the Greeks invented art. To make good this claim, I would have to follow step by step how the numinous image became emancipated from its place inside or outside the temple or sacred precinct and became valued and discussed simply as a piece of sculpture.

One need only open that tantalizing and nostalgic text, the guidebook to Greece from the second century AD by the Greek antiquarian Pausanias, to realize how closely the works of the Greek masters were linked with sacred shrines.[6] The environment of these shrines, whether the Acropolis in Athens or the Temple and Precinct of Olympia, must have been crowded with statues to an almost unimaginable degree. It was the tradition in Olympia, for instance, to make anyone who had broken the rules of the games by bribery or other misdemeanours erect a statue of Zeus by way of expiation. Pausanias lists these statues one by one, together with the scandals that had given rise to them, and there were certainly more than forty such images of the King of the Gods within a narrow compass, stemming from different regions and dating from different periods. What an opportunity for any artist or any lover of art to compare these many images of the same god and to view them not as numinous presences but as solutions to a sculptural problem! I do not know whether the opportunity was ever seized. We do know that this happened with the famous array of statues which Pausanias still saw there, those representing the victors in the Olympic games. For Pausanias, writing as far distant in time from the most famous of these works as we are from the great cathedrals, there was a distinct difference between real votive offerings and these statues which, as he says, were not erected for the glory of a god but were awarded as a prize to the best contestants. That these statues did indeed stimulate comparisons and therefore competition we need not doubt. It is well known that some of them became famous, such as the *Diadoumenos* of Polycleitos, or the *Apoxyomenos* by Lysippus, which was said to embody the canon of proportion. It became commonplace to compare the style and perfection of such sculptures, and out of such comparisons emerged the critical history of art. Both the works of sculpture we know are not the originals but Roman copies. We tend to look somewhat askance at the Roman copying industry, but should remember that without these replicas we would only have a hazy picture of the development of sculpture described by the ancient authors. Moreover, the trade in copies heralded a momentous change: it was through this demand for replicas that the open-air museum that was the Greek temple precinct as described by Pausanias turned into Malraux's 'Musée

imaginaire', not the imaginary museum, perhaps, but the museum of the mind, the memory and continued presence in our mind of the masterpieces of the past. This was exemplified in the previous essay by the demand for engraved and photographic reproductions to be displayed in the home. There was a corresponding demand for bronze reductions and plaster casts of celebrated ancient statues.

That very similar conditions and attitudes prevailed in Roman times can be seen in a letter by Cicero to a friend who had been purchasing statues for him. Cicero thought that his instructions had been misunderstood or disregarded, and the plight in which he found himself gives us an unusually vivid idea of the ambivalence works of this kind have aroused long before Baudelaire found sculpture a nuisance.

> My dear Gallus, there would have been no difficulty if you had bought the things I wanted and had gone no higher than the price I named. I hope, however, that Damiasippus [the art dealer] will stand by his offer to have them back, for I do not really want any of these purchases. Not being quite conversant with my habits, you have bought five statues for a price I do not value all the statues in the world taken together. You compare the Maenads you have bought with the Muses by Metellus, but how can you make such a comparison? Actually, I do not think the Muses would have been worth all that money, and I believe the Nine would share my opinion, but at any rate Muses would have been appropriate to a library and in keeping with my occupation. But where have I a place to put Maenads? 'They are charming,' you will say. I know them well enough, for I have often seen them. Statues so well known to me I would have given you specific instructions to buy, if I had wanted them. The statues I am in the habit of buying are of the sort suitable to adorn a palaestra, after the fashion of a gymnasium. And what, again, shall a promoter of peace do with a statue of Mars? I am glad there was not also a figure of Saturn, for the two together would get me into debt.[7]

After more banter and complaints about the price, he mentions that he has been constructing new alcoves with seats in the portico of his villa in Tusculum and adds slily, 'I should like to decorate them with pictures, for my taste runs to painting rather than sculpture.' No doubt the pictures were also copies, but they were less expensive and less demanding.

Cicero's joke about the way Mars and Saturn would bring him into debt reminds us once more of the twilight region of the mind. The reference is of course to the influence of these divinities as planets, as though Cicero

were only half-humorous when he toys with the idea of the in-dwelling powers of such statues. Would he have been so sensitive about paintings, one wonders? For though this telling text reminds us of the degree to which the demand for sculpture outdoors had become trivialized in the Roman world by turning the copies and replicas into garden furnishings, the potential of animation seems to have persisted, at least in the popular mind.

If proof were needed, it can be found in the hostility of the rising Christian religion to the idols of the pagan world. In the Greek or Byzantine Church this hostility led to an almost total ban on sculpture in favour of the painted icon. I say almost total, for relief sculpture was permitted, at least if it was not too three-dimensional. The popular test was said to be that an image should not be so solid that you could take it by the nose. Manipulation and animation go together.

In the Western world, things did not reach this pass, but by and large it would be true to say that throughout the early and high Middle Ages no free-standing monumental sculpture was created for display outdoors. The few such images still left standing in Rome were regarded with suspicion and awe, like the Horse Tamers on the Quirinal, always mentioned in the guide books for pilgrims. Some of them were reanimated or repersonalized by popular imagination, such as the statues or fragments which were known as speaking figures, the most famous being the so-called Pasquino, a fragment of a group originally representing Ajax with the body of Patroclus, but in its mutilated form looking for all the world like a court jester or clown (fig. 201). It had become the habit or tradition to affix to this statue satirical verses about topical issues as if it was Pasquino who spoke, and the genre of such satires became known as Pasquinades. But, interesting as this folk custom is, it also suggests how remote these ages were from a demand for statues as works of art, which we connect with the Renaissance, the revival of antiquity.

The institution of of sculpture outdoors is intimately connected with this revival. The monuments themselves are familiar enough, but I propose to look at them from a slightly different angle. I shall argue that, in modern times as in antiquity, the spirit of competition aroused by the public display of rival commissions was a powerful agent in the development of this genre.

In speaking of the statuary of cathedrals, Baudelaire rightly called sculpture a complementary art, complementary to architecture. But when the Florentines began to place statues into niches of the church of Or San

201 Pasquino group, Hellenistic original of the 2nd century BC; anonymous engraving from Lafréry's *Speculum romanae magnificientiae*, Rome, 1550

Michele, they did not simply want to decorate the building (fig. 202). It was the Florentine guilds who had to put up the statues of their patron saints, and in the course of this campaign the church developed into that open-air museum of quattrocento sculpture we still admire when we look at each statue in turn, from Ghiberti to Donatello, and enjoy these pieces in isolation. We have no text there which speaks of the competition inherent in these commissions, but we do from other sites in Florence, such as that for the doors of the Baptistery. Less well known is the case of the four evangelists to be placed in front of the cathedral, where it was decided that for the time being three of the four should be allocated to three artists, while the fourth should go to the sculptor who had done best with his figure.[8]

The stipulation was not carried out, but it was in this atmosphere of intense rivalry and competition that both Ghiberti and Donatello rose to fame among the Florentines, and were expected to challenge even the famous ancients on their own ground.[9] Donatello's bronze *David*, commissioned by the Medici (fig. 203), was almost certainly conceived as such a challenge, it being known that in classical antiquity statuary in bronze was esteemed most highly. The commission was followed by that

145

for a group of *Judith and Holofernes* (fig. 204), which was set up in the courtyard of the Medici palace with a Latin inscription composed by Piero de' Medici drawing a political moral from the biblical story: *Regna cadunt*, Reigns fall through indulgence, cities rise through virtue, behold here the indulgent felled by the humble.[10]

The inscription is relevant because at the time when the Medici were expelled from Florence in 1494 and the populace rose against the truly indulgent son of Lorenzo il Magnifico, the statue was taken from the palace and set up in the most important public square of the city, the Piazza della Signoria, the square in front of the Palazzo Vecchio, the town hall, which was flanked by the Loggia dei Lanzi, the covered platform used for public ceremonies (fig. 205). The transfer of this famous piece of sculpture to the square was apparently responsible for a kind of chain reaction. Not that it was surprising in itself that the group of Judith and Holofernes should turn into a symbol of the liberation from tyranny. In fact, it joined another popular work of Donatello, the so-called *Marzocco*

202 Nanni di Banco, *Quattro Santi Coronati*, c.1415. Or San Michele, Florence

203 Donatello, *David*, c.1440–2. Bargello, Florence

204 Donatello, *Judith and Holofernes*, c.1453–5. Piazza della Signoria, Florence (now in the Palazzo Vecchio). The original inscription has not survived.

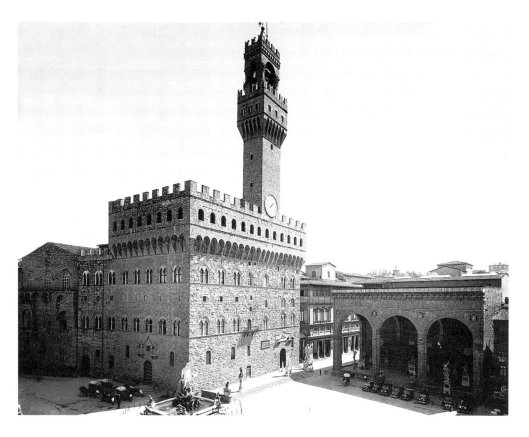

205 Piazza della Signoria, Florence, showing the Palazzo Vecchio (centre) and the Loggia dei Lanzi (right)

(fig. 206), one of the master's early works, which shows the lion as the heraldic supporter for the Florentine lily. We can regard this alert lion in front of the palace as the embodiment or revival of the idea of the guardian, and though it has been replaced by a copy, it still creates this effect in front of the old walls.

The same applies to Michelangelo's *David* (fig. 207), the original of which is now in the safe shelter of the Accademia in Florence, the place of the original outdoors having been filled by a copy. Famous as the statue is, what is remarkable in my context is that here, the demand for the image originated not with society or the public but with the artist, which was certainly not the norm at the time. Briefly, Michelangelo had returned from Rome in 1501, at the age of twenty-six, already covered with glory and eager for work worthy of his skill. Passionate carver as he was, he coveted a large marble block which was lying unused in a building yard of Florence Cathedral since it had been spoilt forty years earlier by Agostino di Duccio during an attempt to create a large figure, probably for one of the supports

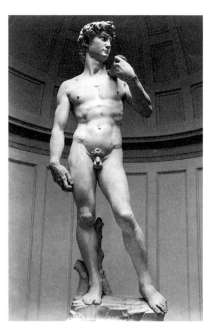

206 Donatello, *Marzocco della Chiesa*, 1418–20. Bargello, Florence

207 Michelangelo, *David*, 1501–4. Accademia, Florence

of the choir, inspired by the cathedral at Milan, where large niches were also set up for statuary. But when Michelangelo had achieved the difficult feat of turning the awkwardly shaped block into a masterpiece of sculpture, nobody thought of using it for a decorative purpose for which it would indeed have been most unsuited. Instead, the Florentines, good democrats as they were in 1504, convened a committee of experts to debate and decide where the statue should go. We have the minutes of this unique assembly, which included Leonardo da Vinci, Filippino Lippi, Sandro Botticelli and other illustrious names, but the first to be asked was, significantly, not an artist but the city's herald. His opinion is rather quaint but interesting on that score. He thought that the statue should be put where Donatello's *Judith* stood at the time, and this for no aesthetic reasons whatever. *Judith*, he said, was a statue dealing with death and ill-placed, for here a woman kills a man, and since the time it was put up, Florence had lost the war with Pisa and things had gone from bad to worse. What mattered to him was what I have called the 'charge' of the statue, which he suspected of being an evil one. A carpenter who spoke next reminded the assembly that one should always stick to one's plans, and since the statue had originally been destined for the pilaster of the cathedral, that was where it should go, if not inside the church. The architect Giuliano da Sangallo, who may well have been Michelangelo's

148

spokesman, suggested the Loggia dei Lanzi where the work would be better protected, but it was found that this placement would interfere with ceremonies and that it should go nearer the palace. Filippino Lippi sensibly intervened and said that the master himself was most likely to know best, and whether with or without Michelangelo's concurrence, the last opinion was adopted, that the statue should be placed next to where the lion now is, that is the *Marzocco* by the side of the entrance to the palace, where indeed it came to stand for some 350 years, deriving from its position the 'charge' of a guardian figure, David the shepherd boy who defeated Goliath being a favourite hero of the Florentine republic so frequently facing superior odds.

It cannot surprise us, given the atmosphere of Florence, that the desire arose to have yet another statue here, of another hero and potential guardian of the city, Hercules. Originally, the commission seemed intended for Michelangelo, but Vasari, who is a biased but not uninformed witness in these matters, tells us that the Pope was persuaded that his requirements would be more expeditiously met by adopting the old Florentine trick of creating competition between rivals. Accordingly, the young sculptor Baccio Bandinelli was ultimately asked to perform this thankless task of matching the *David*, and, alas, he rose to the bait.[11]

If there was any sculptor who felt a burning desire to outdo the most famous master of his time, it was Baccio Bandinelli, and if ever pride came before the fall, it was in this case. The story of this commission, beset as it was by intrigues and rivalries, cannot concern us in detail,[12] but when the statue was at last put up in 1534, it caused a storm of derision and protest. The tradition of the Pasquino was revived, but this time it was the piece of sculpture that was ridiculed in so many libellous verses affixed to it that Alessandro de' Medici intervened and had some of these hostile critics imprisoned, which, as Vasari says laconically, put an end to this matter. Not quite, however, for Baccio's younger rival Benvenuto Cellini has seen to it in his autobiography that we know some of the criticisms that were levelled against the group, for instance that the right leg of Hercules and that of Cacus are so mixed up that you could not separate them without injuring both. I think that Vasari, who had no love for Cellini but tried to be fair, was right when he said that the real trouble was only that the statue had come to stand by the side of Michelangelo's *David*. But as President Truman said, 'If you don't like heat, you must keep out of the kitchen.' What is relevant to my story is really that by now the Piazza with its famous statues was like a kitchen, and it is one of the conditions of sculpture outdoors that it must also satisfy the demands of the people.

Figure 208 shows Bandinelli's statue through the arches of the Loggia dei Lanzi, with Benvenuto Cellini's *Perseus* in the foreground. For the genesis and purpose of this famous work we have again the words of the artist himself, who writes characteristically in his autobiography that when he was returning to his native Florence in 1545, he was burning with the desire to show the noble school of Florence that he was practised in more arts than they imagined – he means the craft of the goldsmith – so he boldly told the Duke that he would willingly erect for him in marble or in bronze a statue on his beautiful square, *'in su quella piazza'*. Cellini was more astute than Baccio Bandinelli; he avoided the comparison with Michelangelo's *David*, but not for that reason *any* comparison. At the time when the *Perseus* was set up, Donatello's *Judith* stood near it, and it is not difficult to see that Cellini courted comparison with this more old-fashioned group. Whether he also thought of neutralizing its meaning is a different question. Remember that the herald had found it inauspicious to show a woman killing a man; here is a man triumphing over a female monster, the Medusa, and holding her head aloft.

But my story of the chain reaction continues, for the Piazza was still without its crowning feature, the Neptune Fountain. In a letter written by the ambitious Baccio Bandinelli in 1550, he asks a courtier to look at his

208 Benvenuto Cellini, *Perseus* (1545–53), Loggia dei Lanzi, Florence, with Bandinelli's *Hercules and Cacus* (1534) behind

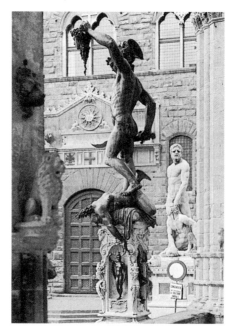

designs for the fountain, for His Excellency the Duke had several times told him that he wanted it to surpass all others: 'I promise His Excellency that if my labours please him I shall make a fountain which will not only surpass all the others which can be seen anywhere on earth today, but I also desire that the Greeks and Romans should never have had such a fountain.' Once more the Duke was intent to egg on even this morbidly ambitious man by asking other artists, Ammanati and Cellini, to submit rival projects. In the end, Bandinelli died, and Ammanati got the commission, largely through Michelangelo and Vasari. Characteristically, one of the claimants who applied insisted that he had a right to be considered, because, he says, I have no work in Florence. The finished fountain, on which many collaborated, was finally unveiled in 1575 (fig. 209).

Meanwhile a much greater master had entered this hothouse atmosphere: Giovanni da Bologna, or more exactly Jean de Boulogne. It was he who was commissioned by the Duke to erect a large equestrian statue of his father Cosimo I. The words in which we first hear of this commission are again significant. One Simone Fontana writes to the Duke of Urbino in October 1581 that there will soon be revealed a Trojan horse which is being cast now, twice the size of that on the Capitol (he means the Marcus Aurelius) to confront the giant of Michelangelo. This demand no

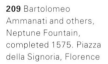

209 Bartolomeo Ammanati and others, Neptune Fountain, completed 1575. Piazza della Signoria, Florence

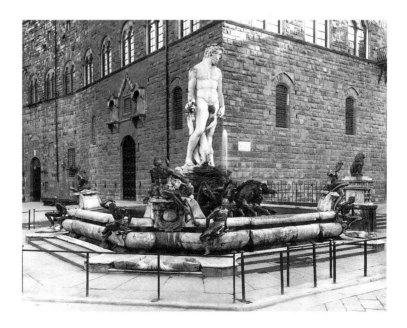

doubt issued from the Duke, who wanted to put the seal of Medici power on the Piazza, once the symbol of the Signoria, the City Council, and commemorate his brutal predecessor, like one of the Roman emperors only on twice the scale. But while the sculptor was still at work on that dubious commission, he also achieved his ambition to show his prowess in a work less hampered by any extrinsic demands even than any of those before.

The story of that group may be described as the final flashpoint of the chain reaction, for we know once more that the sculptor wanted to convince the Florentine élite that he was not only a master in small bronzes but could outdo his rivals in a monumental task. Having made the demand and been encouraged, he sculpted this intricate group of an old man, a young man and woman in extreme movement, without apparently considering what the finished work should represent and what it was be called. The name of the *Rape of a Sabine Woman* was given to it by a scholar, and the artist complied by representing the story as such on a relief on the pedestal. The finished work, completed in 1583 (fig. 210), is stunning, but it has travelled as far as possible from that intrinsic charge I have called animation or numinosity. Confronting it, one thinks of the sculptor, not of the sculpture.

210 Giovanni da Bologna (Giambologna), *Rape of a Sabine Woman*, 1583. Loggia dei Lanzi, Florence

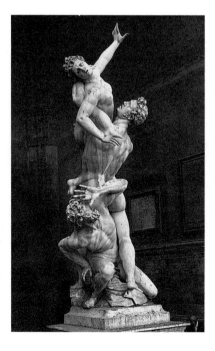

There is another of Giovanni da Bologna's works in the Loggia dei Lanzi which explicitly challenges the ancients, his group of *Hercules and the Centaur*, but I do not want to give the impression that the artist did not also know how to tap the energies of a site; in his astounding personification of the *Apennine*, half rock, half god, in the Villa Demidoff near Florence (fig. 211), he created a truly numinous fountain figure.

It is not my intention to tell the history of all sculpture for outdoors, but to chart some of the consequences which arise from the special character of sculpture as diagnosed so unkindly by Baudelaire, and to show how it is enhanced or neutralized by the siting of sculpture outdoors, in public places. One of these consequences springs to mind when you recall the fate of certain sculptural monuments – their very power, for the sake of which they were commissioned and put up could also be their undoing. They provided a target for revolutionaries who wanted to topple these symbols of dominance and power, as seen on this print from the French Revolution, showing the mob pulling down the statue of Louis XIV in the Place des Victoires (fig. 212). But of course this fate befell these statues not for what they were but for what they stood for, what they represented. But such attention, it turns out, only occurred or occurs in moments of special excitement and mob violence. Normally it is the fate of monuments in our

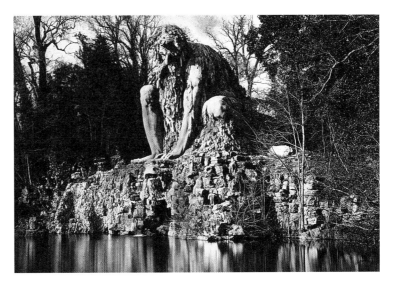

211 Giovanni da Bologna (Giambologna), *Apennine*, *c.*1583. Villa Demidoff, Pratolino, near Florence

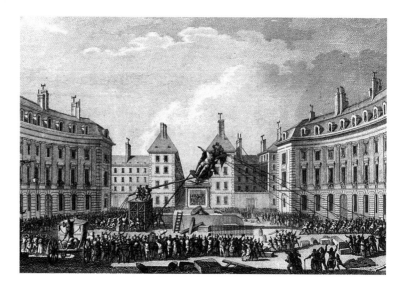

cities not to be attacked but to be ignored. Indeed, few aspects of the history of sculpture outdoors are more remarkable than what one might call the total failure of the public monument to become a public monument. Not that there was a shortage of these in the early nineteenth century. It seemed a pious duty to erect equestrian statues to kings and presidents alike, here George IV, there George Washington. Statesmen like George Canning or benefactors like George Clark followed, but how well does the latter fulfil the function of keeping alive the memory of the person represented? One is reminded of Lessing's epigram on a monument to his friend the poet Ewald Kleist: 'Oh Kleist, dein Denkmal dieser Stein? Du sollst des Steines Denkmal sein', which means roughly, 'Oh Kleist, your monument this stone? It is a monument through you alone'.

But this was not the opinion of the period, the middle of the nineteenth century. Charles Knight comments indignantly on the choice of people to whom statues were erected:

> There are thirteen kings and queens, [including] two of the 1st George, one of the 2nd, and two of the 3rd George; three brothers of kings, Cumberland, Kent, and York; four warriors, namely three Wellingtons and one Nelson; one nobleman, the Duke of Bedford; three statesmen, Fox, Pitt, and Canning; one parliamentary reformer, Cartwright; one public benefactor, Sloane; and one work of art, the admirable figure of the Moor ... which stands in the gardens of Clement's Inn. Of poets we

have – none; philosophers – none; patriots in the highest sense of the term – none; moralists – none; distinguished men of science – none; – but, in short, the list is ended. Again we ask, what does the reader think of it?[13]

Some of these omissions were made good in subsequent decades, but to what purpose? Do we really want more and more men of bronze standing haplessly in the swirling traffic where we could not even read that one is supposed to be, say, D.H. Lawrence, another perhaps Dylan Thomas, a third Rutherford and a fourth Bertrand Russell? I have mentioned the failure of this type of outdoor sculpture mainly to contrast it with an unexpected triumph where one would least expect it. Some works of sculpture of the century have come to life, as it were, and transcended the limitations of the medium. One is the Statue of Liberty guarding the entrance to New York City from the sea (fig. 213). Actually, the work was not a commission, but the idea of the sculptor Bartholdi, who persuaded the French government to present it to the City of New York, much to the embarrassment of the authorities.[14] But whether he knew it or not, the

213 Frédéric-Auguste Bartholdi, Statue of Liberty, 1886. Staten Island, New York

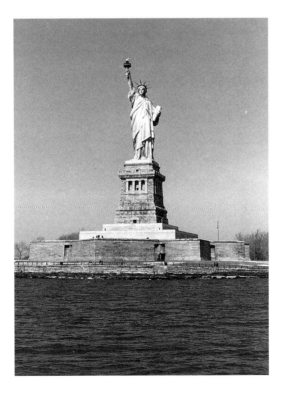

rather conventional image nobody had demanded drew strength from the earth and the sea and defies the critics who tell us it is artistically feeble. Whatever its artistic shortcomings, the statue has become the embodiment of the idea of Liberty; it was so greeted by emigrants from Europe when they first set eyes on it when arriving by sea. When the statue was dismantled for repairs, there must have been something poignant in watching the torch being taken from her hands. I cannot document this, but I can show what happens to a personification when it comes into contact with humans. The photograph reproduced in figure 214, published in *The Times*, shows a workman busying himself with the statue of Justice on the Old Bailey and trying to adjust its scales – a slightly uncomfortable thought which shows that we are not quite free from a feeling of blasphemy when our numinous statues are treated like so much junk. For the point is again that outdoor sculpture has in it the potential to assume a life of its own. On a recent visit to the German university town of Göttingen, I was shown the fountain of the Gänseliesl, the Goose Girl

214 Workman adjusting the Scales of Justice, 9 November 1938

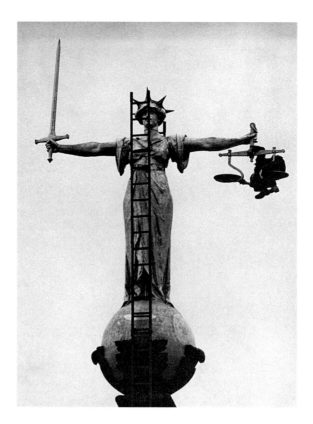

(fig. 215), which is illustrated in all tourist guides. It has become the symbol of the town, for it has become the custom for any student to climb up there on graduation to give her a kiss. I say 'her', not 'it', for she is Liz or Liesl, a presence in the city whose maker has all but been forgotten. In fact, he was called Paul Nisse, but his work has obviously outlived his reputation. There is another such example that comes to mind, the *Little Mermaid* of Copenhagen, who also graces every tourist folder (fig. 216). This figure from Hans Christian Andersen's poignant tale guards the shore outside the city and gazes out on to the sea. I was not really surprised to find that it is not easy to discover the name of the artist of what is surely one of the best-known works of sculpture made this century. Let me make good this general omission and tell you that he was Edvard Eriksen, born in 1876. In a way, it is a tribute to him and his work that the sculpture has lost the character of a work of art and has reverted to something more numinous, closer to our childhood dreams. It is the little mermaid who sits there, not a piece of sculpture representing a mermaid.

215 Paul Nisse, *Gänseliesl*, 1901. Market Square, Göttingen

216 Edvard Eriksen, *Little Mermaid*, 1913. Copenhagen Harbour

There is one more example of a sculpture outdoors which to my mind derives a great deal of extra charge from its site and our associations, Zadkine's *Monument to a Destroyed City* erected at Rotterdam in 1951-3 (fig. 217). Art historians may discover links here with Picasso's *Guernica*, but once more the difference is in the position. Those of us who remember the callous butchering by German dive-bombers of the defenceless Dutch city cannot look at this work coolly as a piece of sculpture; it mobilizes quite different emotions.

There is one contemporary sculptor above all who has felt the pull of the site and its energy-giving powers. This is Henry Moore, who strove throughout his life to restore to sculpture that charge of the numinous

217 Ossip Zadkine, *Monument to a Destroyed City*, 1951–3. Rotterdam

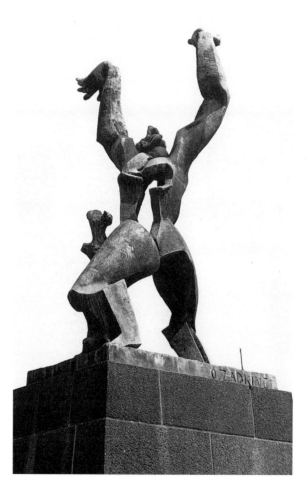

which our public monuments so conspicuously lacked. His work has been favoured by the planners who seek a counterweight, as it were, to the functionalist architecture of our new towns. No doubt his *Upright Motive no. 2* of 1956 in Harlow or his *Knife Edge* of 1961 draw strength from their site and their position (fig. 218), but they also point to the problem of recapturing something of the magic Baudelaire missed in modern sculpture.

This desire to revive a lost possibility has found expression in regulations and laws which would form a worthwhile topic of study – the convention of the so-called one per cent, suggesting or demanding that a small percentage of the cost of any public building should be set aside for a work of fine art. Such legislation may be the only way to keep artists in employment, but there is no denying the fact that the situation needs watching when a demand has to be replaced by a command. The greatest danger here seems to me that such an art dictated from above by more or less anonymous authorities or committees lacks the stimulus of public criticism that kept the sculptors of Florence on their toes. The anonymous crowds of our cities do not pin libellous verses on outdoor statues; they are more likely to be vandalized than criticized.

218 Henry Moore, *Upright Motive no. 2*, 1956. Harlow, Essex

The case for a one per cent levy is made in a pamphlet entitled *Art within Reach*,[15] which certainly gives food for thought, but also stimulates hope for more public debate. What exactly do we want? To support worthy artists or to win over the public? It is useless in this context to decry compromise and pandering to the multitudes. It is they who live there and use the buildings. I for one cannot find that the sculpture in the courtyard of Norwich Public Library helps to humanize the building, all the less as it is called *Extrapolation* (fig. 219). I wonder if anybody would have protested if it were called 'Interpolation'. It may be contrasted with this little watchdog made of bronze from Peterborough (fig. 220), which corresponds more closely to Warburg's formula, 'You are alive and do not harm me.' Even dogs seem to accept it as a harmless presence. Admittedly 'harmless' is not a word I would choose for Sioban Coppinger's *Man and Sheep on a Park Bench* from Nottingham (fig. 221); in this setting, the surrealist invention becomes indeed intriguing and slightly menacing, for what if it is alive after all? But among the works illustrated in the pamphlet, I for one fell for this little joke by Kevin Atherton of a sculpture that is evidently tired of being outdoors and has turned round to run indoors, but her presence now pervades the dreary brick wall (fig. 222).

219 Liliane Lijn, *Extrapolation*, 1982. Norwich City Library

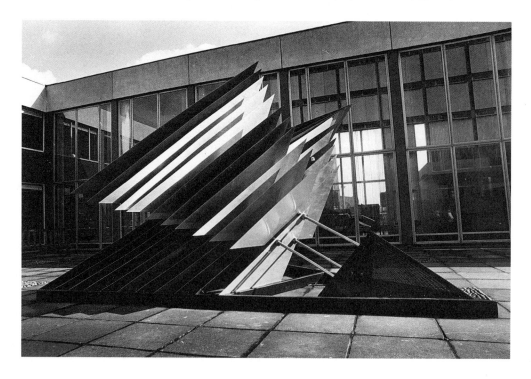

220 Barry Flanagan, *Opera Dog*, 1982. Peterborough Development Corporation

221 Sioban Coppinger, *Man and Sheep on a Park Bench*, 1983. Rufford Country Park, Ollerton, near Nottingham

222 Kevin Atherton, *A Body of Work*, c.1982. Langdon Park School, London

Chapter 6 The Dream of Reason

Symbols of the
French Revolution

First published in *The British Journal for Eighteenth Century Studies*, 2, no. 3 (1979), pp. 187–205. An Italian translation entitled 'Nostra Signora della Libertà' was published in *FMR*, no. 34 (June-July 1985), pp. 90–112, and the original English in the English edition of *FMR*, no. 39 (August 1989), pp. 1–24.

On 10 November 1793 (20 Brumaire II), the Commune and Department of Paris assembled at Notre Dame at ten o'clock in the morning;[1] the choir was screened off, and in the centre was a mountain with a small temple in the Greek style on which was written in enormous letters, *A la Philosophie*. This was flanked by four busts of philosophers, probably Rousseau and Voltaire, and possibly Franklin and Montesquieu. On the altar burned a flame of truth. After a suitable musical prelude, two groups of girls clad in white with tricolour belts and torches in their hands appeared from both sides, paid homage to the altar of Reason and ascended the mountain. At that moment, a beautiful woman, the 'true embodiment of beauty', came out of the temple. She, too, was clad in white with a blue cloak flowing from her shoulders; she wore the red bonnet and held a long pike in her right hand. The congregation, if we can call it so, sang a hymn to liberty by Marie-Joseph Chénier: 'Descend, O Liberty, daughter of Nature', which ended: 'Thou, holy Liberty, make this temple thy dwelling, be the Goddess of the French!' After the ceremony, the Goddess was carried in procession to the National Convention, for the deputies had not taken part in the pageant at Notre Dame. At the bar of the Convention, it was declared that the people had just paid homage to Reason in the *ci-devant* metropolitan church and wanted now to repeat this homage in the Sanctuary of the Law. The Convention, used to such intrusions, admitted the cortège which advanced with music and songs. Arrived in front of the president, the leader of the cortège, Chaumette, announced solemnly:

> Legislators! Fanaticism has yielded to reason. This day a great multitude has filled the ancient vault, which, for the first time in its

history, echoed with the voice of Truth. Here French citizens have come to perform a religious ceremony, to worship Liberty and Reason. Here we have abjured lifeless idols and turned to this living image, Nature's masterpiece.[2]

One feature in this melodramatic story deserves notice: the Goddess somehow changed her identity during her progress from Notre Dame to the Convention. There she had been *La Liberté*; in the Convention she is addressed as the Goddess of Reason. It was as Goddess of Reason that she was asked to place herself by the president's chair; I do not know in which capacity the president and the secretaries each gave her a fraternal kiss. And whoever she was, in the words of Hébert, one of the inspirers of this anti-clerical demonstration, she was 'a charming lady, lovely as the goddess she portrayed'.[3] It is a phrase to warm the heart of any student of symbolism. For it implies that at this moment of heightened tension the woman, whether she was an opera singer, as is more likely, or the fiancée of the printer Nomoro, or both, not only signified some intellectual concept but represented it as it actually existed somewhere in heaven. Far from being a mere personification, a conventional sign standing for some abstract concept, the beautiful woman embodied the qualities of the supernatural power that was to enlist the loyalties and the love of the crowd. This is an interpretation that was articulated and criticized at the time of the French Revolution itself. In one of the provincial ceremonies which imitated and embroidered on the metropolitan Festival of Reason, this fusion between sign and meaning was explicitly mentioned, albeit in theological rather than psychological terms: for the official orator addressed the girl impersonating Reason as follows:

> Goddess of Reason! Man will always be man, notwithstanding the refinements of pride and his puffed-up, fatuous egotism; he will always crave tangible images in order to rise to the invisible world. You, the symbol of Reason, offer her to us in such a natural way that we are tempted to confuse the copy with the original. In you the material and moral are joined to win our love.[4]

At least one contemporary dared publicly to attack this method of spreading the religion of reason. His name was Salaville, and he wrote an article in the *Annales patriotiques* denouncing the logical incongruity of these irrationalities in favour of reason:

> But if we wish to lead the people to the pure cult of Reason, far from pandering to their weakness for embodied abstractions and personified moral qualities, we must rid them first of all of the madness that is the chief cause of all human error; they must first absorb the metaphysical principles of Locke and Condillac, so that they learn to see a statue as a stone, a painting as no more than paints and canvas.[5]

Yet even Salaville was but human and not quite free from the 'madness' of confusing sign and meaning. For it turns out that he was particularly outraged by the idea that the opera singer in Notre Dame had meant to represent Reason. A young woman as Liberty might just have passed muster, for French Liberty was, after all, still young. But Reason? Reason, surely, is mature, grave, austere – qualities he does not expect in a young girl but rather in a mature man. But his real fear is that with these temples of Reason, the old religion will merely be exchanged for a new one; and when every virtue has its own temple, people will be content to worship rather than to practise virtue.[6]

Salaville, it turns out, was an isolated rationalist, untypical of his generation. But criticism of the idolatry of Reason arose from a somewhat unexpected quarter. It was Robespierre himself who thundered his condemnation of the new cult and those who had fostered it. In that great speech of 21 November 1793, he declared that 'atheism is aristocratic'. Soon Hébert perished on the guillotine, and the decree was passed according to which the French people recognized the existence of the Supreme Being and the immortality of the soul. One of Robespierre's toadies, Payan, hurried to denounce the earlier ceremonies of the cult of Reason. What kind of Reason did they mean? Their own? Should the French nation worship the Reason of Hébert and Chaumette?

> At one time it was the wife of a conspirator, borne in triumph by the crowd. At another, an actress who, only the night before, had played Venus or Juno ... To sum up, a mythology more absurd than that of the ancients, priests more corrupt than those we had just overthrown, goddesses viler than those of the Pagans threatened to dominate France. The Convention saw these conspirators ... and they are no more.[7]

And thus the painter Jacques-Louis David had to arrange that grand counter-festival, The Festival of the Supreme Being, which was opened by

Robespierre applying the Torch of Truth to a huge monster labelled Atheism and called the Sole Hope of the Foreigners.[8] As the flames consumed the image, there emerged, somewhat smoky it is said, the figure of Wisdom; after which happy change of personnel and a philosophical speech by Robespierre, the Convention marched up the symbolic mountain to the Altar of the Fatherland. This famous *volte-face* illustrates once more the strangely kaleidoscopic nature of these images and cults. In a sense, of course, Robespierre was philosophically more consistent than the muddle-headed rationalists who wanted to have a cult in a mechanical universe. Even liberty, or reason, can only be worshipped as an emanation of some Platonic principle, a Supreme Being.

But if the propagandists of the new religion were philosophically the more consistent as well as the greater psychological realists, the pure rationalists were perhaps the more interesting devisers of symbols. For not all of them drew the same conclusions from Locke's psychology that Salaville had drawn; not all of them wanted to banish symbols and feed men on abstract concepts only. Charged with replacing the traditional calendar whose dangerous Christian associations were no longer to be tolerated, the Committee appointed to devise a new one explained, through its spokesman Fabre d'Eglantine, how it had been guided in this difficult task by psychological considerations:

> We conceive of nothing without the aid of images. Without images, the most abstract analysis, [and] the most metaphysical reasoning lie beyond our grasp; it is only by and through images that we are able to remember. You must keep this in mind when making your calendar … To take account of the domination of human intelligence by images, we have even sought to exploit the elements of imitation inherent in language in devising these names …[9]

The names of Nivôse, Pluviôse and Ventôse are sad-sounding winter months; Germinal, Floréal and Prairial have to do with the buds of spring – 'A' being naturally more cheerful than 'O' – an idea which the late James Thurber might have challenged.[10]

Be that as it may, the question of this type of symbolism based, as it is felt, on the very nature of sights and sounds must certainly attract the attention of the student of artistic expression. For, rightly or wrongly, this theory has always been based on the assumption that there exists some pre-established harmony between sense impressions and feeling tones which would justify the idea that 'O' is in fact sadder and more suitable for

winter feelings than 'A', which is brighter and naturally suggests spring and joy. Many poets and orators have been interested in these synaesthetic equivalents and even music could not be used for the symbolization of emotions unless some such 'imitative harmony' were part of its nature.[11] Naturally the French Revolution also harnessed the potentialities of music to its chariot. On the first anniversary of the storming of the Bastille on 14 July 1790, a great celebration and pageant was organized, the first of many such manifestations, where a Te Deum by Désaugiers was performed.

> The overture to the Te Deum is both simple and majestic; only, through cunning dissonances, the soul is depressed, led, as it were, by the composer, via sensations of increasing disquiet and unease, up to a recitative, which profoundly moved the audience by reviving memories of the most heart-rending and harrowing nature. A dismal bell added its tolling to this sublime and awesome concert, Dong, dong, dong, dong, dong, dong, each one present, gasping for breath, stared in awful dread into his neighbour's eyes ... Our hearts constricted, our hair standing on end: a faithful image and emblem of what we had experienced in 1789 ... it all ended in fanfares and a hymn to the eternal ...[12]

If these compositions exploited the equivalences and associations of sounds and emotions, the deviser of visual symbolism must rely on similar correspondences in the realm of sight. He could claim, as we have seen, that there is no more natural symbol of what we experience as good than human or rather feminine beauty. Needless to say, this identification of beauty and radiance with the good is not peculiar to the French Revolution; it is part and parcel of the tradition of religious art and imagery, and especially of course, the tradition of the Church. I have drawn attention in different contexts to the use which European art has made of these equivalences, particularly in the large allegorical compositions of the seventeenth and eighteenth centuries.[13] In these paintings we see persons and concepts freely intermingling, the good soaring to the radiant sphere of beautiful angels or abstractions, the bad being hurled down into the abyss of monsters and devils. I have compared these compositions of gradations of good and evil with that 'semantic space' which Charles E. Osgood, in his book *The Measurement of Meaning*,[14] postulates as the filing system by which we range the feeling tones of words and concepts in our conscious mind.

But a filing system can be used for any variety of purposes and the equivalences and conventions of good and bad can equally be used for contrary verdicts on specific experiences. In the seventeenth century, the image of light was identified with the divine light, 'dominus illuminatio mea', the radiance that was of heaven. In the eighteenth century the word *lumière* or enlightenment or *Aufklärung* had gradually assumed that secular tinge which equated the light with the light of reason and darkness with superstition, if not with the Church itself. Thus on Andrea Pozzo's ceiling of the Jesuit church of S. Ignazio in Rome,[15] the founder of that order is the recipient and giver of divine radiance. Less than eighty years later, when the suppression of the Jesuit order was the first triumph of the propaganda of the Enlightenment, it is the Jesuits or their alleged emanations who are being hurled down by the powers of light (fig. 223). There is no more striking and typical visualization of this self-image of Enlightenment than Cochin's title page of the *Grande Encyclopédie* (fig. 224), in which truth in all her radiance is worshipped by the various human disciplines.[16]

It is against this background that we must see the emergence of those divinities, embodied in pageantries and images, that we have encountered. But for good or ill, their beauty and charm shared with the symbol of light

223 French pamphlet against the Jesuits, 1762. Engraving. Bibliothèque Nationale, Paris, Hennin Collection, no. 9123

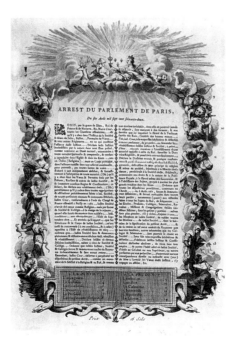

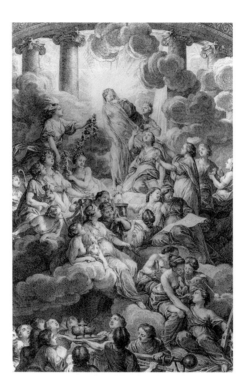

224 Charles-Nicolas Cochin, frontispiece of the *Grande Encyclopédie*, 1764. Engraving

the same lack of specificity. We have seen that the crowd did not seem to mind much whether the pretty girl was supposed to be Liberty or Reason, and who could blame them? Looking at the typical allegorical prints issued at the time of the French Revolution, we shall indeed see this sorority of classically draped, white-clad ladies assuming a variety of names as it suits the context.

In such a typical print of 1791 (fig. 226), the Goddess of Reason has descended to earth in all her beauty. She is aided by the Genius of Geography to explain the new division of France into departments; at her feet are the ancient divisions into provinces which their pride tried in vain to retain. Citizens of various regions embrace, and a stranger demands to be admitted as a citizen of France; others pay homage to Equality on the Altar of the Fatherland. On the *Declaration of the Rights of Man* of 1789 (fig. 225), we see on one side *la France*, who has broken her chains; on the other the Law, who points with her finger at the Rights of Man and with her sceptre at the supreme eye of Reason which has just dispersed the clouds of error obscuring it. The other emblems signify Liberty, Good Citizenship, and the Prudence and Wisdom of the Government. And, on

168

225 *Declaration of the Rights of Man*, 1789. Coloured print. Musée Carnavalet, Paris

226 Monnet, *Reason aided by the Genius of Geography*, 1791. Watercolour. Bibliothèque Nationale, Paris, Hennin Collection, no. 11075

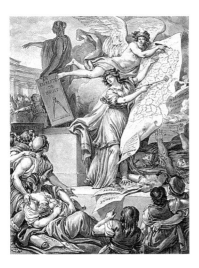

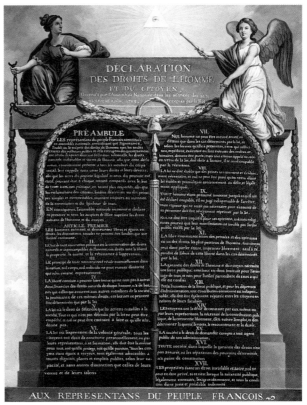

the publication of the New Calendar (fig. 227), we learn from the caption that this time the fair lady is Philosophy. She sits on a marble seat, decorated with the image of fruitful Nature. Her diadem is the bonnet of Liberty, at her feet are the Gothic monuments of error and superstition on which the ignorant and ridiculous divisions of time were based. From the great book of Nature, she copies out the Principles and Names of the New Calendar which a genius by her side takes down at her dictation. On the other side, there are various emblems such as the book of Morality and the emblem of Eternity ...

We could hardly have guessed all that. The overt meaning of the symbols is clearly dependent on an elaborate explanation of what are technically known as the emblems and attributes of these various personifications. It is to these, then, that we must turn if we want to know a little more about the conventional language of symbolism and its adaptation to new contexts. We must first be concerned with what might

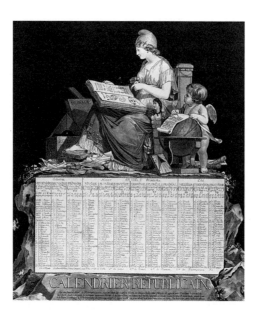

be called the etymology of the emblems and attributes, their genesis and their historical vicissitudes.

The first thing that strikes one as one delves into these questions of visual etymology is the tenacity and longevity of these symbols. The artist, for instance, who had to draw Philosophy for the New Calendar did not invent the image. He took it from the most famous representation of Philosophy, Raphael's fresco on the ceiling of the Stanza della Segnatura, where she is also placed on a throne with the mysterious image of many-breasted Nature and holding the books of Moral Philosophy. You might say that this artist happened to be uninventive. But clearly this is not the point. For those who tried to be original always failed in their purpose. In 1782, a French artist, Métal, published a print of *La Philopatrie*, a 'new iconological personification representing the love of one's country and dedicated to all true Patriots by their brother Métal …' (fig. 228). This noble lady would certainly have been worthy of being impersonated by any opera singer, but she was beaten by a true *diva*; why resort to an invented personage if there is a traditional goddess at hand, the Goddess of Liberty? For the Goddess of Liberty was roaming the world long before she entered the National Convention to receive the kiss of its president.

Ultimately, this vital symbol, familiar to every Westerner through Bartholdi's Statue of Liberty at the entrance to New York's harbour (fig. 213), comes to us from Roman coins (aureus of Nerva of 97 AD), where we

228 Métal, *La Philopatrie*, 1782. Engraving. Bibliothèque Nationale, Paris, Hennin Collection, no. 9884

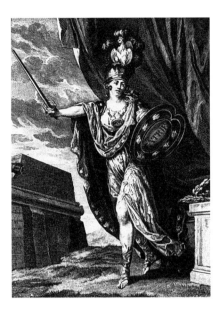

228 Métal, *La Philopatrie*, 1782. Engraving. Bibliothèque Nationale, Paris, Hennin Collection, no. 9884

see *Libertas Publica* with the wand and the *pileus* (fig. 229). This was the hat or cap given to the slave on his emancipation, as a sign of freedom. The *pileus* alone was used on a famous coin by Brutus after Caesar's murder as a symbol of *Libertas restituta* (freedom restored) (fig. 230), and this gesture was echoed in the Renaissance by Lorenzo or Lorenzaccio, the murderer of Alessandro de' Medici, on a medal (fig. 231). In his much-used handbook of personifications Cesare Ripa gives *Libertà* a cardinal's hat (fig. 233). To appear 'hat in hand' is somewhat awkward for a dignified personification, and so it became more usual for the hat to be carried on a pole (fig. 232). Hogarth's satirical portrait of Wilkes shows the self-styled tribune with such a pole supporting the *pileus* in its correct shape as an egg-shaped headgear.[17] Maybe this convention ultimately derives from a story told by Valerius Maximus, that popular collector of useful anecdotes, who tells (VIII.vi.2) of a subversive action by the Roman tribune Lucius Saturninus Apuleius, who incited the slaves to insurrection by displaying a *pileus* 'like a standard' (*in modum vexilii*). The point of this story is that Marius condemned this demagogic device and then also resorted to it in his fight against Sulla.

During the French Revolution the *pileus* or cap of liberty was usually confused with the so-called Phrygian mitre which belonged to the costume of Asiatics; it is sometimes worn by Paris, the Trojan shepherd, and also in early Christian art by the three Magi. Unlike the *pileus*, it tends

229 Gold coin representing the emperor Nerva, 97 AD. On the reverse, *Libertas Publica*. Bibliothèque Nationale, Paris, Cabinet des médailles

230 Silver coin depicting Marcus Junius Brutus, 44 BC. On the reverse, the *pileus*. Bibliothèque Nationale, Paris, Cabinet des médailles

231 Medal depicting Lorenzo de' Medici as Brutus, after 1537. On the reverse, the *pileus*. British Museum, London

232 Design for a medal representing France and Belgium, 1679. From C.F. Menestrier, *Histoire du roy Louis le Grand par les médailles* (Paris, 1691), pl. 30.

233 Cavaliere d'Arpino(?), *Liberty*. Wood engraving in Cesare Ripa's *Iconologia* (1603).

to be soft and folded on the top. Neither of these two ancient headgears was necessarily red, and indeed we have no answer yet to the question how and when the cap of liberty turned into the *bonnet rouge*, the red bonnet, perhaps the most famous symbol of the French Revolution.[18] We see it in its Phrygian shape in the hand of Liberty in Regnault's painting of 1794-5, *Liberty or Death* (fig. 234). What comes as a surprise is the fact that the introduction of the *bonnet rouge* encountered violent opposition at first and that no less an authority than Robespierre tried to prevent its adoption. This is the story as far as I could piece it together by consulting the subject index of that invaluable digest of French Revolution reports, the *Analyse du Moniteur*.[19] On 19 March 1792 Dumouriez rose to speak in the Jacobin Club when he was passed the *bonnet rouge* and donned it with all the good grace of one who is unaffected by the fleeting fashions of liberty … An electrifying spectacle at that very moment when the following letter from the Mayor of Paris was read out:

Brothers and Friends,
I respect as much as any man all emblems which call to mind the ideas of liberty and equality; yet I doubt whether the latest ornament achieves the true aim of patriotism … The purity of your principles, your unswerving conduct has clearly attracted a multitude of honest

234 Jean-Baptiste Regnault, *Liberty or Death*, 1794–5. Kunsthalle, Hamburg

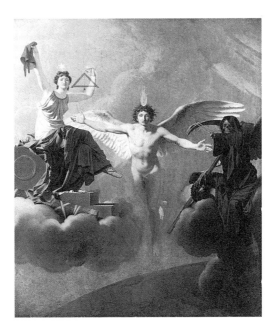

but misguided citizens. The symbol that you sport upsets and turns people away from you and supplies ammunition to those who wish to vilify you … a man who is ardent for the common weal won't give a damn about red bonnets. In this guise liberty will appear neither more beautiful nor more majestic … The people have had their fill of the empty symbols of liberty, they want liberty itself … In no time you will be seeing green bonnets, white bonnets, [and when] all these different-coloured bonnets meet each other, a ridiculous and bloody war, [and] law and order will be imperilled.

We hear that during the reading of that letter the president's red bonnet disappeared in his pocket, and when it was over none was to be seen in the hall. Robespierre must have felt this change of mood and supported Pétion. He pointed to his three-coloured cockade and said: 'If there is a symbol which speaks clearly to both heart and eye, we have this one … to substitute would only serve to weaken it, and suggest that it [the new symbol] is more powerful, which is not true.' His intervention led to the adoption of a resolution which affirmed the unique value of the *tricolore*.[20] But the appeal of the new symbol was too strong. Four weeks later, on 15 April, a great fête took place in Paris arranged by David to honour the survivors of a Swiss regiment from Châteauvieux who were considered 'martyrs of liberty'. They had rebelled against their aristocratic officers in August 1790 and had been brutally decimated, the rest being sent to the galleys. Now their freedom had been bought, and this act of public expiation was celebrated with special fervour. A model of a galley figured in the procession together with a huge chariot of Liberty, drawn by twenty-four horses. At the head walked girls clad in white and carrying the chains of the liberated prisoners. The statue of Louis XV, where the procession passed, was blindfolded and wore a red cap.[21] Yet the ban on the *bonnet rouge* was still recalled on 19 June 1792 when Hérault exclaimed in the Club, 'They had the impudence to inaugurate, at the very gate of the sanctuary of the Law, the bonnet of liberty, that bonnet so wisely denounced by our sober assembly and its prudent members.'[22] But the initiative had long passed out of the hands of these grave citizens. The next day the mob surged into the Tuileries, and one man held out a pike with the red bonnet to the king who meekly donned it to the applause of the bystanders.[23] The cap had ousted the crown.

The last time the *bonnet rouge* is mentioned in the index to the *Moniteur* is on 23 September 1793 and the occasion provides food for thought. For on that day a decree was passed forbidding galley slaves to

wear it. It is hardly likely that these unfortunates had adopted the cap of liberty as a sign of protest. More probably the woollen red cap had formed part of their prison garb for a long time and was now discovered to be incongruous. If this hypothesis could be verified it might also provide an additional pointer to the popularity of the symbol, for it will be remembered that it figures in the fête of the liberated galley slaves. Maybe it was in this way that the *pileus*, the Phrygian cap and the red bonnet came to fuse. The *pileus*, of course, is originally the sign of the freed slave, but if the red bonnet was also a reminder of the unjustly enslaved the contradictory meanings could enhance the 'energy' of the symbol.

This is conjecture, but the fusion of many meanings in the symbols and images of propaganda can be noticed everywhere in those excited days. Take the Tree of Liberty that was such a feature of Revolution pageantries,[24] as on the first anniversary of the 14 July, the Storming of the Bastille. Clearly, we have the fusion between the cap on the pole and the tradition of erecting Trees of Liberty (figs. 235, 236), which is documented from the American War of Independence. After the repeal of the Stamp Act, a huge flagstaff was erected in New York on the king's birthday (4 June 1766), with the inscription 'To the Most Gracious Majesty George III, Mr Pitt and Liberty', by an organization called the Sons of Liberty. Despite the loyal façade, the symbol was not to the liking of the English soldiers, who cut down the pole four times only to find it put up again.[25] Here, the classical symbolism mingles, of course, with another old tradition, that of the

235 The Tree of Liberty planted on top of the mound erected on the Champ de la Réunion for the *Fête de l'Être Suprême*, 1794. Detail from a contemporary engraving

236 Attributed to Étienne Béricourt, *Planting a Tree of Liberty, c.*1792. Gouache. Musée Carnavalet, Paris

Maypole. It cannot be an accident that in his *Lettre à d'Alembert sur les spectacles* (1758), Rousseau specifically recommended that ancient usage, as a focus of village festivals: 'But what will these festivals be concerned with? What will be shown there? Maybe nothing. Wherever there is liberty, wealth will abound, and so will a feeling of contentment. Erect, in the centre of a square, a pole decorated with flowers, call the people together, and you will have a fête.'[26] David Lloyd Dowd,[27] to whose book on David's pageantries I am much indebted, says that this passage was enthusiastically quoted in the French Revolution. It provided, one may surmise, the new symbolism with an ancestry and thus made it look less arbitrary.

For surely this is one of the conditions for the appeal of a symbol. If it is not natural in the sense of Fabre d'Eglantine, it must be naturalized in our thoughts and traditions, and, as we have seen, it will gain in appeal the less defined its application becomes. If the etymology of symbols, the historical analysis of these emblems has any value beyond that of curiosity, it should be that of laying bare these accretions of layers, that penumbra of vagueness that makes for success. Let us again turn from the emblems of Liberty to those of her twin sister Reason, who had so soon to yield up her place to Wisdom. Here she is in her heyday, carrying the sceptre with the eye (fig. 237). History tells us that this symbol reaches back over thousands of years. It really is what esoteric faith usually wants symbols to be, the offspring of an ancient Egyptian sign of holy significance.

It so happens, however, that we need not call in the collective unconscious or the racial memory of mankind to account for its survival, for we can follow it step by step through what might be called the usual channels of iconology. The hieroglyph for the god Osiris in ancient Egypt was a throne, a sceptre and an eye (fig. 238). Knowledge of the hieroglyphs was largely lost in later antiquity, but interest in these mysterious signs increased the less their meaning was known. A fantastic literature on hieroglyphs grew up in which the signs were explained as portentous images.[28] But bogus as this literature was, some faint echoes of meanings sometimes survived, and a passage in Plutarch's *De Iside et Osiride* is a case in point. It records correctly that the God Osiris was signified by a sceptre and an eye. A few centuries later Macrobius tried to demonstrate that all religions are one and all worship the sun in various guises. He used the symbol to prove the point that since Osiris is symbolized by an eye, he must also be the all-seeing sun. The symbol of the eye for God became familiar to the Renaissance in the fantastic explanation of hieroglyphs in a treatise attributed to Horus Apollo and illustrated in the sixteenth century

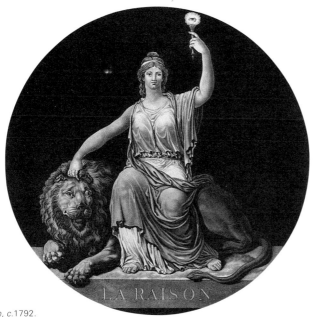

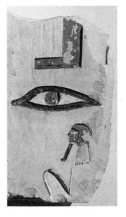

237 *Reason, c.*1792.
Coloured print. Musée
Carnavalet, Paris

238 Hieroglyphic
representing the Egyptian
god Osiris, *c.*670–650 BC.
Brooklyn Museum,
New York, Charles Edwin
Wilbur Fund

(fig. 239). It might not have had the success it had, if the need had not been felt to find a symbol for the Almighty less open to misunderstandings than the image of the old man with a beard familiar in Christian art.[29] In particular it was Protestant and mystical circles who liked to adopt this abstract and mysterious symbol of the radiant eye. One of its earliest occurrences in popular imagery is the print about the gunpowder plot where it is linked with the tetragram of the Divine Name (fig. 255).[30] It appears on a medal celebrating the peace between France and Belgium in 1679 (fig. 232). It also became notoriously embodied in a politico-religious context which harks back to its Egyptian origins, the Great Seal of the United States which we find on every dollar note (fig. 240). Unlike the French, the Founding Fathers do not seem to have embarked on designing

177

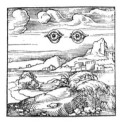

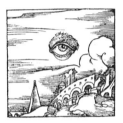

239 Engravings representing the Divine Eye, from Horus Apollo, *Hieroglyphica* (Paris, 1551)

240 The Great Seal of the United States of America, printed on the dollar bill

241 Copper badge engraved by Nicolas-Marie Gatteaux for vendors of prints and pamphlets, inscribed 'La publicité est la sauve-garde du peuple', 1789. Bibliothèque Nationale, Paris, Cabinet des médailles

such a seal with great enthusiasm. It took a Committee of Congress six years, from 1776 till 1782, and some prodding from England.[31] But the device is sufficiently charged with prophecy and promise, the eye of Providence having approved of the undertaking, and the Virgilian hope of the dawn of a new century, an American Century. A medal of the French Revolution, dated seven years later, 1789, rationalizes the all-seeing eye with the circumscription, 'Free debate is the people's safeguard' (fig. 241), but it also graduated into the emblem of the National Convention, overtopped by the *bonnet rouge* and surrounded by a laurel wreath.

The exuberance of meanings that loaded these images with syncretistic beliefs is also characteristic of the florid language of the time. A medal of the period has the remarkable legend, 'Liberty, thy sun is the mountain's eye' – not easy to envisage, perhaps, but all the more fervent.[32] Liberty and Equality are seen adopted by the Genius of France (fig. 242) – though one looks here and elsewhere in vain for the third in the league, Fraternity, who significantly remained a shadowy figure.[33] Equality carries as her emblem the carpenter's level, which takes us to another source and conception of symbolism. We find a woman with the carpenter's level in very orthodox contexts on medals of Louis XIV to commemorate the paving of Paris or the building of churches.[34] But this is not how this tool got its subversive meaning. This comes not from the masons, but from the Freemasons. The history of Masonic symbolism is unfortunately a subject hard to document, since most histories of the Freemasons are written *ex parte*, accepting or half accepting the mystic history of the order. But we need not indulge in guesswork to show that the level in this sense is Masonic, for by the second half of the eighteenth century this was common knowledge. The implement is illustrated in the title page of an

anti-masonic tract of 1758 (fig. 244). A pamphlet of 1747 even quotes the initiation ritual, where the aspirant is asked 'whether he has the vocation for Liberty, for Equality and for Obedience'.[35] In a print celebrating the victory of Equality over Robespierre and his Triumvirate – the gang of three – the carpenter's level is fused with the Scales of Justice (fig. 243). Nor is this the last word in what psychoanalysts would call the 'condensation' of symbols. In an emblem of the Republic, the triangular sign of the level radiates as did the eye of the Trinity (fig. 245), and they all become fused in a new symbol of the Trinity that harks back to the earliest speculations, in a medal of 1794, where Liberty, Equality and Reason form that divine Unity that expresses itself in the curious cult of the Supreme Being (fig. 246).

One thing should have become clear: what these men of the Revolution were longing for was the sanction of mystery. For the Fête of Unity and Indivisibility of 10 August 1793, David erected a Fountain of Regeneration on the site of the Bastille (fig. 247), from which all eighty-six deputies had to drink out of one cup; it was to represent Nature, but as an Egyptian divinity. The new order was somehow a return to the wisdom of the ancients. Here, as always, symbolism relies on the appeal of the remote, the unintelligible even. When, in 1792, a national emblem was needed to be printed on the new paper money (the *assignats*), the device was to be an eagle with outspread wings, holding a thunderbolt, supporting a fasces surmounted by the cap of liberty and surrounded by a serpent in a circle,

243 *Equality Triumphant* or *The Triumvirate Punished*, 1794. Aquatint. Bibliothèque Nationale, Paris, De Vink Collection, no. 6545

244 Frontispiece of an anti-Masonic pamphlet (Amsterdam, 1758). Bibliothèque nationale, Paris

245 *The French Republic*, 1794. Design by Moitte, engraved by Pauquet. Bibliothèque Nationale, Paris, Hennin Collection, no. 12028

246 Medal representing Equality, Liberty and Reason, 1794. Bibliothèque Nationale, Paris, Cabinet des médailles

247 *Festival among the Ruins of the Bastille before the Fountain of Regeneration, c.1793.* Watercolour. Musée Carnavalet, Paris

symbol of eternity, radiant with light (fig. 248). What is it, then, that is radiant with light, that natural and seemingly obvious symbol of the good and divine? It is the darkest symbol of mystery, the serpent biting its own tail, another of the pseudo-hieroglyphs handed down from that mystical literature of late antiquity mentioned before and much discussed and interpreted by the philosophers of the Renaissance. The perplexing image of the serpent which seems to devour itself is seen as an image of time returning to its origins, and also of the Universe. It stands for all that is unfathomable, irrational and profound. No wonder the cult of Reason had to yield to the cult of the Supreme Being, the worship of mystery.

True, we must not overrate the symptomatic importance of these signs and portents. The study of imagery and emblems, in fact, even the study of propaganda, tends to give a one-sided picture of any mass movement precisely because it leaves the rational arguments and realities of the situation out of account. Despite its totalitarian horrors, the French Revolution was not an irrational outburst. It was an age of writing, not of image-making. Arguments and rhetoric surely counted for more than these emblems, and a presentation such as this might easily result in a false impression. The British Library alone possesses some 50,000 pamphlets and journals printed during the Revolution and only very few of them are illustrated. In fact, Salaville, as will be remembered, had warned his compatriots that they should not pander to the irrational forces which feed

248 Sketch by Nicolas-Marie Gatteaux for the *assignats*, *c.*1790–5. Bibliothèque Nationale, Paris, Cabinet des estampes

on images rather than arguments.[36] The true cult of Reason is study, he sternly declared, and he can hardly have gained many adherents for this unpalatable truth. But what even the advocates of natural religion and natural symbolism did not foresee and could not, perhaps, foresee, wedded as they were to the Lockean philosophy of consciousness and associations, was the waning appeal of Reason itself, the increasing ambivalences mobilized by the bright, fair, and exalted divinities which stood for Light, Beauty and Stern Duty. They took it too easily for granted that our semantic space is fixed and that the good and the light will always triumph and defeat the dark and the monstrous. Alas, this is a most dubious proposition. I am not referring to the enemies of the Revolution who shared the rationalist frame of reference; notably the English propagandists such as Gillray who used the same semantic space (to revert to this term) but rearranged the symbols within it, as the Enlightenment had done before. One of his cartoons, of April 1795,[37] entitled *Light Expelling Darkness*, shows William Pitt guiding the solar chariot of the English Constitution 'rising superior to the clouds of opposition', the powers of darkness embodied by the monsters of Whiggery and French subversion. There is nothing in such a reversal that calls for much comment, for it all happens on the level of conscious manipulation.

What is significant is the change of the frame of reference itself that we connect with Romanticism. This account began with the festival in Notre Dame intended to cleanse its ancient vault of the spectre of fanaticism. For the Romantic movement the rebuilding of Cologne Cathedral was a symbolic act of expiation. Soon Rationalism was dismissed as shallow and

classical beauty as academic and empty. The Dark Ages became all the rage, and the new enthusiasm for the Age of Chivalry when loyalties were unbroken proved an effective counter to the Age of Reason. The celebration of Metternich's Holy Alliance by the German Romantic Heinrich Olivier, painted in 1815 (fig. 249), depicts the three monarchs as crusaders in medieval cuirasses, making solemn vows in a Gothic church, and is meant quite seriously. Yet it was an artist of the period who knew more about the nightside of life than any fashionable Romantic, who planned to preface his series of uncanny satires with a title page which I have taken as the title of this paper. 'El sueño de la razon produce monstruos' (fig. 250) can mean 'the sleep of reason produces monsters', but also can refer to the 'dream' of reason – and whatever Goya may have meant, both interpretations convey an important truth.

249 Heinrich Olivier, *The Holy Alliance*, 1815. Anhaltische Gemälde-galerie, Dessau

250 Francisco Goya, *The Sleep of Reason Produces Monsters*, 1799. Engraving from *Los Caprichos*

183

Chapter 7 Magic, Myth and Metaphor

Reflections on Pictorial Satire

Paper delivered at the 23rd Congrès International d'Histoire de l'Art, Strasbourg, September 1989, and published in the proceedings, *L'Art et les révolutions, conférences plénières* (Strasbourg, 1990), pp. 23-66; reprinted in *The Essential Gombrich* (London: Phaidon, 1996), pp. 331-53.

It should not be too difficult to explain the three notions or concepts mentioned in my title, the notions of magic, myth and metaphor in the context of pictorial satire. I need only remind you of the most frequent motif in this type of political imagery, the figure of the Devil. If a computer were ever employed to record and analyse all satirical prints of the last five hundred years in a database, the Devil is likely to come out on top.

That the Devil is connected with magic requires no elaborate proof: what is called 'black magic' rested firmly on the belief that the powers of darkness could be enlisted to do the bidding of the witch or wizard who had entered into a pact with the Devil. It almost follows that this same Devil is also part of myth, if by this we mean the system of shared beliefs that hold a society together. Few of us may still entertain that belief, but the Devil still lives on in our speech, in the metaphors we use in expressions of disapproval, calling a cruel ruler a veritable fiend, or even in expressions of endearment, as when we describe a lively child as a little devil.

My first point must be, however, that the very variety in what we may call the ontological status of the Devil presents an enduring problem to the student of pictorial satires. How can we really tell what any of them mean when they represent the Devil? I think we know the answer in the case of the first systematically organized campaign of pictorial satire, that of Martin Luther, whose violent attacks on the Church of Rome were supported by a famous series of woodcuts, in which the devil or devils are frequently shown in such images as hurling the Pope to Hell (fig. 251) or seizing the the souls of the Pope and cardinals, shown hanging on the gallows (fig. 252).[1] Visitors to the Wartburg are still shown the stain on the

251 Lucas Cranach, 'The
Pope Cast into Hell', from
*Passionale Christi et
Antichristi*, 1521.
Woodcut

251 Lucas Cranach, 'The Pope Cast into Hell', from *Passionale Christi et Antichristi*, 1521. Woodcut

wall of Luther's cell which is said to have been caused by the inkpot he hurled at the Devil, who came to tempt him. Whether or not there is anything in that anecdote, we have Luther's pamphlets and hymns to prove that for him the Devil was no less a reality than was almighty God. The same is surely true of his opponents who retaliated by linking the name of Luther with 'Lucifer', and published a print showing the reformer hand in hand (or rather hand in claw) with the Devil (fig. 253).

Nor can we forget that the Church of Rome claimed the power of anathema, the curse that is really a prayer to God to consign a person to Hell. Heretics condemned to the stake were frequently made to wear a mitre showing devils, as if to anticipate their eternal torment.[2] Presumably a crude woodcut such as that showing the king of France, Henri III, being taken to Hell (fig. 254) was intended to be taken literally,[3] since the world was seen as the stage upon which the opposing forces of good and evil were intervening in the affairs of man.

The famous print of 1621 celebrating the 'double deliverance' of England from the Gunpowder Plot and the Spanish menace (fig. 255) may stand for many.[4] Note the Devil who is sitting in his tent plotting with the King of Spain and the Pope, while the Divine Eye, looking down on Guy Fawkes, is labelled 'video rideo' ('I see, I laugh') .

In seventeenth-century prints, the Devil or devils are regularly shown to govern the real or pretended machinations of the Jesuits in their devil's kitchen (fig. 256). It is also the disgraced Jesuits who, in a French print of the eighteenth century, are seen to be hurled into Hell (fig. 257).

252 Workshop of Lucas Cranach, 'The Pope and Cardinal Hanged', from *Abbildung des Papstums*, 1545. Woodcut

253 Titlepage to Petrus Sylvius, *Luther und Lucifer*, 1535

254 *King Henri III led to Hell*, 1588. Woodcut. Bibliothèque Nationale, Paris, Cabinet des estampes

255 *The Double Deliverance*, 1621. British Museum, London

256 *Father Peters, a Great Labourer in Works of Darkness*, 1689. British Museum, London

257 *Le Crime puny (The Crime Punished)*, c.1786. Bibliothèque Nationale, Paris, Cabinet des estampes

Needless to say, the prints of the French Revolution do not let us down. Fig. 258 shows a print of 1790 showing the member of the Third Estate who plays the fiddle to drive the other two into Hell, 'Les Aristocrates aux Diables'. In another print of the same year, two devils are shown defecating on two members of the National Assembly who championed the traditional position of the Church (fig. 259). Luther's old theme of the Pope in Hell was taken up in another print (fig. 260), while an elaborate composition by Villeneuve of January 1793 illustrates the arrival of the beheaded King in Hell, surrounded by previous victims of Divine Justice

258 *Les Aristocrates aux Diables (Aristocrats to the Devil)*, 1790. Bibliothèque Nationale, Paris, Cabinet des estampes

259 *Les Deux Diables en fureur (Two Devils in a Rage)*, 1790. Bibliothèque Nationale, Paris, Cabinet des estampes

260 *Arrivée du Pape aux Enfers (The Arrival of the Pope in Hell)*, 1791. Bibliothèque Nationale, Paris, Cabinet des estampes

(fig. 261). Surprisingly, even the Neoclassicist master Jacques-Louis David accepted a commission for a propaganda print in which the British government is shown as the Devil (fig. 262). More homely, if that is the right word, is the *Devil's Dinner* of 1793 where the Devil prepares to roast and eat Marat (fig. 263), while an anonymous print in the grand manner, *In Memory of Marat, Friend of the People*, associates his murderess, Charlotte Corday, with a winged devil (fig. 264).

But how many of those who produced or saw these prints believed in the Devil? That slow process of emancipation that D.P. Walker has traced in his memorable book on *The Decline of Hell*[5] had certainly had its effect on many free spirits of the time who may still have used the figure as a convenient code, a pictograph that signified evil. That all-important moment of transition when myth fades into metaphor must of necessity elude the student of pictorial satire.

But is it not exactly the same with our speech? Can we ever draw a line between cursing and swearing? Would we gain much if a recording angel was equipped with a computer to list every moment when we say 'Go to Hell', or 'Damn it', or 'What the Hell are you doing here?' The more we are in the grip of emotions, the more easily do we feel tempted to regress to the

261 *Villeneuve, Réception de Louis Capet aux Enfers (Louis Capet being Received in Hell)*, 1793. Bibliothèque Nationale, Paris, Cabinet des estampes

262 Jacques-Louis David, *Gouvernement Anglois (English Government)*, 1793–4. Bibliothèque Nationale, Paris, Cabinet des estampes

263 *Souper du Diable (Devil's Dinner)*, c.1793. Bibliothèque Nationale, Paris, Cabinet des estampes

264 *À la mémoire de Marat, ami du peuple (In Memory of Marat, Friend of the People)*, 1793. Bibliothèque Nationale, Paris, Cabinet des estampes

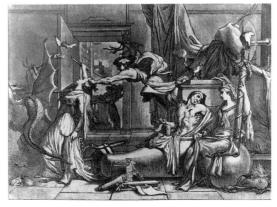

265 Neb (Ronald Niebur), *Goebbels and Hitler.* Pocket cartoon from the Daily Mail, 26 August 1941

remnants of irrational belief which form part of our cultural heritage. Few of us, if asked at pistol point, would avow that we really meant what we said when we thus invoke the Devil, but somewhere the figure of speech still retains its power over our half-conscious mind.

This willing suspension of disbelief is cleverly exploited in a modest little pocket cartoon of the last war that shows Goebbels watching Hitler going to bed and discovering that he really has the hooves and tail of the Devil. 'Himmel', he is made to exclaim, 'I thought Churchill meant it as a figure of speech' (fig. 265). I wonder if we would be tickled if we did not sense for a split second that after all there may be some kind of reality behind the metaphor.

My late friend Ernst Kris, who introduced me to this whole area of studies more than half a century ago, would have argued that it is on this oscillation between reality and dream, between myth and metaphor, that pictorial satire relies for its psychological effect. His starting point had been Freud's theory of the Joke or Wit which he condensed into the formula that this genre made use of 'regression in the service of ego', in other words, a conscious exploitation of an unconscious mechanism.[6] And just as Freud had looked at verbal wit mainly as an outlet for human aggression, so Kris saw pictorial satire as an instrument of hostile impulses.

It was in this context that he was led to include magic, the first of my three notions, into the equation. He proposed to trace the whole genre of pictorial satire back to its distant roots in the murky practices of black magic. Images certainly play a part in these widespread rituals when a wax doll serves as a substitute for the intended victim and is pierced amidst some mumbo jumbo. Kris was impressed by the similarity between this hostile act and the custom of hanging or burning in effigy in which the image of the enemy is subjected to the death penalty. Thus he was specially interested in the late medieval institution of defamatory images such as this crude drawing of 1438 showing the Landgrave of Hesse and his coat of arms suspended upside down from a gibbet (fig. 266). The mere threat of publicizing such an image could be used as a means of pressure to ensure the repayment of a loan or the righting of a wrong. Mark that this pictorial insult is not a caricature; there is no attempt to distort the nobleman's physiognomy. It was in fact in the contrast between the aggressive use of images and the artistic genre of 'caricatura', which emerged in Italy around 1600, that Kris looked for the key to the comparatively late arrival of portrait caricature. As long as the aggressive intention, he argued, was linked with a threat of magic, it would have been inconceivable to make

266 Defamatory image of
the Landgrave of Hesse,
1438

267 Gianlorenzo Bernini,
*Caricature of Scipione
Borghese*, c.1632. Vatican
Library

play with the features of a dignitary as Bernini did in his caricature of the
Pope (fig. 267). While mankind remained in the thrall of magic fears it was
literally no joke to transform a person's likeness. It was a neat hypothesis,
and I certainly learned a lot in pursuing it jointly with a mentor of such
profound insights.[7] However, it is one of the advantages of a long life, that
one is granted time for second thoughts.

The book we finished in 1937 never came out, because of the political
upheavals that preceded the last war, and when Kris and I met some ten
years later, we had both gained some distance from our pet ideas. What
began to disturb us was that our story was a trifle too tidy.[8] Like Freud
himself, and also like Aby Warburg, Kris had been under the spell of an
evolutionist interpretation of human history which was conceived as
moving from primitive irrationality to the triumph of reason. Just as
Warburg arranged the sections of his library to illustrate the progress from
magic to science, so the history of pictorial satire in our book was to
illustrate a corresponding secular development.

Recent experience has disabused all of us of such optimism. Not that
we need deny the reality of progress in the history of civilizations, but one
can hold on to this belief and yet accept the basic fact that what is called
human nature never changes.[9]

Luck will have it that I do not have to lose myself in abstract
speculations to justify this conviction. It so happens that in the month of
July 1989, while I was preparing this text, the London *Times* printed two
items which illustrate my point to perfection. One was a court case in

which it was reported that a woman had paid a practitioner of the occult the paltry sum of £25 to kill her estranged husband by means of the usual paraphernalia of a wax doll and earth from a cemetery;[10] a story as recent as you could wish. The other, ten days later, was a letter describing an incident in which the effigy of a British Minister of the Crown was burnt in protest against a planning regulation.[11] *Plus ça change* ... Even so, the values of our civilization asserted themselves in both cases. In the past the magician would certainly have been condemned to be burnt at the stake; in the case in question, the judge merely told him that he was a silly man. Equally telling is the fact that the Minister of the Crown received a public apology for the outrage, which in the eyes of his very opponents could only do harm to their case. What the fabric of civilization had achieved was to impose its conventional code of manners that aims at taming such manifestations of human savagery.

One could not easily imagine a social code that condoned the intentions of black magic aiming at clandestine murder. It is entirely different with punishments in effigy. We have seen that such rituals were in fact part of the legal code in many medieval communities. Samuel Edgerton has devoted a monograph to part of this tradition in his book on *Painting and Punishment in Tuscany*,[12] in which he shows how frequently leading painters such as Andrea del Sarto were commissioned to represent on the façade of town halls criminals or public enemies as hanging ignominiously from the gallows (fig. 268). I must agree with him that this has nothing to do with what he calls voodoo. The worthy city magistrates would have been horrified if they had been told that they practised *maleficium*. Their aim was not to enlist the services of the Devil to contravene the laws of man and of nature by inflicting physical damage on the enemy. They wanted rather to perpetuate or, if necessary, to replace the public disgrace of a shameful execution.

Many years ago I published an essay entitled 'Meditations on a Hobby Horse', in which I argued that the toy served the child as a substitute for the real thing.[13] Those who cheer at mock executions are not children, but they share with children that capacity of entertaining fictions that is really part of unchanging human nature. When I wrote that essay I did not know, or did not remember, that the German philosopher Vaihinger had written a heavy tome on what he called *Die Philosophie des Als-Ob* (*The Philosophy of 'As If'*),[14] pointing out how much of human culture comes under the heading of *Als-Ob*, of fiction; not only art, and play of course, and a good deal of science, but also the conventions and traditions of social life. Whether we begin a letter with 'Dear Sir' or end it with 'Yours

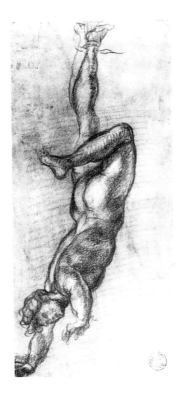

268 Andrea del Sarto,
Sketch of a Hanged Man,
1530. Uffizi, Florence

sincerely', we do not expect to be asked how dear the addressee happens to be to us, or how sincerely we mean it. Culture as we know it could hardly exist without our joining in these perpetual games of make-believe which oil the wheels of social interaction. In thus referring to the basic fictional character of these insulting images I do not want to minimize their social importance. Even though the purpose was not to injure the victim physically, it was still intended to injure his or her *persona*, its position in that network of cultural conventions of which I have spoken, that sum of all the shared values and beliefs that secure a person's standing; everything, in fact, that distinguishes him or her from an animal and is experienced as honour.

The annals of human cruelty record only too many methods by which a person could be dishonoured, from the victor setting his foot on the neck of the vanquished, to the stock and the pillory and similar exposures to public derision and disgrace. I need not tell you that the code of honour maintained by society is no laughing matter; an insult would leave a stain that could only be washed off with blood, as the saying went. The metaphor of the stain is as telling as any. If honour was equated with

193

purity, dishonour meant besmirching, defilement, that horror of our early childhood dating back to our toilet training.

We may here return to Luther, whose polemics and prints equally indulged in scatological imagery, as in the print of the peasants relieving themselves into the papal tiara (fig. 269). I claimed that human nature remains the same, and sure enough you find a close parallel in that anti-clerical print of the French Revolution where the papal *breve* is used as toilet paper (fig. 270). If proof were needed that revolutions can be pretty revolting, you would have it here. Revolting, yes – but effective? In asking this simple question we must surely distinguish between their effect on the followers and on the opposing camp. No doubt the demonstration that you can desecrate with impunity what the others hold sacred may have strengthened waverers. Like the prophets and missionaries of old, Luther and the anti-clerical revolutionaries were eager to demonstrate that the gods their opponents worshipped were unable to protect their honour. You could insult the Vicar of Christ in the crudest manner and the heavens did not fall. One is tempted to describe the desired effect, if not as magic, at least as anti-magic, undoing the opponents' pretensions to supernatural power. But was this demonstration likely to convince anyone not yet converted to such daring views? Would it not rather arouse contempt and fury and rally them to defend the honour of their faith?

Once more, I find confirmation of the views implied in this sceptical question in events with which press reports have made us only too familiar. I am thinking first of all of the case in front of the Supreme Court of the United States dealing precisely with the defilement of a national symbol, the case of the youngster who had spat on the American flag

269 Workshop of Lucas Cranach, 'The Papal Arms Defiled', from *Abbildung des Papstums*, 1545. Woodcut

270 *Bref du Pape (The Papal Breve)*, 1791. Bibliothèque Nationale, Paris, Cabinet des estampes

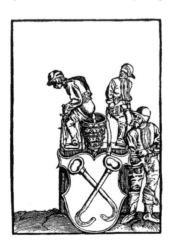

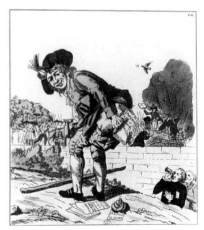

amidst derisory chants before burning it in public. The court allowed him to go free since the States, unlike other communities, has no laws forbidding such outrages. But the very decision of the court caused such a public reaction that it certainly had the opposite effect of that intended by the silly insult. Far from bringing the flag into disrepute, it led to a widespread demand for its sanctification. Indeed, I can document this reaction once more from the pages of *The Times*, an article of 31 July 1989 containing the dire prediction 'that future historians will date the decline and fall of the United States' from that decision.

Not surprisingly, perhaps, this opinion was voiced in connection with that other topical example of a real or alleged insult, Salman Rushdie's alleged blasphemy against the prophet of Islam. If any single act could have served to rally and unite the Muslim world, it was the publication of Salman Rushdie's novel *The Satanic Verses*, which few of the protesters are likely even to have read. No matter – they are forced by public pressure to act as if they have read it and have taken deep offence.

It is observations of this kind which have prompted second thoughts in me about the true function of pictorial satire. There is a heavy German volume on this subject with the title *Bild als Waffe* (*The Image as a Weapon*),[15] which also contains an old paper of mine called, in the same vein, 'The Cartoonist's Armoury'.[16] But are these images such formidable weapons? No doubt they were often so intended, but have they not frequently backfired? Is their true function not rather to preach to the converted?

We frequently use this phrase when we wish to dismiss an effort of this kind as pointless, but if preaching to the converted were quite without a function there would be no sermons, day in, day out, in all the churches and shrines of the world. The sermon, like other ritual acts, exists of course to renew and reinforce the ties of common faith and common values that hold the community together.

What is described nowadays as a sense of identity is always buttressed by an assumption of superiority over those who do not belong. It is this function satire has always served, whether we think of images, of songs, or merely of anecdotes and jokes at the expense of the neighbours. The guild of the cobblers used to mock that of the tailors, the city-dwellers the clod-hopping peasants, the sailors the landlubbers, and no doubt, if you listen to common-room conversation, you will hear art historians who feel superior to scientists or vice versa. Every nation invents derisory names for their neighbours; the British used to call the French 'frogs' and the Germans 'Krauts', because their diet was considered contemptible.

It is this rather fatuous sense of superiority to which pictorial satire has contributed by reinforcing the stereotype any group has of itself and of others. Think of Hogarth's *Gate of Calais*, which mocks the gluttonous French monk and the starveling frontier guard greedily eyeing the roast beef, that symbol of British well-being (fig. 271); or of Gillray's cartoon of 1792 tellingly contrasting 'French Liberty and British Slavery' (fig. 272). No doubt the cohesion of the group tends to precede rather than to follow the sharing of ideologies.

Returning from this side to the role of myth in pictorial satire, we may see more easily how a mythical figure such as the Devil retains its position across the transformations we have observed. There are many ways in which the shared values and beliefs of a myth can turn into the fiction of 'as if' without losing their hold on the group. The patriotic conviction that

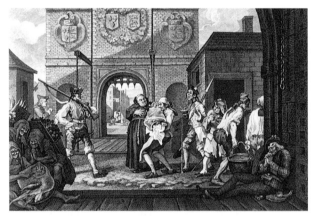

271 William Hogarth, *The Gate of Calais* (detail), 1748–9. British Museum, London

272 James Gillray, *French Liberty, British Slavery*, 1792. British Museum, London

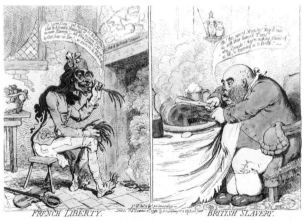

FRENCH LIBERTY. BRITISH SLAVERY.

273 *Papstesel* (the Popish Ass), 1523. Woodcut

God is on our side in any conflict is rarely challenged even by those who cannot share it, and here again irrational beliefs may be seen to shade into mere metaphor. Nearly all early cultures, for instance, shared the belief in portents and apparitions as signals and signs from superior powers. Comets or monstrous births have been universally interpreted as signs from above presaging cataclysmic events, and political imagery has never been slow in taking up these prognostics. Their role in the German Reformation has been described in a memorable paper by Aby Warburg.[17] Their meaning and message is summed up most succinctly in the caption of the notorious woodcut of the *Papstesel* or Popish Ass, the alleged miscarriage of a donkey said to have been washed up by the Tiber at the end of the fifteenth century (fig. 273):

> Was Gott selbs von dem Bapstum helt
> Zeigt dis schrecklich Bild hie gestellt.

'What God himself thinks of Popery is shown in the awesome image here represented.' We may compare it with Villeneuve's powerful image from the French Revolution, alluding to the biblical portent of the 'Writing on the Wall' at Belshazzar's feast (fig. 274). But here again the question arises how far the artist or his public believed in the literal truth of that story, or whether he merely tapped it, as it were, to enhance the prediction of doom.[18] Luck will have it that one of the many political satires against

274 Villeneuve, *Louis le traître, lis ta sentence (Louis the Traitor, Read your Sentence)*, 1793. Bibliothèque Nationale, Paris, Cabinet des estampes

Louis XIV explicitly answers this question. I refer to a German print of 1706 celebrating Marlborough's victory over the Sun King (*Roi Soleil*) as *Die grosse Sonnenfinsternis* (*The Great Eclipse of the Sun*) of 12 May (fig. 275). There actually had been an eclipse on the day when the Battle of Ramillies was fought which attracted much comment, but the letterpress of our print is careful to explain to the reader that 'it is well known in our enlightened century that events in Heaven have no influence on what happens on earth'. The eclipse is to be interpreted as a metaphor for the defeat of the Sun King. The author seems to have been eager to distance himself from the common run of vulgar prognostics and to appeal to the sense of superiority of his more sophisticated public while deflating the talk about the Sun King as mere make-believe. Naturally, in taking this stance, the author of this satirical image must forgo the original advantage of the use of myth, which could explain to the reader the true significance of events in the news. Unlike Luther's Popish Ass or the print celebrating the failure of the Gunpowder Plot, the metaphorical comment can now claim to be no more than a witty marginal note to the news of the day. Its merits must lie in its aptness. Thus, by disclaiming all magic or mythical elements, our print reveals itself as an early example of what we now call a political cartoon. It is this genre of the cartoon, of course, that derives its effect from the use of the metaphor to comment on the topical reports of the day. It relies on a public that enjoys the wit of the comparison which may not explain but sum up a situation.

275 *Die grosse Sonnenfinsternis (The Great Eclipse of the Sun)*, 1706. British Museum, London

In the same years in which our mock prognostic appeared, a clever publisher of prints in Holland seized on this potentiality of pictorial comparison to make easy money. He evidently bought up a number of old copper plates with biblical illustrations and reissued them with new superimposed texts alluding to the events of the day.[19] Thus one of Lucas van Leyden's prints showing David returning with the head of Goliath is reinterpreted as *The Goliath of War Beheaded (by Peace)* (fig. 276). I do not propose to pursue the further allusions in the text nor show you some of his more far-fetched comparisons which can never have been very funny or effective. Even so, I find the example as illuminating as the one previously discussed, because it exemplifies in the neatest possible form what the cartoonist is trying to do in his play with metaphors. He is applying a story or myth known to the public to an event that is news and thus links the familiar with the unfamiliar. He treats the incidents of the day as if they were all part of the old story, as if there was never really anything new under the sun. If one of the functions of myth may be said to offer an explanation for the events in nature, the skilfully applied metaphor will present at least a fictional explanation of world events. Hence nothing is more characteristic of pictorial satire than its conservatism, the tendency to draw on the same old stock of motifs and stereotypes. These motifs can take the place of the communal myth serving to reassure in the guise of an explanation.

276 Allard after Lucas van Leyden, *De onthoofde Oorlogs Goliat (The Goliath of War Beheaded)*, 1713. Rijksmuseum, Amsterdam, Prentenkabinett

I should like to document the tenacity of these traditions by going back as far as possible in the history of the genre, in fact to the end of the twelfth century, and to show to what extent the motifs and metaphors that served a medieval author retained their usefulness for six hundred years or more. My demonstration piece will be an illuminated manuscript from southern Italy preserved in the library at Berne, which contains a poem by Pietro da Eboli celebrating the triumph of the Hohenstaufen emperor, Henri VI, over Tancred in the struggle for power over the kingdom of Sicily in the years between 1190 and 1194.[20] Not that the satirical pictures of Tancred which you will see can have been meant as propaganda in the modern sense. The manuscript was not intended for publicity but as a gift to the Emperor, who might just have chuckled over the derision of his erstwhile opponent.

This opponent had actually been elected king by a vocal section of the population as you see it represented on one of the first folios of the codex (fig. 277). Tancred appears to have been small of stature and of questionable noble birth, and the author goes all out in his book to lampoon him for these disadvantages.

The most telling of the pages setting the scene anticipates the story to follow: the man falling from his horse is labelled 'The Fortune of Tancred' (fig. 278). Naturally this does not represent a real incident but refers to his sin of pride, one of the seven mortal sins in the moral system of the period, which is also represented by a rider falling from his mount on the jambs of Notre Dame de Paris and Amiens dating from the same decades (fig. 279). But while the images on the cathedral porches offer a generalized picture sermon, our manuscript singles out Tancred as an exemplar of pride, much as Dante, more than a century later, was to select his memorable portraits of individual sinners and saints from within the cosmic framework of the Divine Comedy. But the metaphor of the rider falling from his mount is too tempting a comparison ever to be abandoned. Thus there is a print of 1779 showing George III being thrown by the horse America (fig. 280); the satire dates from the period when portrait caricature had been absorbed by political prints.

The drawing next to the horse should certainly be of interest to the historian of portrait caricature because it will compel him to qualify the assertion of the late emergence of that genre. Here Tancred is vilified as having the 'body of a boy and the face of an old man' ('Facie senex, statura puelli'). We may never know how close this description came to the real appearance of Tancred, but we can see that the author, skilled as he was, was defeated in portraying these contradictory features: he drew both a

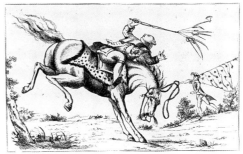

277 'The Contested Election of Tancred', from Pietro da Eboli, *De rebus siculis*, *c*.1190–4. Stadtbibliothek, Berne, MS.120, fol. 99

278 'Fortuna Tancredi' ('The Fortune of Tancred'), from Pietro da Eboli, *De rebus siculis*, *c*.1190–4. Stadtbibliothek, Berne, MS.120, fol. 103

279 *The Sin of Pride*, *c*.1200. Drawing of carving from Notre-Dame, Paris

280 *The Horse America Throwing his Master*, 1779. British Museum, London

boy and the head of an old man. It took some time in the history of the genre for this formula to become commonplace. Let me take David Low's teasing caricature of Beaverbrook, whose body he deliberately reduced in scale to concentrate on the grinning head (fig. 281).

Maybe it was because of his inability to do justice to his theme of Tancred's ugliness by purely pictorial means that the author indulged himself on the rest of the page (fig. 278) in a lengthy account of the reasons for that physical deformity. A medical expert from Salerno had explained

to the author that this deformity was the result of the child's mixed blood, which produced such abominations in men and animals. He shows us next the scene of the birth where the midwife holds up the newborn, and another woman hides her face in horror.

You might think and even hope that this coarse kind of vilification did not survive into more enlightened ages – but this hope would be disappointed. There is a satirical print against the poet Alexander Pope, whose name is indicated by the punning symbol of the Papal tiara for 'Pope', and whose monkey's body brutally alludes to the poet's physical deformity (fig. 282). The caption echoes the earlier slander in even more brutal terms:

> Nature herself shrank back when thou wert born
> And cry's the work's not mine –
> The midwife stood aghast, and when she saw
> Thy mountain back and thy distorted legs
> The face half-minted with the stamp of man
> And half o'ercome with Beast stood doubting long …

The temptation of comparing a small man with a monkey was too obvious to have been resisted by our medieval illuminator, who describes and depicts Tancred on another page as a monkey turned king ('Simia factus rex', fig. 283). You will not be surprised that this kind of mockery survived into the French Revolution, though I find it neat that on this print it happens to be the King of Naples who is represented as a monkey under the table (fig. 284).

It used to be the fashion in art history to deny or at least to minimize the element of skill needed in shaping an image; everybody could do what

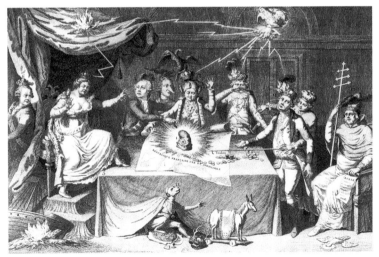

he wanted to do. I have never believed this. In any case, our twelfth-century artist certainly made a valiant effort to render his victim with the appropriate facial expression. He represented Tancred sitting on his throne in the solitude of his chamber meditating on his helplessness in the face of the approaching armies, 'Thinking of the Future, Tancred Weeps' ('Futura cogitans, lacrimatur', or rather, 'lacrimat') (fig. 285). It is a motif which has equally appealed to later satirists. Here is a German cartoon against Napoleon showing him as a double-headed Janus, smiling at the past and trembling at the future (fig. 286); and here is the master of the genre,

285 'Tancredus futura cogitans lacrimat[ur]' ('Thinking of the Future, Tancred Weeps'), from Pietro da Eboli, *De rebus siculis*, 1190–4. Stadtbibliothek, Berne, MS.120, fol. 121

286 Johann M. Voltz, *Blick in die Vergangenheit und Zukunft beim Anfang des Jahres 1814 (A Glimpse into the Past and the Future at the Beginning of the Year 1814)*, 1814

Daumier, going one better, using the caricatured head of Louis-Philippe, the *poire* of Philippon's campaign, as a *signum triceps*, the triad of the past, present and future (fig. 287). Nor can I resist showing that other print purporting to demonstrate how the King's face had changed from confident bonhomie to disgruntled pessimism (fig. 288), reminding us what a real master of satire can do with an ancient motif.

Turning to the concluding pages of our medieval manuscript, we find the participants of the struggle inserted into the cosmic conflict between good and evil. The legitimate Emperor, Henri VI, is attended by the seven virtues, and below you see the goddess Fortuna (fig. 289). We read that she wanted to join the Emperor's attendants, but was repulsed, and rightly so – for Fortune is fickle, she continuously turns her wheel, and he who is exalted to glory, as the caption says, is diminished and carried downwards, as happened to Tancred whom we see prostrate below.

This particular visualization of the ups and downs of fate has appealed to the imagination of man ever since it was first conceived by Boethius. The Wheel of Fortune became part of the stock-in-trade of the political

287 Honoré Daumier, *Le Passé, le présent, l'avenir (The Past, the Present, the Future)*, from *La Caricature*, 9 January 1834

288 Honoré Daumier, *Louis-Philippe, 1830 and 1833*, from *La Caricature*, 15 August 1833

289 'Henri VI and Fortuna', from Pietro da Eboli, *De rebus siculis*, c.1190–4. Stadtbibliothek, Berne, MS.120, fol. 146

satirist. A print of 1621 applies the metaphor to the dramatic story of Frederick of the Palatinate, the so-called Winter King who lost his short-lived kingdom of Bohemia at the Battle of White Mountain (fig. 290). Few episodes of the past provoked a larger spate of satirical prints than this discomfiture of a pretender.[21] It is fairly obvious once more, therefore, that these prints were not intended as weapons. He had failed and serves him right. His case, like that of Tancred, would confirm the homely adage that pride comes before a fall. We know for whom Pietro da Eboli had produced his poem, and why. He did so to flatter the Emperor and benefit

from his bounty. But what can have moved the publishers of these prints to go to such trouble? The answer may be simple – they also wanted to make money, and they knew that their public would enjoy the reassuring news that those who ride too high will come to grief. It may not be to the credit of mankind that satire so often hits at those who are down, but the German proverb says: 'Wer den Schaden hat, hat auch den Spott' – roughly translated as Injury attracts Insult. It is often claimed that English has no word for the ugly emotion of Schadenfreude, but it has the verb 'gloating', and gloating is precisely what satirists have done since the days of Pietro da Eboli. How else can we describe the concluding page of the manuscript with the glorification of the Emperor, who sits on the throne of Solomon, the seat of Wisdom, flanked and guarded by his faithful Paladins (fig. 291). Wisdom once more rejects Fortuna who is seen to weep while Tancred has fallen under her wheel. Wisdom reminds her of another Sicilian usurper, one Andronicus, who had recently come to grief, and she recalls the fate of Icarus and that of the giants who were hurled down by Zeus. The crudely drawn falling limbs under the image of the sun are another reminder of the sticky end to which ambition must ultimately lead.

Once more the same association occurred spontaneously to subsequent generations of satirists for whom Icarus provided a convenient metaphor. Figure 292 shows Gillray in 1807 representing the fall from office of Lord Temple, with George III as the sun. But the jokes and allusions of this cruel print are much more complex in the way they condense any number of metaphors into one image. Temple had belonged to a cabinet which was said to have been broadly based and whose

206

291 'Henri VI triumphing over his Enemies', from Pietro da Eboli, *De rebus siculis*, *c*.1190–4. Stadtbibliothek, Berne, MS.120, fol. 147

292 James Gillray, *The Fall of Icarus*, 20 April 1807. British Museum, London

members were therefore lampooned by Gillray as broad-bottoms. When leaving office he was rumoured to have taken with him a good deal of official stationery and sealing wax, and this provided the idea of his having needed wax to make wings as Daedalus and Icarus had done. The stake on which he is about to impale himself, by the way, is not merely a sadistic addition. It refers to a remark by Lord Temple who claimed that he had a stake in the country, provoking the retort that he had stolen the stake from the public hedge. Such jokes and tittle-tattle were frequently suggested as material to Gillray by far from disinterested amateurs, and what must look laboured to us was probably quite obvious to their fellow politicians. Cruel or not, they must have found the print extremely funny. The way all these motifs and several others are condensed into one image illustrates the sophistication that pictorial satire had reached as an art form. True, the insinuations woven into this lampoon cannot but have been wounding to the victim, all the more as there was no substance to the story of the purloined sealing wax. The print impugns Lord Temple's honour, but he had no redress, and I doubt that he looked for one. We do not read that he

207

wanted to horse-whip Gillray, for all is fair in love and war, and in the game of politics you had to take the rough with the smooth. It is this new tolerance in relation to honour which the student of satire cannot leave out of his equation.[22]

There is a striking episode in Gillray's career which proves this radical change more vividly than any other. It turns out that at the time when George Canning was still an aspiring politician eager for publicity, he moved heaven and earth for his picture to be included in one of Gillray's cartoons, regardless of whether it made fun of him or not. The relevant documents, which are published in Draper Hill's book on Gillray, make hilarious reading.[23] It took a long time for Gillray to comply and in the end he finally paid Canning the desired compliment by hanging him in effigy from a lamp-post (fig. 293). The reversal could not have been more drastic. The context of Gillray's print of October 1796 fits in well with the leading theme of this conference: it is called *Promis'd Horrors of the French Invasion, or Forcible Reasons for Negotiating a Regicide Peace.* In the centre we see Pitt tied to a Tree of Liberty and scourged by Fox. Decapitated heads abound, while the Whigs, gathered at their club at Brooks's, rejoice; and White's, the club of the Tories, is invaded by French soldiers.

You might think, and rightly, that horrors, even imaginary horrors, are not a laughing matter. Indeed the history of pictorial satire records many blood-curdling prints of atrocities committed by Turks or Spaniards in the

293 James Gillray, *The Promis'd Horrors of the French Invasion*, 20 October 1796. British Museum, London

terrible wars of the past. But for Gillray, pictorial satire had become a humorous genre; and so he gives his account of the horrors a humorous twist by lampooning the scaremongers. In doing so, of course, he makes light of the real terrors of the French Revolution, which a solid Englishman need not take seriously.

'Making light' seems to me altogether the formula for describing many of the political prints or cartoons which accompany the events of the eighteenth and nineteenth centuries. What better method of 'making light' than a lighthearted comparison, an illustrated metaphor? Take Gillray's print of 1798 entitled *Fighting for the Dunghill, or Jack Tar Settling Bonaparte* (fig. 294). He presents the war with all its dangers and agonies, as if it were nothing but a fight for a dunghill. In any case there is nothing to worry about. Jack Tar may be a bit slow and uncouth, but he can take on anybody, and the comic emaciated Frenchman with his theatrical airs is surely no match for him. It is a reassuring picture, less an incitement against Napoleon than a boost to the morale at home.

The nearer we move to our time, the more this aspect of political satire appears to have come to the fore. On the whole it is more important for the political satirist to flatter his public than to incite to hatred. The recipe for success is rarely different from that of the popular press and the popular television programme. Build up their egos, confirm their prejudices, and above all, tell them not to worry.

Take that classic of a political cartoon, Tenniel's reaction to the news of Bismarck's dismissal – his famous drawing for *Punch*, captioned 'Dropping the Pilot' (fig. 295). It must have been a shock for English

294 James Gillray,
Fighting for the Dunghill,
20 November 1798.
British Museum, London

295 John Tenniel,
'Dropping the Pilot',
Punch, March 1890

readers to receive the news at their breakfast table that the most respected and feared statesman, the most powerful figure of the political chessboard, was to disappear overnight at the whim of the young Kaiser. Tenniel's comment on this turn of the Wheel of Fortune is a reassuring one. By equating the event with the institution of dropping the pilot, his cartoon must have acted as a shock-absorber. It has often been observed that the metaphor was totally misleading. The pilot goes of his own accord, having performed his service of guiding the ship through the dangerous passage. Bismarck had not been a pilot, he had been the captain of the ship of state he himself had helped to launch, and he did not leave voluntarily. But it is precisely by masking this bitter truth that the cartoon must have achieved such popularity. All is well with the world and God in heaven, we need neither be sorry for the grand old man nor incensed about the Kaiser. Pass the butter please. This may be an extreme case, but all the more telling for that.

It does not often happen that an art historian is lucky enough to find that the results of his somewhat laborious thought processes harmonize with the ideas a contemporary artist has formulated more succinctly about his craft. I was delighted, therefore, when I listened to a radio interview given by Nicholas Garland, a leading British newspaper cartoonist of our day, who worthily and wittily continues the tradition of David Low and Vicky.[24] Let me show you his cartoon for the *Independent*, dated 24 January 1989, in which he prophetically applied the metaphor of 'dragging one kicking and screaming into the twentieth century' to the evolving situation in Poland (fig. 296).

Asked by the interviewer whether he wanted to influence what people think, Nicholas Garland replied emphatically, 'I never, never think of political cartoons influencing people … but they do something else, I think. The cartoons I particularly remember are cartoons that in some encapsulated way express something I already know, but in a form that is very readily available to me …' The cartoon, he says, 'simplifies what are often very complicated political issues right down to very child-like, simple pictures. It creates a little world in which all sorts of issues … that affect you in rather serious ways you can get another look at. Sometimes it has the effect of rather reducing one's anxiety about it …'

Chapter 8 Pleasures of Boredom

Four Centuries of Doodles

First published in Italian as the introduction to Giuseppe Zevola, *Piaceri di noia: Quattro secoli di scarabocchi nell'Archivio Storico del Banco di Napoli* (Milan, Leonardo, 1991), pp. 7–18.

Among the more unexpected art-historical books of recent years has been the extensive publication of the doodles in the ledgers of the Banco di Napoli. The modest authors of these drawings would have been incredulous if they had been told that, after the passage of centuries, some of their amusing and occasionally moving scribbles on the margins of documents would be collected and published in a stately volume. For them, the idea of 'art' was no doubt connected with mastery, and they never aspired to be masters. Thus we owe the pleasure of looking at these fruits of their boredom to that radical change that came to identify artistic activity not so much with skill as with the urge to create, and which for the last hundred years has provoked interest in the art of the 'primitive', Sunday painters or psychotics and that of untrained laymen like our scribes.

Yet it must not be thought that the existence of some link between the creative urge and the achievement of mastery had to wait so long to be discovered. We find it explicitly described in what may be called the Foundation Charter of art-historical studies, Giorgio Vasari's *Lives of the Most Eminent Painters, Sculptors and Architects*, first published in Florence in 1550. In the first of these biographies, the life of Cimabue, we read that the boy was considered by his parents to be so gifted that he was sent to a schoolmaster to learn writing and grammar. 'But instead of attending to his lessons, he spent the whole day, as if he was feeling driven by nature, painting in his books and on other sheets of paper, men, horses, houses and various other fantasies.'[1] Fortune, so Vasari tells us, favoured these inclinations, because painters from Byzantium had just arrived in Florence and Cimabue often played truant from school to watch them at work, thus ultimately initiating the great tradition that was to culminate in Michelangelo.

212

It goes without saying that this opening of what is altogether a purely legendary biography is of no historical value. It is most unlikely that in the thirteenth century boys were given school books, and even if they had ever existed, Vasari could never have seen them. But precisely for that reason Vasari's text deserves to be regarded as a parable, expressing his ideas about the link between the creative urge manifested in the art of children and that acquisition of mastery that turned Cimabue into the alleged founder of the Renaissance tradition. To Vasari, the early inclinations of the boy presaged the skills he was later to master.

It is indeed rewarding to look at the doodles collected in this volume as an expression of the play instinct which never leaves us even when we grow up.[2] Basically, there are two kinds of games which these scribes like to indulge in, one derived from writing, the other from image-making. It is writing that develops that pleasure in manual skills discussed by Professor Colette Sirat,[3] a pleasure that manifests itself in an extended range from simple garlands and spirals to the elaborate flourishes derived from manuals of calligraphy. Sometimes, indeed, we can follow the process that leads from the mere pleasure in rhythmical movement to the intricate knots or images formed by continuous lines (fig. 297). The alternative game of images proved much less easy to master; the imitation of nature is

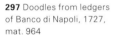

297 Doodles from ledgers of Banco di Napoli, 1727, mat. 964

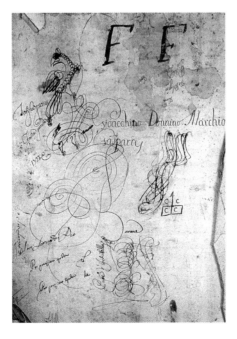

a skill that has to be learned in years of apprenticeship and our scribes rarely possessed this skill. It is evident that they occasionally looked for support in models which they tried to copy as best they could (figs. 298, 299). Even in these instances, however, the mastery of correct proportions usually proved beyond their capacity: the limbs and bodies of their images rarely fit together. Yet it is unlikely that these failures discouraged them. After all, they were not in earnest; they merely wished to play, and the game was rewarding whatever the outcome. For this is precisely the attraction of doodling manikins or faces: even if their looks surprise you and differ greatly from what you had intended, they prove to have a character and physiognomy of their own. I have paid tribute elsewhere to the artist who first described this discovery.[4] This was Rodolphe Töpffer (1799-1846), the inventor of the comic strip and author of an amusing treatise[5] on physiognomics in which he introduced what may be called the empirical study of facial expression (fig. 300). Any face you scribble, however primitive or distorted, will impress you as a 'creation', an individual being, the potential inhabitant of an imaginary world. This fact,

298 Doodles from ledgers of Banco di Napoli, 1684, mat. 598

299 Doodles from ledgers of Banco di Napoli, 1684, mat. 442

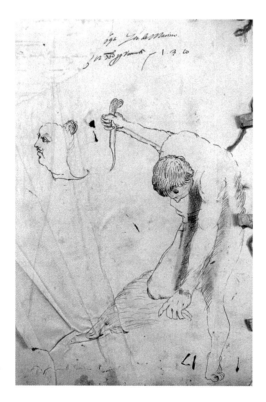

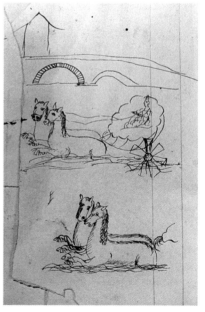

300 Illustration from
Rodolphe Töpffer, *Essai
de physiognomie* (Geneva,
1845)

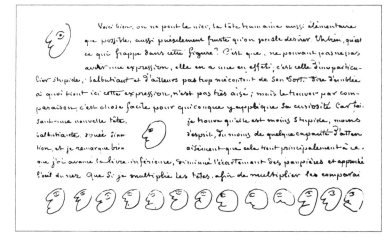

to repeat, is independent of the skill of the draftsman – independent also
of the degree to which he deliberately employs a primitive idiom or aims
at a reasonably realistic portrayal. It is never easy in any case to decide
between these alternatives. Regression to an infantile mode of behaviour
belongs, after all, to the most common techniques of humour, and images
which strike us as clumsy may have been made in jest.

Even so, it will be obvious to any historian of art who looks at the
images in these ledgers that much of their visual vocabulary has filtered
through from the current idioms of art. Such methods as shading are taken
over from drawings or engravings known to the designer (figs. 301, 302).[6]
On the other hand, it is also clear that they tended to adopt the line of least
resistance, for instance preferring profiles to facial views and drawing the
heads looking to the left, which comes more naturally to anybody holding
the pen in his right hand (fig. 303).[7]

While it is easy to show that doodles tend to owe a great deal to the
style and conventions of their time, we should not forget the reverse
process, the influence which the game of doodles has had on the art of the
masters. Not that this influence can have made itself felt at all times and on
all styles: where artistic conventions are grounded in strict discipline and
the application of rigid formulas, the practice of art will exclude any
playful relaxation of standards. It is only when these standards are
deliberately loosened that artistic practice becomes permeable to that free
play of the pen we call doodling. There is one master above all who
cultivated this relaxation, Leonardo da Vinci, in whose *œuvre* the skill of
drawing also reached an unprecedented climax. It was Leonardo who

301 Doodles from ledgers of Banco di Napoli, 1615, mat. 42

302 Doodles from ledgers of Banco di Napoli, 1730, mat. 1010

303 Doodles from ledgers of Banco di Napoli, 1698, mat. 683

notoriously urged the painter to seek the stimulation of accidental shapes such as patches on the wall or glowing embers to enhance his power of invention,[8] and his manuscripts offer plenty of evidence to show to what extent he also gave rein to his pen. His notebooks contain a regular 'verbal doodle', the compulsive question 'Dimmi se mai fu fatta una cosa' ('tell me if anything was ever done'), which he apparently liked to write when trying out a new pen,[9] but these same manuscripts also show him engrossed in his *ludi geometrici*, the permutation of shapes that he pursued both as a relaxation and a quest for geometrical laws.[10] He laid it down in his *Treatise on Painting* that in sketching the artist should avoid a careful finish so as not to impede the flow of his imagination. What he called 'un componimento inculto', an untidy sketch, was preferable for arousing the mind.[11] Most of all, Leonardo freely gave in to the impulse to scribble funny profiles while working on other projects, and he sometimes elaborated them later into his grotesque heads (fig. 304).[12]

Leonardo's Northern contemporary, Albrecht Dürer, exemplified another meeting ground between mastery and relaxation. His marginal

304 Leonardo da Vinci, sheet with doodles and geometric games, *c*.1510. Royal Library, Windsor, 12669r

drawings for the prayerbook of the Emperor Maximilian (fig. 305) display a stunning virtuosity of calligraphic flourishes and invented fantasies which recall doodles in their dream-like and inconsequential imagery.[13] To be sure, Dürer here refined and exploited the tradition of the marginal grotesque which had flourished in the decorative art of the Middle Ages, an art that may well have been nourished by the dreaming mind (fig. 306). The same might be said of the new forms of the grotesque that became fashionable in subsequent centuries.[14] The bizarre inventions of Bracelli (1624; fig. 307), with their exploitation of pen-play, come indeed close to some of the doodles in the Neapolitan ledgers (figs. 308, 309).

But for the doodle to move from the margin to the centre of the artistic stage, no less was required than the revolution of the twentieth century to which allusion has been made at the opening of this essay. Only when manual skill was considered less essential to the notion of art than originality and creativity could the doodle merge with the modern currents of art. The climax of this development was reached in Surrealism after André Breton had advocated automatic writing and drawing. Some of the resulting products are indeed indistinguishable from the doodles of the untrained.[15] Even earlier, a leading master such as Paul Klee had described in one of his lectures given at the Bauhaus to what an extent

217

305 Albrecht Dürer, drawings in the margin of the Prayerbook of the Emperor Maximilian, 1515. Bayerische Staatsbibliothek, Munich

306 Grotesques in the margin of the Luttrell Psalter, c.1340. British Library, London, Add. MS. 42 130, fol. 196v

307 Giovanni Battista Bracelli, engraving from *Bizzarie di varie figure* (Florence, 1624)

308 Doodles from ledgers of Banco di Napoli, 1758, mat. 1383

309 Doodles from ledgers of Banco di Napoli, 1767, mat. 1845

he relaxed conscious control in the creation of his visual fantasies.[16] Far from setting out with a firm intention, he allowed the shapes to grow under his hand, following them wherever they led him (fig. 310) – in the terminology of the modern engineers, he relied on feedback much as the idle doodler tends to do, saluting whatever emerged if he found it acceptable.

It was almost inevitable that this shift in the practice of art would also attract the attention of critics and psychologists to the doodle, but the final impulse for its official acceptance came from Hollywood in the season 1936-7. In Frank Capra's film *Mr Deeds Goes to Town*, Gary Cooper plays an attractive country lad who is happy in his village playing the tuba, when he finds himself unexpectedly the heir of an enormous fortune. His wish, however, to use the money to alleviate distress is about to be thwarted by a rival who lays claim to the inheritance, alleging that young Mr Deeds is not *compos mentis*. In the ensuing court scene which forms the climax of the comedy, the rival produces two old crones from the hero's village to testify that they consider the young man 'pixillated' (in other words crazy). However, it is easy for the defence to elicit the further reply from the old ladies that in their view, 'everybody is pixillated'. When an Austrian psychiatrist is called to prove that a partiality for playing the tuba must be a symptom of madness, the hero argues triumphantly that everybody has similar partialities. The presiding judge is shown up to be an 'O-filler', having coloured in every letter O in the text in front of him, and as to the psychiatrist himself, he is shown to have covered his papers with the most

310 Paul Klee, *Exotic Theatre*, 1922. Paul Klee Stiftung, Berne

bizarre 'doodles', which would suffice to have anyone confined in an asylum. The case is dismissed and Mr Deeds is free to distribute his fortune.

It was through the success of this film that the habit of doodling attracted general attention and gave the word general currency in the Anglo-Saxon world. If proof were needed, it would be found in the publication in the same year of a little book borrowing its title from the remark quoted above, 'everybody is pixillated'.[17] It is true that the author asserted that he had been collecting doodles for many years, beginning his series with a selection of doodles by American Presidents from George Washington to Franklin D. Roosevelt, adding a brief psychological diagnosis to their products. The author also had the bright idea of following a legislative project through its passage up to the President and reproducing doodles he claimed to have collected after each session. He ended with doodles solicited from various celebrities of the day, and a tabulation of stereotype features to which he attributed diagnostic value, not without admitting, however, that their reliability as symptoms must not be overrated.

Even so, the vogue for interpreting doodles soon reached the media and the *London Evening Standard* launched a competition called 'Send in your Doodles', promising a premium (fig. 311) to anyone whose drawing was published and analysed by a psychologist. I must here make a confession of having committed a crime, hoping that after more than fifty years the statute of limitations will save me from prosecution: I forged a doodle, hooking the bait with the remark, 'I am a terrible doodler' (fig. 312). It had the desired effect. The diagnosis printed under my doodle was not worth much, but I was pleased to have the ten shillings with which I was promptly rewarded. The question of when is a doodle not a doodle still awaits an answer from the philosophers.

Frankly, it was not really greed which prompted me to participate in this competition. I had been interested in the matter for some time: the interest arose from my collaboration with the art historian and psychoanalyst Ernst Kris in a study of caricature which was also to include the grotesque. In one of the lectures he gave at the time on the art of the insane, Kris himself also turned to the discussion of the doodle, which he rightly wished to distinguish from the products observed in the asylum. The difference seems to lie mainly in the function which doodling has in the lives of untrained normal and abnormal individuals. While doodles may occupy a significant part in the life of the mentally ill, they are incidental products of the normal. Occasional observations of untrained

311 *London Evening Standard,* 14 September 1937, p. 18

DOODLES—send yours to-day

THE LATE SIR HENRY CURTIS-BENNETT,

the famous K.C., did the doodle at the top of this page on a legal document while sitting in court waiting for his case to come on, about a year before his death. Mr. R. A. Roberts, managing clerk to the solicitor in that case, sent the document from 67, Glanfield-road, Beckenham.

ANALYSIS

These drawings afford a most interesting example of the mode of action of a very able brain considering points in an argument.

They are the work of a clear-cut mind, very masculine in character, excellently ordered and under perfect control. The author has some artistic ability and very good observation. He has obviously played cricket in his youth and become interested in watching it.

The doodles seem to portray his view of what is at the moment going on. I would take them as follows:

1.—"A knotty point! The ball is now ours to play. Can we play it?"

2.—"This is all rather vague and getting mixed."

3.—"Ah! Here we set to."

4.—"I see—it's a concrete kind of proposition. Let us look at it in more detail." No. 1 is a cricketer addressing a ball; No. 2 a set of meaningless lines and a vague piece of shading; No. 3 a small lay-out for noughts and crosses and then a big one; No. 4 a house with one side not completed the detail of the window repeated twice, small and then large.

This is a mind that sees issues clearly, turns its attention first to one and then another part of a given argument and selects out of the subject before him certain details to consider with greater and greater attention.

MOST people are doodlers—that is, they scribble absentmindedly on blotters, menus, telephone-pads, during moments of waiting or concentration. The "Evening Standard" invites you to send your doodle for publication.

Psychologists see in these unconscious jottings a clue to the individual's true character. So a psychologist who is an expert in this kind of interpretation is analysing briefly each doodle printed.

It is, as you will see, a game with plenty of fun—and a certain personal interest. All you have to do is to send in your doodle on whatever scrap of paper it was done. Each one published wins **half a guinea**; and there is a prize of **TEN GUINEAS** for the best doodle of the week.

If you happen to possess a doodle by some famous person, send that along, saying how it came into your possession.

Address entries to Doodles, "Evening Standard," 47, Shoe-lane, London, E.C.4. State your name, address, and occupation.

ABOVE IS A SHOPPING LIST

decorated with doodles by housewife Mrs. R. Demuth, of 113, Ladbroke-road, W.11, while thinking out the tradesmen's orders for the day.

ANALYSIS

A vital, active, amusing and humorous personality, with considerable artistic ability, good observation, a vivid and adaptable attitude to life. Fond of animals; at present suffering from energy and gifts which break out on their own and appear detached from her ordinary life.

Is not tidy, and finds the ordering of daily life difficult, is bored by routine, not conventional, interested in people and in movement and not in ideas. Not a logical thinker, from one thing to another quick in thought and action. Her approach to life is intuitive rather than logical.

DOODLED ON A POSTCARD

is the elaborate pattern above. It was done by Mr. James Exton, street lamp attendant, of 70, Park-lane, Romford, when pondering about a letter.

ANALYSIS

This is an unusual mind, keen on ideas of power of different sorts—the power represented by money, by love, by magic and mystic forces, by Freemasonry, and by skill. The writer is a craftsman with considerable control of material; tends to over-elaborate his thought and is interested in the East and its charms.

Likes things neat and tidy and has a taste for lay-out and pattern. There are many conflicting elements in his character which he forces into an outward agreement, rather than bring them into real harmony.

STANLEY LUPINO

is a great "doodler," and usually scribbles abstract patterns. He sent the one above for this competition.

ANALYSIS

This is an artist who is interested in what he creates himself and not in what is presented to him. He is a self-sufficient individual, enjoying intricacies and creating baffling situations for other people. He is reserved, unexpected and in his apparent casualness there is considerable order.

Having once got an idea, he likes to round it out to a complete whole before dropping it.

"I AM A TERRIBLE DOODLER,"

says Dr. Ernst Gombrich, an art historian, enclosing the example reproduced above. His address is 24, Stanhope-gardens, N.6.

ANALYSIS

A friendly and amusing personality, with a kindly and humorous attitude to life. Has a good sense of the grotesque. Impulsive by nature, but has trained himself to work his impulses into a design. Unconventional, tolerant, spontaneous. Has a somewhat critical view of his fellow-men.

Not interested in machinery; not rigid or conventional. Has some familiarity with Oriental china. Prefers to state his point of view well rather than to argue about it.

THIS DECORATIVE DESIGN

is the doodle sent by Mr. G. E. Remington, of 35, Redcliffe-gardens, S.W.10. He is a civil engineer.

ANALYSIS

This is an interesting mind, fond of detail and delicacy. Capable of thinking of two things at once, with efficiency. Is precise, tidy, aware of artistic values and interested in them. Neat handed, capable of humour. Will express his own ideas rather than take in those of other people. Keen on decoration and in the working out of contrasts.

A HIGHLY INTRICATE DOODLE

has been worked out by Mr. F. H. Bennett, insurance broker, of 6, Lawrence Pountney-hill, Cannon-street, E.C.4.

ANALYSIS

This is a mind that finds it difficult to take a decision owing to the number of aspects from which any proposition is seen. He has no artistic tendencies; is interested in argument; likes to take an idea or a fact and try many aspects of it.

Is not interested in people, not an active temperament, apt to over-elaborate. Could be a good draughtsman.

Somewhat fixed in outlook. Likes everything not into neat

FUNNY FACES

scribbled by Major C. Hughman, of the National Club, 12, Queen Anne's-gate, S.W.1. He is a retired army officer.

ANALYSIS

This doodler is interested in people rather than in things or ideas. Has a humorous outlook and likes trying out effects. His ideas are detached and not built into a logical system. Fighting is present in his mind, but in its results rather than in the action itself. He is interested in . . .

BOXES AND A FLAG

are features of the doodle submitted by Mr. D. L. Roslyn, F.S.M.C., ophthalmic optician, of 80, Mitcham-road, S.W.17.

ANALYSIS

It would appear that the mind of this doodler is divided between his work and the outdoor world; that he is a walker, possibly a climber, and enjoys being out of doors. Impulsive, more interested in action than . . .

normal individuals, as well as self-observations, suggest that doodling tends to occur while one is either 'unoccupied' or in a state of distracted attention, i.e., when the ego is fully occupied with something else. At first one is frequently aware of a certain purposive idea, an 'intention to draw', which may refer to any geometrical or decorative design. In some instances, one may 'intend' to reproduce some object in the environment; in others, there is no such intention. The drawing hand 'creates' autonomously; lines or steps 'suggest' subsequent ones. Clinical observation shows that doodling has a frequent if not regular dynamic function for the normal: fantasies and thoughts hidden in doodles are those of which the doodler wants to liberate himself, lest they disturb the process of concentration.[18] In another lecture Kris proceeded to exemplify the theory by analysing the associations of a patient revealing her preoccupation at the time when she drew what looked like an idle doodle.[19]

The reference by Kris to the discharge of tension reminds us of a psychological mechanism that biologists have meanwhile come to call 'displacement activity', as when an impatient person drums with his fingers on the table, or, in embarrassment, scratches his head. It looks as if the blocked emotion is seeking an alternative outlet, something that can also be observed in the behaviour of animals.[20] There certainly are instances and contexts of doodles which suggest a connection with a 'mental block'. I refer to the elaborate doodles found in the manuscripts of Dostoevsky's novels (figs. 313, 314). Here we must indeed assume that these

313 Fyodor Dostoevsky, page from the manuscript of *The Devils*, reproduced in Ernest J. Simmons, *Dostoevski* (London, 1950)

314 Fyodor Dostoevsky, page from the manuscript of *The Idiot*, reproduced from Edward Wasiolek, ed., *The Notebook for the Idiot, Fiodor Dostoevsky* (Chicago, 1967)

fantasies served him to overcome a block or dilemma that had impeded his writing and offered an alternative that must have helped him to resume the thread of his invention.

There can be no doubt, however, that seen from a psychological point of view, the doodle can serve a variety of functions. To get a little closer to this role, we may have to investigate the mystery of attention, a human faculty of which we still know too little.[21] We tend to be told, no doubt rightly, that any constructive achievement requires the utmost concentration of the mind. On the other hand, we also know that it is hard, if not wholly impossible, to concentrate for any length of time on a monotonous task. Try as we may, our mind begins to wander and sooner or later the quality of the work will suffer. Experience shows that this danger is diminished by keeping the mind mildly occupied in another way during the performance of an almost mechanical task. It is told of Rubens that he had the classics read to him while painting, and of Mozart that he asked his wife to read to him while copying a score. Minor mortals have long ago discovered this remedy against fatigue by turning on the radio or listening to a 'walkman'. There are many students who claim that they could not work without such a paradoxical aid to concentration. What is going on? Maybe the alternative channel of impressions is keeping the mind from going off in every direction and this indirectly improves the performance. One might imagine that doodling could assume a similar function. Almost by definition it requires no concentration, but it keeps our minds busy and amused. While listening more or less unwillingly to the voice on the telephone or to the lecturer's lengthy arguments we also enjoy the pleasant game of watching the most unexpected configurations arising and assuming a life of their own.

As children we are told that we must not indulge ourselves in play before we have finished our homework, but the doodle subverts this virtuous injunction and allows us secretly to play while we must attend to some kind of serious pursuit. The outcome of this play, as we have seen, is not fully under our conscious control and this is precisely why it is felt to be relaxing, but we have also learned from these ledgers that the doodler is never quite unaware of the standards of his culture. It is my impression that acquaintance with the licence enjoyed by contemporary art has encouraged many doodlers today to follow the suggestions of their dreaming minds much further than was the habit of the bank clerks of Naples. Our doodles, no less than theirs, have a style of their own.

Even so, the kinship between doodling and artistic creation must not be exaggerated. One difference clearly stands out: that of function and

purpose. Even the modern artist must make an effort to obtain his materials, his canvas, paper, brush or pencil, if he is to make a living. The doodle, like the graffito, is the fruit of opportunity. The two have indeed much in common, but the doodle may be described as the innocent brother of the graffito. While the vandal is tempted to disfigure a white wall with his rude message or scrawl, mainly to exercise his power and get rid of his aggression, the doodler normally wishes to remain private.[22] It is the temptation of the empty sheet of paper placed next to the telephone or on the table at a meeting that induces us to enliven the hours of boredom or to relax our tensions by permitting our pen to play a game of its own on this licensed playground. The tool in our hands demands to be used and to demonstrate to us its creative power – today no less than many centuries ago. A few years ago, I received from my London bank an elegant pamphlet recommending a variety of services it could offer to its customers (fig. 315). Its illustrations made me pause, for it showed a pen engaged on the same kind of calligraphic doodle that provided solace and recreation to the employees of the Banco di Napoli over the centuries. *Plus ça change …*

315 Leaflet produced by the National Westminster Bank

ARRANGING A MEETING

If you would like to arrange a meeting with a NatWest Personal Financial

Manager, simply complete and return the attached form and we shall contact you.

225

Chapter 9 Pictorial Instructions

First published in *Images and Understanding*, ed. Horace Benlow, Colin Blakemore and Miranda Weston-Smith (Cambridge, 1990), pp. 26-45.

It must be appropriate to start my study on images and understanding with one of the cases in which it may be a matter of life and death whether an image is correctly understood: those leaflets or cards we all know from our air travels containing pictorial instructions on what to do in an emergency. Here are two examples (figs. 316, 317): one (removed by one of my accomplices) from a British Airways plane, another which I myself purloined from Lufthansa, illustrating the same contingency of what to do when the aircraft comes down on water. The British Airways sequence merely reminds you at first that you will find the vests for adults under the seat; the designer assumes that you know how to start putting them on, two stages illustrated in the Lufthansa leaflet. Both instructions then show the passenger from the back fastening a strap around their bodies, a movement explained by Lufthansa by means of two arrows. I confess that watching the air steward demonstrating the next stage always worried me. Will I be able in the rush to tie the strap 'securely in a bow' on my side as I have often been told? I am not very good at this. Apparently there are no bows in the Lufthansa model – you are supposed to hook the straps in or up. In any case, if British Airways lands you on the water you must apparently end up standing stock still and reflect on the meaning of the red cross symbol, unless you have understood the air steward who told you that it points to the valve to be used for inflating the vest – but not yet, lest its bulk impede your movement through the emergency door, graphically but not very reassuringly illustrated below. The Lufthansa model is more detailed. It shows you extending the straps sideways – but not where to leave them; it also illustrates the movement of pulling with both hands for inflation and of topping up the air by blowing through a tube. Finally, it reassures you by showing how a lamp will light up to facilitate your rescue as you float in the water.

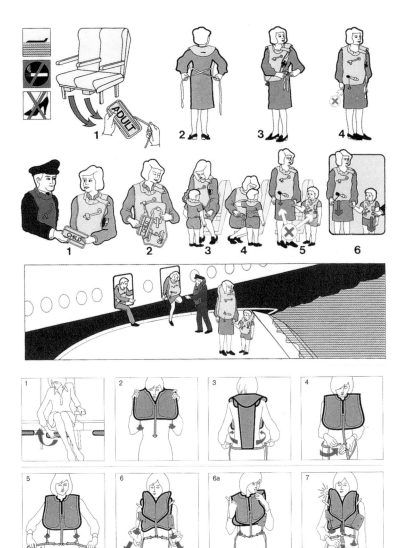

316 Instruction leaflet, British Airways, Super One-Eleven

317 Instruction leaflet, Lufthansa, A3120

I have no wish to criticize these various instructions, only to point out that the task they are intended to teach is not all that easy to perform if you have never done it. The demonstrations by the stewards surely help, and I was happy on a recent flight across the Atlantic also to see a movie being shown which obviously relieved the cabin staff of a very tedious task and seemed to me reassuringly clear, though the matter of the bow on the hip still eluded me. In any case, few would doubt that the understanding of

227

images, whether still or moving, is vastly facilitated by the addition of verbal explanations.

The pictorial instructions I have shown try to get on with the minimum of words or of other symbols which would not be intelligible to a passenger hailing from a foreign culture. One exception is the sequence of the panels, which are to be read from left to right, and in most cases numbered in arabic numerals. Another exception is the use of the symbol of the arrow to indicate the direction of the required movement. Of course it takes the meaning of the symbol wholly for granted, but as a historian I have come to wonder when and where it assumed this universal significance as a pointer or vector. One need only ask such a question to find how poorly the world of the image is explored. I have not found such symbolic arrows before the 18th century, as in this illustration (fig. 318) from a French treatise on *Hydraulic Architecture* of 1737, indicating the direction of rotation; in the same century, topographical artists also sometimes used to show the direction of flow of the river by a discreet arrow.[1] Needless to say, the type of wordless pictorial instruction I have discussed is the exception rather than the rule in the genre. More frequently, language is called in for the mutual elucidation of word and image in the interest of understanding. The method is employed to good effect in a Reader's Digest book of 400 pages called *What to do in an Emergency*,[2] using more or less naturalistic illustrations supported by a text. Although many of the emergencies illustrated are a little too unpleasant to contemplate, nobody will mind looking at figure 319, with an instruction on how to right an overturned caravan. True, the text tells us that the safest course in such a case is to get expert help from a garage or motoring organization, but if you have at your disposal three fairly strong adults and at least 18 metres of stout rope you may try your luck in the way illustrated, which I have selected because the authors here take no chances over tying the knots, which is explained in comforting detail.

318 Diagram of waterwheel (with arrow) after Bernard Forest de Bélidor, *Architecture hydraulique*, Paris (1737)

319 'Righting an
overturned caravan', from
*What to do in an
Emergency* (Reader's
Digest, 1986), pp. 292–3

If high winds topple a caravan onto its side, the safest course is to get expert help from a garage or motoring organisation. But it is possible to get the caravan back up on your own.

To use the technique, you need three fairly strong adults and at least 60ft (18m) of stout rope such as that used by climbers. You also need to practise the pulley knot shown here. It uses the rope to make a series of loops which act like pulleys, giving you extra leverage. Once you have mastered the knot, however, you can use it in any situation to move much heavier weights than you could otherwise handle: to help to free a car stuck in mud, for example.

• Remove as much equipment as possible from the caravan, and put it in the car. If the door is inaccessible, get into the caravan through an end window. Turn off any gas cylinders and disconnect the electricity as well.
• Raise the corner legs, or 'steadies', on the lower side. Put a block against the lower wheel, too, to stop it slipping. Lower the upper steadies slightly – not fully – so that they will make a three-point touchdown with the wheel.
• Tie the middle of the rope securely to the upper axle or a nearby part of the chassis. Then make the pulley knot shown here. Put the loop at the end of the knot round a sturdy stake driven into the ground at an angle.
• Throw the rope's other end over the caravan and wind it twice round a second stake to make a lowering line.
• Pull slowly and carefully on the free end of the rope. Ask at least two adults to pay out the lowering line gradually at the same time. Use as many adults as are available.
• Alternatively, you may be able to use the car either to help to pull the caravan up or in place of one of the stakes. Attach or loop the rope round the car's towing bracket.
• As the caravan comes upright, do not let it drop the last few feet; you could damage the axle and sub-frame. Let it down carefully.

HOW TO MAKE A PULLEY KNOT

1 *Attach the middle of the rope firmly to the caravan's axle or chassis. Throw one end over the caravan to make the lowering line.*

2 *Make a fold in the other rope about 2ft (600mm) from the fixing point, and bring the doubled section across and behind the rope.*

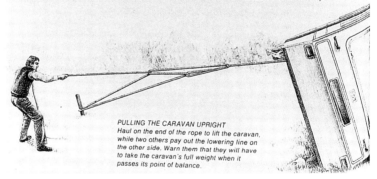

PULLING THE CARAVAN UPRIGHT
Haul on the end of the rope to lift the caravan, while two others pay out the lowering line on the other side. Warn them that they will have to take the caravan's full weight when it passes its point of balance.

Even these few examples should suffice to remind you that in the genre of pictorial instruction the role of the designer, however important, still comes second after that of the inventor. In real life, the performance of a particular task is usually learned by imitation and trial and error. You are shown how to ride a bicycle and then you try it until you get the hang of it. Whether you can verbalize, let alone illustrate, the necessary movements is another matter.

There is a time-honoured story of the man who goes to the doctor who asks him what is wrong. 'Doctor,' he says, 'when I put my left hand behind my neck, and afterwards far down behind my back and stretch the arm swinging it round, my shoulder hurts terribly.' 'Why on earth are you performing such foolish antics?' 'How else should I put on my overcoat?' I have asked a young artist to illustrate the procedure for me in easy stages and reproduce our joint results (fig. 320), though I am sure Dr Jonathan Miller could improve on them. The point, of course, is that the movement for seeking your armhole behind your back is again one of trial and error.

Engineers who are used to analysing motor skills have termed the components of such actions 'chunks'. The illustrator must learn to isolate the chunks and to show the performance from its most telling angle. As you see, the genre of pictorial instruction is by no means as trivial as it may sound at first sight. It must break up the flow of the skilled movement into a fixed sequence of stationary positions.

Admittedly this need applies only to one special kind of pictorial instruction, the one I have chosen to deal with here. That there are other forms of pictorial instruction must be apparent in any case, for what else are a lecturer's 'visual aids' than a form of pictorial instruction? More relevant for historians is the fact that pictorial instruction was precisely the task assigned to the visual arts by the Christian Church to avoid the charge of idolatry. To quote the famous pronouncement by Pope Gregory the Great at the beginning of the Middle Ages: 'What writing is to the reader, pictures are to those who cannot read.'[3] I need hardly remind you of the application of this doctrine by the Church during a millennium of image-making, in which the Last Judgement was displayed to the faithful in awe-inspiring compositions, and the lives of Christ and the Saints told in many episodes in various media.

320 How to put on an overcoat, drawn by Leonie Gombrich.

Not that all teaching was religious. The image had been used for instruction even before the development of sequential narrative. No system of the various possibilities can or need be given here; suffice it to remind you that there is a spectrum extending from the realistic portrayal of a specimen to a purely abstract diagram. The typical case of portrayal is to be found in herbals, where the characteristics of a plant are represented as faithfully as possible.[4] On the opposite pole of the diagram are cosmological images, notably calendar images like the Hellenistic Egyptian temple ceiling at Dendera, representing the annual cycle with images of the Zodiac, and other symbolic figures such as the Decans, representing units of ten days.[5]

In the class of portrayal we may also place the marked or manipulated illustration of a specimen such as we find in the type of medical treatises demonstrating the point of the body suitable for cauterization.[6] Closer still to a manual of instruction is that astounding treatise by the Hohenstaufen Emperor Frederick II, *De arte venandi cum avibus*, on the art of hawking. The magnificent illuminated manuscript of that treatise (in the Vatican) from the thirteenth century also illustrates the various forms of holding the hawk on the fist.[7]

Somewhere between the portrayal of a specimen and the abstract diagram of relationships we may place that vital instrument of visual communication, the map, for the map is intended to represent the spatial relationship between locations on the globe in a more or less schematic form.[8] Even so, the abstract diagrammatic map merges almost imperceptibly with the bird's eye view of a territory as in certain drawings by Leonardo da Vinci of a part of central Italy.[9] These, of course, are imaginary bird's eye views, for even Leonardo did not succeed in his dream of rivalling the birds. We may call such imaginary views visualizations.

Various forms of visualization play a crucial role in images intended for pictorial instructions, though it is not always easy to establish where portrayal ends and visualization begins. The history of anatomical illustration offers numerous examples.[10] A well-known woodcut from the *Fasciculo de medicina* by Johannes de Ketham of 1491 purports to illustrate the main positions of the body organs (fig. 321). It has often and rightly been contrasted with an anatomical drawing by Leonardo da Vinci done only a few years later (fig. 322), but even this exploration of the female body, though based on autopsy, is largely a visualization and not even a wholly correct one. Even so, it is clear that Leonardo's heroic visualization excluded the insertion of labels and captions which characterize the earlier

321 Diagram from Johannes de Ketham, *Fasciculo de medicina* (Venice, 1491).

322 Leonardo da Vinci, *Anatomical Drawing of the Female Body*, c.1510. Royal Library, Windsor, 12281

image. Here, too, Leonardo was a pioneer, for in his scientific drawings he usually inserted a letter key to which he referred in his explanatory texts, a method surely derived from geometrical demonstrations in the tradition of Euclid.[11] This method, which we too easily take for granted, came to triumph in the many woodcuts of Georg Agricola's classic textbook on mining, *De re metallica*, from the middle of the sixteenth century. On the next plate (fig. 323) we see under A a workman carrying broken rock in a barrow, under B the first chute, under C the first box with its handle marked D, and so all the way down to X, the third tub, and Y the plugs.

This example, however, has led me out of the Middle Ages and strayed a little too far from my central problem of the teaching of manual skills. Even before the end of the fifteenth century, there is an early example of a real pictorial instruction, demonstrating the sequence of a performance in easy stages: the pattern book showing how to paint the decorative scrolls that adorned manuscripts and even the early printed books of the period (fig. 324).[12] The author demonstrates how to draw and colour the scroll in successive stages until it gets a rounded and supple appearance.

323 Woodcut from G. Agricola, *De re metallica*, Book VIII (1556; after the English translation, New York, 1950)

324 Page from the Göttingen Model Book, 15th century. Niedersächsische Staats und Universitätsbibliothek, Göttingen.

I did not know this early example when I wrote *Art and Illusion*, in which I illustrated a number of somewhat later drawing manuals, like the one by Odoardo Fialetti of 1608, which starts with this instruction of how to draw eyes in profile (fig. 325). Notice that this type of pictorial instruction stands somewhat apart, because here every stage of the performance to be taught leaves a permanent trace and can therefore be illustrated with ease. Such books are still being produced in great numbers. Another method which never died out is the demonstration by means of contrast of the right and wrong way of setting about a task, for example on the correct and incorrect way of holding the pen when drawing a map.[13] If you rest your hand on the surface you will certainly smudge the drawing.

Maybe instructions in penmanship took second place to those in swordsmanship and similar skills in combat which formed part of the education of the gentleman. Quite a number of such manuals have been preserved from the fifteenth century onwards. Many of them are strictly utilitarian, lacking any artistic ambitions, like the bulky fencing book

233

325 Illustration from Odoardo Fialetti, *Il vero modo ... per disegnare* (Venice, 1610).

drawn on paper by one Thalhofer, dated 1443, which also includes instructions in wrestling and unarmed combat (fig. 328). Naturally, there are also luxury editions for the use of princes.[14] The two illustrations in figures 326 and 327 come from the most sophisticated fencing book I know, appropriately called *A Treatise on the Science of Arms* of 1553 by Camillo Agrippa. One illustration shows within one frame four stages of the fencer's movement, lettered successively A, B, C, and D, in almost cinematic sequence. The other gives a sample of the movements of the blade in a complex geometrical figure, though I must confess that I have so far failed to profit fully from this pictorial instruction in the complex science of thrust and parry.

What is relevant in these handbooks for my context is that the analysis of movements is part of the skill. They all have a name familiar to the fencing master. There is a natural transition, therefore, from the teaching of fencing to the teaching of dancing; indeed the fencing master and the dancing master may have been one and the same person. This natural transition is evident in two pages from the dialogue on dancing by Thoinot Arbeau of which an English translation was published in 1967 (fig. 329):

You see above four pictures of the gestures I have described to you, to wit: *Feinte, estocade, taille haute and revers haut.* There remain the pictures of the other two gestures which you see below. Besides these,

Feincte Eftocade

Taille haulte Reuers hault

326, 327 Illustrations from Camillo Agrippa, *Trattato di scienzia d'arme*, 1553 (after Bascetta, vol. 2).

328 Illustration from Hans Thalhofer, *Fechtbuch*, 1443 (ed. G. Hergsell, Prague, 1901).

329 Illustration from Thoinot Arbeau, *Orchéosographie*, English edn. (New York, 1967), pp. 184–5.

there are several other body movements but it seems to me it will suffice for you to have them in writing without necessitating pictures – fencing has already acquainted me with all these gestures. Now tell me how to dance the buffens.[15]

Other forms of exercise also share with dancing and fencing the need for a technical vocabulary to describe relevant movements. We still use such a vocabulary when speaking of swimming, for instance breaststroke or crawl. The first illustrated swimming manual, by one Everard Digby, came out in England in Latin in 1587 and in English in 1595.[16] One of the most

sophisticated and ambitious of such illustrated treatises on athletics is a work by one Giocondo Baluda of 1630 on various exercises to be performed on the wooden horse (fig. 331). Like Agrippa before him, he also illustrates the successive movements of the athletes, showing five phases of the action from various sides, but he adds another feature by indicating the position of the feet in schematic form.

A treatise on the art of catering of 1639 contains instructions on the folding of napkins (fig. 330), which may be one of the first to illustrate the exact position of the hands in performing the task as well as the desired result that recalls the Japanese technique of origami.[17]

But all these individual examples are eclipsed by the greatest enterprise in pictorial instruction, the *Grande Encyclopédie* launched in 1751 by Diderot and D'Alembert in conscious imitation of Chambers's *Encyclopaedia*; but as the preface of the French work proudly announces, Chambers had 30 pages of illustrations, and they proposed to have 600. Indeed the large engraved folio plates of the illustrated supplements of the *Encyclopédie* were an integral part of that great educational venture, for it was intended, among other things, to remove the secrecy from craft traditions and to demonstrate the importance of trade and industry to the

330 Illustration from M. Giegher, *Trattato delle piegature (Treatise on Catering)*, 1639 (after Facciolo, vol. 2)

331 Illustration from Giocondo Baluda, *Trattato del modo di volteggiare e saltare il cavallo di legno*, 1630 (after Bascetta, vol. 1)

public, invoking the spirit and example of Francis Bacon who had diagnosed so long ago the bias of education against manual skills.[18] To turn the pages of these magnificent folio volumes is to be transported back to the eighteenth century at the threshold of the Industrial Revolution.

Figures 332 and 333 show the first two plates of the article on cotton from the section *Oeconomie rustique*, illustrating the interior of the workroom and the view of the machine, which is then carefully analysed and measured for those who want to read the description. On the next plate we can follow the sequence of the manual operation from 1 to 6 with figure 1 having a subsidiary commentary. Naturally, the military arts are not neglected. The many plates devoted to the individual positions of parading soldiers would have gladdened the heart of any sergeant-major. More theoretical are the plates devoted to the complex skill of manoeuvre in carrying out evolutions, that is turning movements in formation. Figure 334 illustrates the passing of a bridge and the reformation of a detachment.

The rest of my story would have to concern technology and sociology, in other words the means and the demands shaping the history of pictorial instruction up to the present day. The greatest contribution of technology is of course the use of the photographic camera for pictorial instruction. It

332, 333 Illustrations from the *Grande Encyclopédie* (Paris, 1751), vol. 1, 'coton', pls. 1 & 2

has enabled teachers and writers of manuals to illustrate the hands of the great masters, as Malvine Brée has illustrated the hands of the great pedagogue Leschetitzky in her book demonstrating the position of the hands while playing a scale. A recent development is the arrival of video-tapes showing the hands of our master pianists, either taken from television performances or made *ad hoc* for the purpose of 'master classes'.

The growing demand for visual instructions goes together with the popularity of handicrafts outside the workshop and in the home. Such a typical manual as the *Encyclopedia of Needlework* brings to mind the busy hands of Victorian ladies (fig. 335). Of greater social significance are the manuals issued with the first sewing machine, for they remind us of the increase in home industries which required such basic instructions in manual skills. It must soon have been realized how much the marketing of tools and instruments could benefit from the addition of instruction leaflets of various kinds; indeed it is rare today to find an apparatus which

334 Illustration from the *Grande Encyclopédie* (Paris, 1751), 'art militaire'

335 Illustration from Thérèse de Dillmont, *Encyclopedia of Needlework*, p. 518

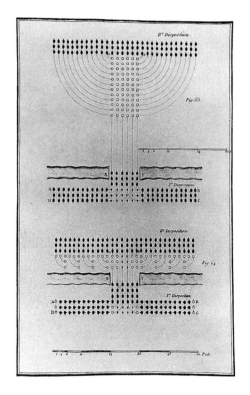

finger, you must pass the knot and the ends of thread as well, over into the left hand, and with the right hand pull the thread that lies on the right and draw up the loop, fig. 833.

FIG. 831. KNOTTED CORD. FIRST POSITION OF THE HANDS.

FIG. 832. KNOTTED CORD. SECOND POSITION OF THE HANDS.

FIG. 833. KNOTTED CORD. THIRD POSITION OF THE HANDS.

In fig. 834, representing the fourth position of the hands, you are shown how the forefinger of the right hand lifts up the thread and passes through the loop on the left hand; the end will consequently also pass immediately into the right hand and the left hand will tighten the knot.

is not also explained in multi-lingual and pictorial instructions.

I end my survey by paying tribute to that great store in Chicago called Marshall Field where I bought a tie, for I have always treasured the leaflet they sold with it (fig. 336). Unlike other guides, the designer shows himself aware of the special problem presented by the mirror which fiendishly changes right to left and left to right, forward to back and back to forward. I know that motorists, dentists and engravers have overcome this difficulty and can make the inverse movements of those they see in the mirror. I am not one of them, and though I have studied the pictorial instruction about the tying of the black tie for evening wear with special attention, I shall here reveal that I cowardly use a made-up tie.

336 The Windsor Knot
and the Bow Tie, leaflet,
Marshall Field Store,
Chicago

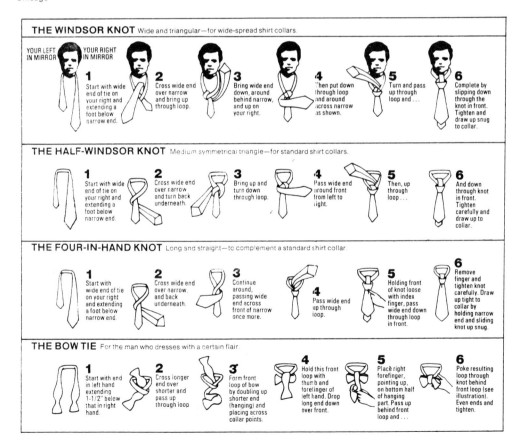

Chapter 10 Styles of Art and Styles of Life

The Reynolds Lecture, delivered at the Royal Academy of Arts, 27 November 1990; first published by the Royal Academy (London, 1991)

The title of this chapter may be best explained by comparing two plates from Osbert Lancaster's satirical survey of the history of style, which I consider the best textbook on the topic ever published.[1] The first illustrates the style of life and of art known as the Rococo (fig. 337); the other is entitled 'Twentieth Century Functional' (fig. 338), and I must leave it open whether it represents the style of a vanished epoch or one of the future.

Though the emphasis of the book is on the architectural setting, the sharp eye of the artist has also encompassed the style of life we associate with the respective periods. The elegant couple in the Rococo interior would have found it as unthinkable to sunbathe on the roof of their dwelling as their twentieth-century great-great-great grandson would

337, 338 Osbert Lancaster, 'Rococo' and 'Twentieth Century Functional', from *Here, of all Places: The Pocket Lamp of Architecture* (London, 1959)

have found it to carry a sword. Nor do I have to persuade you at length that the painting of a naked nymph attended by a cupid that hangs in the eighteenth-century boudoir would be as much out of character in the functional house as the cactus and the painting we can just glimpse in the downstairs room would be in the Rococo interior.

We tend to say in such cases that both pictures perfectly represent the spirit of their respective ages. It is a cliché that has always worried me, and that I have worried in my turn.[2] I have never seen a spirit, and I have an instinctive aversion to all forms of collectivism, whether they are called racialism, nationalism, or, if you will allow the term, periodism. I am an individualist, and I cannot believe that we are no more than puppets dangling from the strings controlled by an invisible puppet master, representing the spirit of the age, or, perhaps, the class conflict. Indeed, I have come to wonder whether we have to postulate such a puppet master as a Super Artist who creates the style or styles of an epoch in their various media. Could it not rather be the other way round? Could not art and artists have at least contributed to what we call the spirit of the age? Would we not all feel different if we were asked to don Rococo costumes, wear powdered wigs, and engage in elegant conversation with a lady sipping chocolate, rather than lie on the functional roof hoping to gain in health and vigour? I am concerned in this essay with these two contrasting interpretations of the phenomenon of style. The first, that style is the expression of the age, has become a commonplace here in the West. Eastern Europe is, or was until recently, dominated by the opposite conviction, the belief that the effects of art are so powerful that they necessitate the central control and censorship of all media.

If I may use a metaphor taken from medicine, we might call the Western view that style is a manifestation or symptom of the age the 'diagnostic' approach. Such diagnostic skill has been the pride of eminent practitioners of the history of art in the past, and, if I understand it rightly, is still the aim of the so-called new art history. The opposite doctrine, which emphasizes the effects of art, be it as stimulant or as tranquillizer, might be dubbed the 'pharmacological' interpretation. Though one may not find this term in any history of criticism, the underlying idea happens to be the earlier of the two. Former centuries were interested in the effects of the arts on the human psyche as such, rather than in the passing states of mind of individual artists.[3] In Plato's *Dialogues*, we find this profound concern with the influence of the arts, particularly that of music. It is well known that he wanted sensuous and relaxing music to be banished from the ideal state; only austere and invigorating strains were to be allowed,

241

which would secure the young against corruption. No doubt Plato would have more easily approved of the couple on the roof than of the frivolous pair in the Rococo interior.

It fits my purpose, however, that the ancient world was also familiar with the diagnostic approach, in a context, moreover, that directly concerns our notion of style. It is contained in a letter by the Stoic philosopher Seneca the Younger, written in answer to the question of why it is that at certain periods a corrupt literary style comes into being. Naturally his answer is moralistic. 'People's speech,' he says, 'matches their lives;' a luxuriant style is a symptom of an extravagant society. Just as the way a man walks or moves reveals his character, so does his manner of writing.[4]

Seneca's telling example was that of the famous Roman tycoon Maecenas, a friend of the Emperor Augustus, whom we still remember and honour as a generous sponsor of the arts. The Stoics saw him in a very different light: for them his style was as undisciplined as his dress was sloppy. Giving examples of his contorted sentences and far-fetched metaphors which are, of course, untranslatable, Seneca explains, 'When you read this sort of thing, does it not immediately occur to you that this is the same man who invariably went around in casual dress ... who appeared on the bench or on the platform ... wearing a mantle draped over his head leaving both ears exposed, looking just like the rich man's runaway slave on the comic stage?'

I have not found a portrait of Maecenas showing him in shirtsleeves, as it were, while attending the ceremony at the cenotaph, nor have I been lucky in my search for exactly the type of comic slave mentioned by Seneca. But the famous relief of the Ara Pacis (fig. 339), showing Augustus at a ceremony, may remind us of the standard of dignity in dress and deportment which was *de rigueur* in the Roman world. It is precisely for this reason that Seneca's strictures present the diagnostic problem in a nutshell. I wonder if there are many people today who, on reading a passage written by Maecenas, would immediately conclude that he showed his ears. Briefly, what Seneca objects to is, of course, any breach of decorum, of the conventions that govern both the style of life and the style of speech; but to spot this breach for the purpose of diagnosis you must first know the convention.

The model art for the ancient world was oratory; it was in this art that the theory of decorum was so developed that it retained its importance as long as the classical tradition in Western art survived. It may be said to rest on the observation that linguistic usage reflects the various styles of life in

339 Augustus officiating
at an Imperial Ceremony,
13–9 BC. Marble relief
from the Ara Pacis, Rome

339 Augustus officiating at an Imperial Ceremony, 13–9 BC. Marble relief from the Ara Pacis, Rome

a hierarchical society. The lowly or humble speech of simple folk differs markedly from the grand or elevated language of the man of power. It was a breach of decorum, then as now, to use vulgar slang at a solemn ceremony, just as it was felt to be ridiculous to use solemn or grand language on trivial occasions. Seneca's reactions demonstrate the Romans' highly developed sensitivity to any departure from the norm. But mark that it is the departure that he finds telling. The norm, like the toga worn by all the dignitaries, is just a uniform; it would hinder rather than encourage a diagnosis.

An example from daily life will demonstrate this conclusion: if it is the convention in an office to say 'good morning' on arrival, failure to do so may be taken as a symptom of bad temper or bad manners. The convention itself should be of no significance to the diagnostic approach. Yet, if our elders did not think that to say 'good morning' inculcates the right attitude to our fellow men, they would not insist on teaching the convention to children. It is good for them, for 'manners maketh man'.

To return to styles of life, the first President of the Royal Academy, Sir Joshua Reynolds (fig. 340), was, of course, steeped in the classical doctrine of oratory. It might be said that all his discourses are devoted to the teaching of decorum (fig. 341). Naturally, it was the noble style, the grand manner of the canonic Renaissance masters that he endeavoured to inculcate in his students, and he rarely omitted to warn them against its opposite which he saw embodied in Dutch painting: 'It is certain', he says, 'that the lowest style will be the most popular as it falls within the compass

243

340 Sir Joshua Reynolds, *Self-Portrait as a Doctor of Civil Law, c.*1780. Royal Academy, London

341 Sir Joshua Reynolds, *Theory, c.*1799. Royal Academy, London

of ignorance itself and the vulgar will always be pleased with what is natural in the confined and misunderstood sense of the word.'[5] But Reynolds never gave up the hope that the noble style of art which he advocated might be carried over into the style of life. He believed that the Royal Academy could assist in creating a better society, but he was not a collectivist. He realized that the agents of this transformation must be individual human beings. Here is the touching conclusion of his Ninth Discourse:

> The Art which we profess has beauty for its object; this is our business to discover and to express; … it is an idea residing in the breast of the artist, which he is always labouring to impart, and which he dies at last without imparting; but which he is yet so far able to communicate, as to raise the thoughts, and extend the views of the spectator; and which, by a succession of art, may be so far diffused, that its effects may extend themselves imperceptibly into public benefits, and be among the means of bestowing on whole nations refinement of taste: which, if it does not lead directly to purity of manners, obviates at least their greatest depravation, by disentangling the mind from appetite, and conducting the thoughts through successive stages of excellence, till that contemplation of universal rectitude and harmony which began by Taste, may, as it is exalted and refined, conclude in Virtue.[6]

In other words, 'Help us to create a virtuous society'. Not that the hope that art might contribute to virtue was at all new at the time that Reynolds spoke. But usually the theme of the didactic powers of art was connected with the subject-matter artists were enjoined to paint, or perhaps to avoid. Among the subjects they were expected to paint, the great *exempla* of ancient heroism ranked second only to religious themes and were especially commended by French academic reformers in the eighteenth century.[7] What was less common in Reynolds's time was to assign such a didactic role not to the subject-matter but to the style, or manner, of painting, which, so we heard, was to elevate the minds of individuals so that they got rid of what Reynolds called 'the appetites' and preferred the contemplation of rectitude, slowly diffusing this desirable style of life throughout the whole nation.

But Reynolds would not have been the highly intelligent man he was if he had believed that this desirable aim was easily achieved. He said in his last Discourse that men are not born with the relish for arts in their most refined state.[8] However, it was precisely in this context that he had recourse to a recommendation he found in the writings of a contemporary critic, James Harris, a recommendation that may well be found shocking, but which has an important bearing on my subject. In speaking of the rules of art, which he considered to be quite immutable but unpopular, Harris suggested that we should at least pretend to enjoy good art, and that this pretence would gradually turn into second nature; in the words that Reynolds quoted, we should 'Feign a relish till we find a relish come; and feel, that what began in fiction terminates in reality'.[9] In other words, we are asked to practise auto-suggestion. If we are distressed to find that a work of art generally considered to be wonderful really repels us, we need not lose heart. If we say 'isn't that marvellous?' often enough, we may talk ourselves into genuine admiration. We have successfully brainwashed ourselves.

Although I would be the last to recommend such attitudinizing, not all unwelcome insights into the human psyche are wrong: we are more malleable in matters of taste than we would like to admit. But maybe our reluctance to admit it is, in itself, part of the historical change. In this respect, we are on the other side of the great divide that separates our conceptions of art and expression from those which Reynolds had inherited from the classical tradition. For that earlier tradition, as I have indicated, the model art was oratory, the art of arousing emotions. We still assign this role to what are called the performing arts, such as acting or music making. In these arts, the relation between emotion and expression

may be said to be inverted. The expression may come first and engender the emotion, so that 'what began in fiction, terminates in reality'. Think of Hamlet's comment on the actor who weeps real tears in describing the death of Hecuba: 'What's Hecuba to him, or he to Hecuba, that he should weep for her?' The actor, we would say, has talked himself into that grief; the lines have affected him as they were intended to affect the audience. Reynolds had no doubt that this mechanism, which we describe with an engineering metaphor as 'feedback', should always be taken into account in discussions of his own art. His admiration for the great masters of the past led him to imitate them – a practice he also commended to others – as when he modelled his portrait of *Mrs Siddons as the Tragic Muse* (Dulwich Picture Gallery) on Michelangelo's *Isaiah* on the Sistine ceiling.[10] He wrote 'our hearts frequently warmed in this manner by those we wish to resemble, will undoubtedly catch something of their way of thinking; and we shall receive in our own bosoms some radiation at least of their fire and splendour'.[11] Far from advocating hypocrisy when he proposed that we go through the motions of 'relish till we feel it', Reynolds simply placed his trust in feedback. As a Platonist he firmly believed in the objective validity of the values he admired, and hoped we would also be led to discover them.

If you read his Discourses, however, you may feel that he fully realized that the tradition he defended was already under threat. This threat came precisely from the alternative theory of expression that was eventually to win the day. You find him constantly warning his students against a facile belief in inspiration and the fashionable cult of the 'original genius', who has no need to learn from tradition.

We all know that the ideal of art as noble and ennobling that Reynolds espoused was unable to withstand the assault of the rival values that clustered around the slogan of sincerity.[12] M. H. Abrams, in his seminal book *The Mirror and the Lamp*,[13] has traced this momentous shift to subjectivity that arose in the late eighteenth century, affecting the style of life as much as the style of art. It may be no accident that Jean-Jacques Rousseau, who flaunted his sincerity in his *Confessions*, had himself portrayed by Allan Ramsay (National Gallery of Scotland, Edinburgh) without the powdered wig which was still *de rigueur* for most of Reynolds's sitters. No doubt, the transformation of society we connect with the French Revolution reverberated in the arts. If ancient rhetoric and its descendants had reflected the social hierarchies extending from the grand to the humble, it is not surprising that the grand manner was now identified with affectation, while the humble had the appeal of sincerity. It

is well known that one of the manifestos of this new ideal was the preface added in 1800 by William Wordsworth to the second edition of his *Lyrical Ballads*, in which he described poetry as 'the spontaneous overflow of powerful feelings' and attacked the current ideals of 'poetic diction'.[14] Among painters, of course, it was John Constable who never ceased to criticize what he called 'manner', and who strove all his life to discard artificiality for the sake of sincerity. To what extent this adoption of a deliberately humble style (to speak in rhetorical terms) was felt also to express or manifest a style of life can be discerned in the passage John Ruskin devoted to Constable in his *Modern Painters*. Ruskin, the champion of Turner's Grand Manner and poetic diction, believed that Constable's 'early education and associations were ... against him: they induced in him a morbid preference for subjects of low order ... yet', Ruskin grudgingly admits, 'his works are to be deeply respected, thoroughly original, thoroughly honest, free from affectation, manly in manner.'[15] In other words, Ruskin understood him, but did not like him.

Ruskin's preferred form of sincerity was that of the Pre-Raphaelite Brotherhood, whose very name proclaims the rejection of Raphael, the idolized master of the Grand Manner. If proof were needed of the extent to which what is experienced as expression depends on the departure from the expected norm, it might again be found in Ruskin's words. He praises the Brotherhood 'for the principal resistance they had to make ... to spurious beauty, whose attractiveness had tempted man to forget, or to despise, the more noble quality of sincerity'.[16]

We need not doubt that painters such as Holman Hunt, the creator of *The Hireling Shepherd* (fig. 342), felt particularly sincere in rejecting such theatricalities and sensualities as displayed in William Etty's *Venus and her Satellites* (fig. 343). What is relevant to my subject is only their dubious conviction that the earlier Italians, such as Fra Angelico, may have lacked the technical mastery of later periods but were, for that very reason, more sincere than Raphael. The cult of the so-called Italian 'Primitives' in the nineteenth century was rooted in this conviction. The travellers to Italy stood entranced in front of the frescoes by Giotto (fig. 344) and enjoyed what they took to be the expression of a better age; indeed a paradise of innocence. Consider the introduction of the chapter on Giotto in Lord Lindsay's *Sketches of the History of Christian Art* of 1846:

> The period we have now to deal with is one, comparatively speaking, of repose and tranquillity – the storm sleeps and the winds are still, the currents set in one direction, and we may sail from isle to isle over a

sunny sea, dallying with time, secure of a cloudless sky and of the greetings of innocence and love wheresoever the breeze may waft us. There is in truth a holy purity, an innocent naïveté, a child-like grace and simplicity, a freshness, a fearlessness, an utter freedom from affectation, a yearning after all things truthful, lovely and of good report, in the productions of this early time, which invest them with a charm peculiar in its kind, and which few even of the most perfect works of the mature era can boast of.[17]

You need not be an art historian to recognize in this dream a complete figment of the author's imagination. The period of Giotto was also that of Dante, when the streets of Florence resounded with the clash between the

Guelphs and the Ghibellines and the exiled poet painted a fearful picture of the wicked goings-on in his native city. No wonder I have so little patience with the notion that the style of art expresses the spirit of the age. There never was an age to match the majesty of Giotto's paintings.

And yet it may have been the appeal of these fanciful interpretations of the art of the past which contributed to the insistent demand that the artists of the present should also, in their turn, express their own age. Not that it is surprising that Daumier's dictum 'il faut être de son temps' ('one must be of one's time') gained so much ground among nineteenth-century artists.[18] The change brought about in the style of life by the Industrial Revolution, the coming of the railways, the growth of the cities, and the achievements of medicine were bound to raise the question of why artists should continue to paint Greek gods or knights in armour rather than *la vie moderne*,[19] which so enchanted Baudelaire in the paintings of Constantin Guys.

Courbet was one of many to insist that 'art … for an artist is merely a means of applying his personal faculties to the ideas and the things of the period in which he lives'.[20] But then, what is this period, this age? It is a commonplace that at any time the stage of history is crowded with several generations of people of infinitely diverse views, influences, power and taste. Here the theory of progress could come to the rescue by postulating that those who remain stuck in the past do not count. The age is identified by the avant-garde which alone represents the march of history. It was no doubt this persuasive creed that led to that deification of history which Popper has called historicism,[21] the faith in an underlying plot or plan that inevitably carries mankind forward to a higher mode of existence.

It was Hegel in Germany who provided a metaphysical foundation for this creed, Karl Marx who attempted to turn it into a predictive science, and Hegel's translator Hippolyte Taine, in France, who popularized it in more sociological terms. By the turn of the twentieth century this utopian promise had gripped the minds of many artists, especially the architects who felt it necessary to catch up with their time after generations of stylistic eclecticism. The opinions of the American architect Louis Sullivan, who is credited with the creation of the skyscraper, are a case in point: 'The art of the people', he wrote, 'is a reflex or direct expression of the life of that people … At no time and in no instance has architecture been other than … an emanation of the inmost life of the people.'[22] It was this conviction that turned so many architects into utopian reformers, in particular Sullivan's Austrian disciple Adolf Loos, who in vain tried for so long to transform the lifestyle of his Viennese fellow citizens.

I remember a recent lecture by one of our leading architects whose work I frequently admire but whose argument – that we must accept it because it is of our time – I ventured to criticize. Why did he think he was more of our time than the rest of us, I asked. He was genuinely baffled. And in a newspaper article it was recently suggested that in order to educate public taste the Royal Academy should at all times be 'slightly ahead of its time'.[23] You may wonder why I am making such heavy weather over what is apparently a purely intellectual issue. I wish it were. I have alluded at the outset to the consequences of the Platonic view of the effects of art on society which led the Greek philosopher to propose forbidding certain types of music in his ideal republic. Unhappily it has been demonstrated that an even more explosive mixture arises if what I have called the 'pharmacological' interpretation of art is fused with the view of art as a symptom. I think this is precisely what happened in the totalitarian dictatorships of Germany, Italy, Russia and China.

That dismal story has recently been chronicled in a well documented and illustrated book by the Russian *émigré* Igor Golomstock entitled *Totalitarian Art*.[24] No one needs to be reminded of the fact that in National Socialist Germany modern movements were outlawed and branded as 'degenerate art',[25] but the tragic element in this episode may still require our attention. What was so tragic was that many of the champions of these movements, especially in Germany, were inspired by the conviction that in rejecting the styles and conventions of the nineteenth century and in turning their back on the study of nature, they were preparing the ground for a new epoch of pure spirituality. This goes for Emil Nolde (fig. 345), who flirted with National Socialism, no less than for Wassily Kandinsky, whose book on *The Spiritual in Art* is a manifesto of messianism. Instead, of course, the new Messiah in the person of Adolf Hitler decreed that it was he alone who would decide what the future age and the new man of the coming millennium should be like. This may have been Platonism gone mad, but in pillorying the alternative trends as degenerate, he was using the language of the diagnostics of art. Nor is the medical metaphor here inappropriate. In nineteenth-century medicine the problem of heredity and degeneracy had begun to loom large, but what had started in a purely clinical context soon gripped the imagination of writers and critics.[26] Heredity was to take the place of destiny. Zola's cycle of novels, *Les Rougon-Macquart*, set out to trace the fate of a family in terms of heredity, and Nietzsche was to lay down that morality itself was a symptom of decadence manifest no less in Socrates than in Richard Wagner. There is an added irony in the fact that it was an ardent Zionist, writing under the

345 Emil Nolde, *The Last Supper*, 1909. Statens Museum fur Kunst, Copenhagen

pseudonym Max Nordau, who provided ammunition for the Nazis when he made a splash late in the century with a book entitled *Entartung*.[27] In it, he proved to his satisfaction that all the artists he did not like or could not understand, including Whistler and Cézanne, were decadent. To make things worse, some artists even fell for the slogan and gloried in the idea that decadence was something to be welcomed because it distinguished the refined and sensitive creator from the stolid and robust bourgeois. No wonder the bourgeoisie was delighted by this confirmation of its worst prejudices, and decided that any departures from accepted norms were symptoms of degeneracy.

It needed the Platonic ingredient, however, to justify the interpretation that degenerate art was also a poison that had to be destroyed lest it corrupt the health of the nation. This national health could only be secured and fortified by images of heroism and physical beauty. Italy, it seems, was saved from a similar tragedy largely, perhaps, because the Italian Modernists who made the headlines early in the century were in fact precursors of Fascism. These were the Futurists who loudly proclaimed the need to smash the old and create a utopia of fast cars (or at least bicycles) and glorious wars (fig. 346). I am old enough to have heard their spokesman, Marinetti, in Vienna, giving a reading of his Futurist poetry more than sixty years ago. I am afraid that I thought he was just a clown, for I was struck by the ludicrous contrast between his dandified

346 Umberto Boccioni, *Dynamism of a Cyclist*, 1913. Mattioli Collection, Milan

appearance – down to his remarkably resplendent shoe-shine – and his wild revolutionary talk as he howled in imitation of the noise of the machines he so admired (fig. 347).

It appears from Golomstock's book that the artist of the Russian avant-garde largely shared his megalomaniac ideology. They, too, aspired to refashioning the human psyche for the coming age. From that book I learnt that a certain Aleksei Gastev, a leading Communist, demanded that 'the art-worker must stand beside the man of science as a psycho-engineer … propaganda towards the forging of the new man is in essence the only content of the works of the futurist.' This view was later echoed by Stalin.[28]

In Russia, no less than in Germany or China, those who held the levers of power had their own ideas about the future utopia and demanded an art that was almost indistinguishable from that of Nazi Germany (figs. 348, 349). Yet, however tightly the frontiers were controlled, alternative views and alternative images could not wholly be kept out. The attractions of forbidden fruit were irresistible. It was precisely the style of art that was banned that seemed to embody a style of life infinitely more desirable than the one to which the majority was condemned.

It would be interesting to trace these influences and effects in more detail – the lure of pop music or of abstract art – but surely the most decisive impact must have been that of Western television programmes that could be watched in East Germany, for these did not simply symbolize a style of life, they appeared to show it, however false and distorted they may have been in detail.

347 Filippo Marinetti
in Vienna, 1924

348 Josef Thorak,
Comradeship, made for
the German Pavilion at the
International Exhibition,
Paris, 1937

349 Vera Mukhina, *Worker
and Collective Farm
Woman*, made for the
Soviet Pavilion at the
International Exhibition,
Paris, 1937

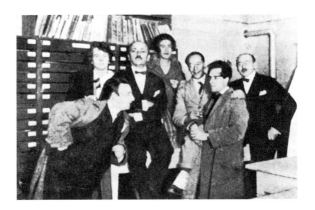

It is a relief to be able to look back on that nightmare as a thing of the past. But one must agree with those who remind us that its consequences are by no means over. In the united Germany and elsewhere, both East and West, it will prove far from easy to separate political opportunism from artistic achievement. The Royal Academy, of course, has come to display an admirably even-handed pluralism in its Summer Exhibition, but

elsewhere the unholy link between ideological alliance and artistic preference has not yet been broken.

I do not think this is a proper subject for moral sermons, it deserves sober analysis. Such unbiased analysis is too rarely found in the literature and criticism of art, but meanwhile another discipline has grown up that may well take its place – the field of social psychology.

I do not want to introduce a discipline in which I have never been at home as a kind of *deus ex machina*. I am not enamoured of its jargon, but at least it offers a fresh start because its preferred instrument, the questionnaire, must take its cue from the individual in a given situation. It is naturally all done in the interest of the market rather than that of the art historian. Perhaps my only credential for mentioning this approach is the fact that one of its pioneers, Pierre Bourdieu, occasionally quotes me in his book significantly called *La Distinction* with the witty subtitle *Critique sociale du jugement,*[29] a polemical counter to Kant's *Critique of Judgement*. In contrast to Kant, who regarded the aesthetic judgement as wholly devoid of self-interest, Bourdieu seeks to investigate the human urge, and the need of groups to establish their distinctive identity by separating their style of life from those they consider their rivals, their inferiors or even their superiors.

No doubt this need has always existed. There is no tribe, nation or class that does not want to distinguish itself from its neighbours. Thus, there is an instructive parallel between the belief in the Spirit of the Age and those other forms of collectivism such as racialism and nationalism which I mentioned at the outset of this essay. Just as the historian learns to distrust the clichés about periods and ages as soon as he delves more deeply into the events of the past, so the serious traveller will come to dismiss the facile generalisation about races and peoples which have always loomed so large in the popular imagination. He will be struck by the differences in the styles of life he encounters, but here as always the question arises to what extent these peculiarities should be seen as the outward 'expression' of some invisible essence that is common to all members of the group. Is it not more likely that what is experienced as 'national character' is rather due to the cumulative 'impression' of shared conventions and traditions, in other words to culture?[30]

I was confronted with this question when I was assigned the task of lecturing to Austrian prisoners of war in this country towards the end of the Second World War. Admittedly, these men had every incentive to stress their national identity, since they hoped thereby to be released ahead of the Germans. But the form in which they insisted on *la distinction* still

struck me: we are easy-going, they are rigid, we have the waltz, they their military marches. As a born Viennese who has never mastered the waltz I had never taken these stereotypes at all seriously, and I was aware of too many famous and infamous Austrians to whom they never applied. Yet, these simple people evidently believed what they said, and I began to ask myself whether the image they had of themselves was really so irrelevant. Could it be that dancing to the music of 'their' Johann Strauss would bring out a different aspect of their personality which might have been suppressed or undeveloped if they had always been exposed to Prussian marches? To be sure, we know to our cost that such feedback effects have their limits; both self-interest and propaganda can blot them out, and so can the change of generations.

It is with these changes over time that we must concern ourselves in returning to the form of collectivism known as the Spirit of the Age. We know that the young can easily be persuaded to establish their identity *vis-à-vis* the older generation by a different type of music, a different language or art. No doubt the ideology of progress facilitated such a break with the past in conservative societies, but there were other social factors contributing to the acceleration of change. To put it briefly, the old pecking order embodied in the hierarchical structure of society has been much weakened through increasing mobility. When Reynolds spoke to his students about vulgarity and grandeur, they recognized and accepted the social overtones of these terms, and even when the French *bohémiens* proclaimed their aim to *épater le bourgeois*, they knew from which social class they wished to distinguish themselves. Our society is certainly far from classless, but it is much less structured than in the past. Alas, even welcome developments can have less desirable side-effects, for man remains a social animal, always seeking the shelter of a group. You need only look out into the world to see how the disintegration of a large power structure has led to the appearance of any number of sub-groups protesting their separate identity. Hence, also, the tendency that we observe nearer home to replace traditional élites by novel groups of anti-élitist élites which mark our so-called youth culture.

I have been interested for some time in the way fashion models are expected to stand or move. These changing conventions seem to me a perfect testing ground for the theory of feedback in expression to which I have alluded. Try to adopt the contrasting postures of the two models illustrated here (figs. 350, 351) and you will know what I mean. The posture not so much expresses a given state of mind as affects it. It might be easier to make polite small talk if you follow the role model

of 1910 than if you adopted the stance of the young lady I took from an issue of *The Observer*.

One wonders what Seneca would have thought of that young lady's attire and deportment; maybe he would have been correct in his diagnosis that she had no use for syntax and spelling. But there is still a difference between her appearance and that of old Maecenas censured by the philosopher. The Roman obviously thought he need not care for decorum because, after all, he was on top. His behaviour was rather that of arrogant disdain described and recommended in Castiglione's *The Courtier* as *sprezzatura*. The modern version suggests a strenuous effort to break all the taboos in the book. Any manual of deportment for young ladies will show what I mean. Here, as always, it is the deviation from convention that is intended to impress you, but as soon as the deviation turns into a convention of its own, what I have called the 'logic of vanity fair'[31] leads inexorably to its demise. For all I know that development may already have started, and we may be in for a post-modern ideal of anti-anti-élitism in fashion as well as building.

I have little doubt that this kind of process has been accelerated in our time by the medium of television that beams new role models into practically every home, and serves vested interests in a rapid turnover. But the psychological and social forces on which it relies govern not only the change of fashions but also the styles of art.

Art takes longer to produce and to market than clothing, but I believe

that the desire for *la distinction* has rarely been absent from the movement of artistic styles. I think that in studying contemporary records and memoirs we can sometimes catch these movements on the wing, as it were, and I should like to quote two such examples. The first is a passage written by G.K. Chesterton in 1904. Chesterton was writing a biography of Watts (fig. 353), who was still alive at the time, yet he felt compelled to defend his enterprise of celebrating a master of what was obviously already a bygone epoch:

> There is no more remarkable psychological element in history than the way in which a period suddenly becomes unintelligible. To the early Victorian period we have in a moment lost the key. The thing always happens sharply: a whisper runs through the salons. Mr Max Beerbohm [fig. 352] waves a wand and a whole generation of great men and great achievement suddenly looks mildewed and unmeaning.[32]

What was that whisper that ran through the salon? I suppose it was the phrase *vieux jeu*. It is sometimes sufficient to adopt a certain tone of voice in pronouncing such words as 'earnest' or 'grand'; the same quality can then easily be termed 'portentous', 'theatrical', 'corny', or 'kitsch', and a

352 Max Beerbohm, *Self-Portrait*, from *The Poets' Corner* (London and New York, 1943)

353 G.F. Watts, *Hope*, 1860. Tate Gallery, London

257

whole mode of art can be dismissed as slightly embarrassing. Remember how the words 'sentimental', 'anecdotal' and even, I regret to say, 'academic' changed colour to signify all that has become taboo. It would be interesting to write a history of art in terms of such rejections and pet aversions. It might suggest that really we should reverse the advice we took over from Harris that we should 'feign a relish till we feel it'. The improved version might read 'mock a relish till no one feels it'. In fact, it is not so much common ideals that mark a period as common aversions. These aversions, luckily, still leave plenty of scope for the young artist to do what he wants – well or badly – provided he heeds those social prohibitions. Thus, in somewhat approximating the history of artistic taste to fluctuations in fashion, we are in no need whatever to surrender to relativism in aesthetics as Bourdieu has done. You need only think of the artistic scene in England around 1904, when Chesterton was writing, and of the various gifts and talents displayed by such artists as Walter Sickert (fig. 354), Wilson Steer or Augustus John. They all preserved their artistic integrity, but I would be surprised to see a painting from that period that emulated the high-minded ambitions of Watts.

354 Walter Sickert, *Ennui*, 1914. Tate Gallery, London

Naturally, within this wide latitude, new nuclei and new antagonisms arise which may turn into trends or even styles. The mechanism is tellingly illustrated in a book called *Evolution in Modern Art* written in the 1920s.[33] The author recalled how at the beginning of the century during his visits to Paris artistic friends would try to wean him away from his lazy visual habits which had prevented him from appreciating the Impressionists, and how they ultimately succeeded in convincing him on their joint walks that shadows were not always grey but sometimes purple.

Some ten years later, on another visit to Paris, Frank Rutter found the young artists were no longer interested in the true appearance of nature but only in abstract ideas and theories. 'A new phrase was an inspiration, a new word, a joy. One day a painter I knew accompanied ... a student of science to a lecture on mineralogy. He returned from an improving afternoon with a new word – *crystallization*. It was ... destined to become a talisman.'[34] Sitting in a cafe soon after, Rutter recalls that he incautiously remarked that he admired Velázquez. 'Velázquez', was the outraged reaction, 'but he has no crystallization.' We do not have to accept this story as gospel truth to regard it as an instructive parable. Of course, Rutter was wrong in insinuating that it was this chance encounter that led to the rise of Cubism, but even if he had been right this would not explain the originality and wit with which Picasso and Braque made a new kind of painting out of such an uncompromising slogan (fig. 355). As a committed individualist, I do not think that the social pressures of which I am speaking can ever determine or explain the talent that can lead to mastery, but they cannot be left out of the equation when we want to account for their success or failure. The launching of any innovation can be seen as a social experiment, and the radical departure from the norm represented by Cubism would surely have remained stillborn if the ground had not been prepared by the ideology of historicism, the fear of being left behind in the march towards the unknown future. If Cubist painting required an effort to relish, the air was full of rumours about other startling novelties in occult creeds, in philosophy and the sciences which appeared to fly in the face of common sense.[35] In stressing that a taste for these visual conundrums was an acquired taste, I am not trying to suggest that the game was not worth the candle. Indeed, those who discovered its pleasures could experience , in Reynolds's famous words, 'a feeling of self-congratulation in knowing themselves capable of such sensations'.[36] The rewards of achieving *la distinction* could not be more neatly summed up.

Aesthetics is not an exact science; neither is social psychology. Who would dare to quantify the proportions of objective and subjective

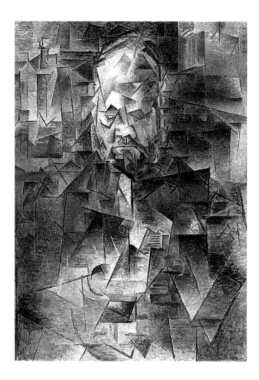

355 Pablo Picasso, *Portrait of Ambroise Vollard*, 1909–10. Pushkin Museum, Moscow

ingredients in the chemical compound of such an experience? Even so, I realize that in assigning the role of a catalyst to the whispers and slogans current in Paris among artists and intellectuals at the time, I may seem to have made concessions to my bugbear, the spirit of the age. I hope, however, that I may insist on the difference between such a causal hypothesis and the claims of our diagnosticians to discern in Picasso's cubism a symptom of the same Zeitgeist that also manifested itself in Einstein's Special Theory of Relativity.

Having traversed so much ground, it is surely time for me to return, after the bumpy ride, to our initial examples. It is not difficult to discern the principles of exclusion or avoidance that link the styles of art illustrated by Osbert Lancaster to their respective styles of life. No doubt, the social élite that cultivated the Rococo in eighteenth-century France and Germany (fig. 337) desired to eliminate from their environment and their mode of life anything that was uncouth, boorish, angular, and unrefined, just as the earnest pair on the roof (fig. 338) felt all the better for having shunned the vulgarity of ornament which they considered to be close to crime. It may well be that the fulfilment of this desire also 'brought out' certain tendencies of their personalities, such as playfulness in the

one, briskness in the other, tendencies that may conceivably also have coloured their choice of words, their gestures, and facial expressions.

But even if, as I suggested at the outset, donning Rococo attire may make us 'feel different', we must not be tempted to conclude, as certain historians have done, that 'Rococo man' was altogether a different species, having nothing in common with his twentieth-century descendant.[37] It was this fatal illusion that led to the utopian attempt by the '*terribles simplificateurs*'[38] to fashion a 'new man' by controlling the powers of art. Here the puppet master was bound to fail, for human beings exist on many levels. They may yield to social pressures in one respect, and jealously guard their privacy in another. The man in the boudoir may have been a faithful member of the church or an avid reader of Voltaire, just as the pair on the roof may have been devotees of science or members of a cranky cult. We must never forget that style, like any other uniform, is also a mask which hides as much as it reveals.

Chapter 11 What Art Tells Us

Review of Francis Haskell, *History and its Images: Art and the Interpretation of the Past* (New Haven and London: Yale University Press, 1993), *New York Review of Books* (21 October 1993), pp. 60-2; reprinted with revisions.

With his splendidly written and beautifully produced book Francis Haskell has broken entirely new ground. There are libraries full of books on the history and method of historiography dealing with the development of historical criticism, the use of charters and documents, and (more recently) with the statistical evaluation of personal records, but none of them is much concerned with the use of visual evidence by historians. Not that the reader should expect or fear to encounter lengthy disquisitions on method. Instead, the author adopts the good old approach that goes back, at least, to Aristotle, of confronting any fresh problem by reviewing the contributions of his predecessors. True, while Aristotle generally devoted a few perfunctory sections to such retrospection, Haskell has filled no fewer than 495 learned pages, rich in vivid anecdotes and half-forgotten incidents.

That, all the same, he had to be selective in this pioneering effort should go without saying; selective not only in the figures he chose to deal with, but also in the problems posed by visual evidence in the wider sense. In this respect the book clearly divides into two distinct parts. The first four chapters deal with what the author calls 'the discovery of the image'. Here he is mainly concerned with the factual information that, between the fifteenth and eighteenth centuries, numismatists, antiquaries, and archaeologists tried to extract from the monuments of the past about portrait likeness, rituals, and what was called *realia*, the form of weapons or apparel and other equipment. The ninety-two excellent illustrations enlivening this section help to introduce the reader to an important but rather neglected episode in the history of historiography.

At this point, however, the author breaks off his account of the extraction of information from visual evidence, though his preface reveals

that he is fully aware of leaving it incomplete. Indeed to fill this gap would need a volume of at least the same size, taking the history of archaeological investigations up to the present day. It would have to pay tribute, for example, to the Protestant theologian Ferdinand Piper, whose oddly named *Einleitung in die monumentale Theologie* (Gotha, 1867) has still not been superseded as a guide to Christian archaeology.[1] Neither could it omit such spectacular uses of visual evidence as the discovery by a French cavalry officer, Lefebvre des Noettes, that the methods used by the ancients for harnessing their horses deprived the animals of their strength by cutting off their windpipes, and that it was only in the Carolingian period that we find illustrations showing the reform that multiplied what we still call 'horsepower'.[2]

However, it was certainly not this kind of incidental information that Ruskin had in mind when he wrote in 1884 that great nations write their autobiographies in three manuscripts: the book of their deeds, the book of their words, and the book of their art. Not one of these can be understood unless we read the two others; but of the three, the only quite trustworthy one is the last.[3] Even after more than a century this claim is still frequently advanced in academic life, and we must be grateful to Haskell for having devoted the second and longer part of his book to the debate it engendered in the past.

Here, as in the first section, Haskell presents us with a gallery of unforgettable portraits. We make the personal acquaintance of Andrea de Jorio, the explorer of Neapolitan gesture language; that learned antiquarian the Comte de Caylus, who was so shabbily treated by Winckelmann and Lessing; William Roscoe, the biographer of Lorenzo de Medici; Alexandre Lenoir, the creator of the *Musée des Monuments Français*; Michelet, the great historian of France; 'Champfleury', the student of folk art; and Huizinga, the famous cultural historian, to mention only a few. Given such a fascinating cast of characters, one would have no right to complain that not all participants in this debate are given their due.

The one question that is somehow left open is that of the transition between the first and second part of the book. How did the history of art, which in earlier periods consisted mainly of the biographies of artists, become transformed into the history of styles ready to offer a key to the past? The author was certainly aware of this lacuna: indeed he decided to begin the second story *in medias res*. Opening his chapter on 'The Arts as an Index to Society', he writes correctly that 'by the 1840s it had become almost conventional to assert that the arts of a country could give a more reliable impression of its true character than those more usual yardsticks

… which had hitherto been made use of by historians'; and he adds, equally correctly, that it is 'very difficult to follow the exact processes of thought that led to this conviction'. The seventeen pages that follow introduce the reader to three of the crucial figures in this process, Winckelmann, Herder and Hegel, but in comparison with some of the portraits mentioned above they do not fully come to life.

One can appreciate the author's lack of sympathy for this German tradition but it is still doubtful whether we can ignore such figures as the Hegelian Carl Schnaase, whose multi-volumed *Geschichte der bildenden Künste* (Leipzig, 1842ff.) provided the first model of a marriage between cultural history and art history:

> Art too, belongs to the necessary expressions of mankind; indeed one may say that the genius of mankind expresses itself more completely and more characteristically in art than in religion. (p. 83)

> It is true that the keen eye of the beholder will also penetrate into the nature of a nation when examining its political life or its scientific achievement, but the most subtle and most characteristic features of a people's soul can only be recognized in its artistic creations. (p. 86)

> Thus the art of every period is both the most complete and the most reliable expression of the national spirit in question, it is something like a hieroglyph … in which the secret essence of the nation declares itself, condensed, it is true, dark at first sight, but completely and unambiguously to those who can read these signs … thus a continuous history of art provides the spectacle of the progressive evolution of the human spirit. (p. 87)[4]

And should the vital chapter entitled 'The Deceptive Evidence of Art' not have referred to Friedrich Nietzsche, whose *Birth of Tragedy* (1872) took issue with Winckelmann's influential interpretation of the ancient world by suggesting that the visual arts of the Greeks told us only of the Apollonian aspect of their soul, while music and drama revealed its Dionysiac side – an interpretation that rejected the monolithic nature of the spirit of the age, and that also influenced Aby Warburg?

This may be the point at which it seems in order for me to insert what in legal parlance is called a 'declaration of interest', for it so happens that I was personally involved in this issue and – strangely enough – on both sides of the battle line. In 1947 the great Romanist and medievalist Ernst

Robert Curtius published an advance extract of his book *European Literature and the Latin Middle Ages*, in which he attacked the very claims about visual evidence with which Haskell is concerned.[5] Texts, he reminds his readers, are either intelligible to us, or not. They contain difficult passages which can only be unriddled by philologists. The student of art has an easier life:

> He works with images – and lantern slides. There is nothing here that is unintelligible. To understand Pindar's poems we have to rack our brains. That does not apply to the Parthenon frieze. The same contrast obtains between Dante and the cathedrals etc. The scientific study of images is effortless compared with the study of books. Our students know that very well. If it is possible to grasp the 'essence of gothic' from cathedrals, you no longer have to read Dante. Quite on the contrary! The history of literature (and that awkward discipline, philology) must learn from the history of art.

The author of this broadside had been a friend and admirer of the Warburg Institute for many years, and its director, Fritz Saxl, was disturbed by its implications. It had been his hope to make Warburg's method of interpreting the cultural significance of images palatable to British historians by stressing precisely that images no less than charters could offer valuable historical evidence. Accordingly he instructed me, who was working at the time on Warburg's papers, to expostulate with Curtius and to defend the study of images. Frankly, I was not very happy about this task since I largely agreed with Curtius. I have described elsewhere[6] that the easy option which Curtius derided had in fact appealed to me while I was still at school, but that I had been convinced of its fallacies in my university years. All I could do was to write a letter (which has meanwhile been published)[7] conceding the points made by the great scholar but reminding him of the fact that even works of art (such as the Parthenon frieze) can only be understood in any sense of the term by 'racking our brains', by exploring, for instance, the ritual of the Panathenaic procession.

I did not know at the time that Curtius's championship of philology against the study of art was not the first of its kind. We catch a glimpse of a similar debate in Goethe's *Annals* for 1805:[8] intending to devote a literary memorial to Winckelmann, Goethe and his Weimar friends had invited a contribution from the most famous classical philologist of his time, Professor Friedrich August Wolf. He found the great scholar somewhat

unresponsive to these concerns, for it turned out that Wolf only regarded written testimonials of the past as worthy of attention. Goethe and his friends, so we read, had chosen a different path. Their passionate love of the visual arts had created in them the conviction that art too should be viewed historically, an approach which Wolf stubbornly rejected. 'We were unable to make him admit that our documents were equally valid as were his but we derived the advantage from this conflict that all the arguments pro and con were ventilated, so that everybody profited.'

How one would wish to have been present at these debates! It appears that what Goethe and his friends argued most of all was that it was possible to arrange images in an historical sequence, and here, surely, they were right. It cannot be denied that the history of image-making provides in this respect an easy access to historical change as such. It is less laborious to compare a Madonna by Giotto with one painted by Simone Martini than to compare a sonnet written by Dante with one by Petrarch. No wonder art collectors and museums had begun even in Goethe's time to arrange their treasures historically and to give the visitor a vicarious experience of the passage of time.

What Haskell may have overlooked is precisely that the study of the visual arts has more affinity with history than, say, the study of diplomacy. Many cultures have erected memorials and monuments to tell future ages of specific events or to secure that these events were seen in certain ways. In many cases these monuments, in their turn, proclaimed to later periods their old age by the very way they were fashioned. To be sure the language of inscriptions, indeed their letter forms, may also indicate the passage of time to initiates, but in certain ages the art and skill of image-making changed so rapidly that their very transformations aroused the curiosity of later generations.

Thus one of the central notions of historiography, the idea of progress, became intimately associated with the images of the past. Pliny in the ancient world and Vasari in the Renaissance offered the paradigm of a technological history which assigned specific inventions and innovations for the making of images to particular masters, and also speculated on the causes of the decline of skill. Haskell has a most interesting chapter on 'The Issue of Quality' and the interpretations of declining craftsmanship, but he is less informative on another issue that became a vital ingredient in his story: the history of image-making provided a model not only for the progress of skill but also for its abuse for immoral ends. Like so many critical topics this model was no doubt taken over from the ancient writers on rhetoric, notably Plato, who condemned the misuse of oratorical skills

as a sign of depravity. Maybe it was this concern more that any other that gave rise to the idea that the health of art was an index to the health of society. Thus Shaftesbury, Rousseau and finally Winckelmann transformed the criticism of art into a species of moral prophecy.

Perhaps it would not be possible to account for this change without focusing on a shift in the cultural role of art of which Winckelmann's message is itself only a symptom. M.H. Abrams, to whom we owe so many insights into the origins of the Romantic movement, has drawn attention to the novel approach in the eighteenth century to what he calls 'art as such'.[9] Earlier periods would speak of painting, sculpture or the other arts as skills to be admired and treasured, but the idea that exposure to the works of the past would be an improving experience arose only in the wake of the Grand Tour and of the idealistic travellers who looked for guidance to philosophers such as Shaftesbury. In the opinion of these prophets the very power of images to impress the mind increases their ability not only to inspire but also to seduce and corrupt. It was in this sense that the arts came to be interpreted as an 'index of society'. A sensuous art could only be the symptom of a corrupt society, all the more guilty in that sensuality also infected religious imagery. Here, perhaps, is one of the elements of the revolution that was to place art right in the centre of historical awareness. It is hard to say what share Rousseau's denunciations of society had in this development and what share had the blasphemies of the French Revolution against established religion. In any case there was an easy transition from the 'noble simplicity' exalted by Winckelmann to the 'pious simplicity', the ideal that the early Romantics such as Wilhelm Wackenroder and the Nazarenes saw embodied in the arts of the early Renaissance, before sensuality had corrupted even the soul of the divine Raphael.

Of course it would be absurd to accuse Francis Haskell of having ignored the importance of religious art in his story. After all he earned his first laurels in demolishing the myth of 'Jesuit art', which attributed to that order the intention of using all the theatrical tricks of the Baroque to achieve their political aims, and he returns to this issue in his chapter on Hippolyte Taine. But even Taine, who prided himself on his scientific objectivity, could not avoid interpreting the art of the past in moral terms. Basically it was always this moral interpretation that divided the minds of the critics in the nineteenth century. The same developments which could be celebrated as triumphs of progress could also be condemned as symptoms of decline. It was in particular in the evaluation of the Renaissance that these divergences came to the fore. What

Chateaubriand, Pugin and Ruskin denounced as a departure from the purity of medieval art was acclaimed as progress by Lenoir, Hegel, Michelet, Taine, Burckhardt and Warburg. Not that any of the latter would have wanted to renounce the historian's right to diagnose certain stylistic trends as decadent; but their standards varied with their general bias.

What secured the survival of Hegel's philosophy among the interpreters of art may well have been its capacity to reconcile these opposites through the device of the dialectic. Without the decline of certain modes of art there could have been no general progress, because mankind had advanced by discarding the obsolete. Haskell does not concern himself with the theory of the avant-garde in the battles about contemporary art, but he deals with one bizarre consequence of this metaphysical view of progress, the interpretation of art as prophecy that follows from the belief that the artist will anticipate the movements of history. Whether all of Haskell's examples can be easily so classified is a different matter. It is surely not irrational to discover by hindsight that certain tendencies in past ages manifested themselves later in such dramatic events as the Reformation, the French Revolution or the Great War. Naturally such fulfilments could and did also strengthen the irrational belief in the predetermined course of history which Karl Popper has dubbed 'historicism'.[10] Even so, faith in progress never quite ousted the belief in decadence and decline – indeed our century has witnessed support for the belief in decadence in the activities of the secret police in both Nazi Germany and the Communist East.

Haskell rightly refrains from commenting on these excesses. But maybe even his last chapter might have profited from a greater awareness of these perennial questions. His book culminates in a memorable chapter on 'Huizinga and the "Flemish Renaissance"', in which the dilemmas of the great Dutch cultural historian are presented as a final example of the problems posed by all interpretation of the art of the past.

From the time of Vasari (if not earlier) the 'invention of oil painting' attributed to Jan van Eyck had been regarded as an important contribution to the progress of art – on a par with the invention of linear perspective. No wonder that art historians north of the Alps liked to celebrate this achievement as equal to that of the Italian Renaissance. Haskell demonstrates the importance this evaluation acquired among nationalists at the time of the great exhibition of Flemish painting in 1902 in Bruges. Over a period of three and a half months, beginning in the middle of June 1902, some 35,000 visitors walked through the immense entrance hall and

vestibule of the Palais Provincial and up the monumental staircase, all of which had been decorated with medieval tapestries lent by the Rothschilds, the Somzées and other private and public owners. The small, badly lit room that faced them on the first floor was devoted to the Van Eycks, their predecessors and their immediate successors; and the two gaunt nudes lent from Brussels were thus among the first works to strike the crowds. The impact was overwhelming and set the tone for much later discussion on Flemish art. They had, it was claimed by one critic, been painted 'with a sincerity, indeed a brutality, which astounds even the most modern of our own realists'. Facing them, in the place of honour, was the *Virgin and Child in the Presence of Saints Donation and George and Canon G. van der Paele* (fig. 356): it was the 'grave, withdrawn' features of the prior, unsurpassable even by Dürer, that made the greatest impact in this richly coloured masterpiece, and one critic felt inspired to write that it was the 'most realist picture that can be conceived, not, of course, through its choice of subject, but through its conception of art, which is the essential

356 Jan van Eyck, *Virgin and Child in the Presence of Saints Donation and George and Canon G. van der Paele,* 1436. Groeninge Museum, Bruges

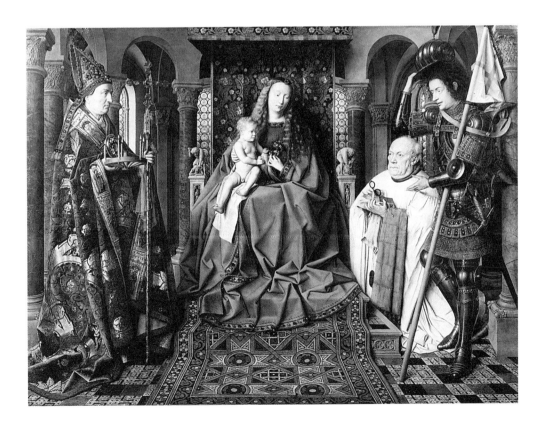

point. Courbet "who had never seen angels" is no more rigorous a realist than Jan van Eyck who painted them.'

What makes the episode so decisive for Haskell's general theme, however, are the doubts about this interpretation which Huizinga began to harbour. Huizinga's most famous work, which rivals in power and richness Burckhardt's *Civilization of the Renaissance in Italy*, bears the title *The Waning of the Middle Ages*, and indeed his analysis is devoted to symptoms of decadence in the culture of the period. But was there not a contradiction, Huizinga asked, between this diagnosis and the general view of its art? It was this view that led the historian to question the symptomatic character of artistic manifestations and to offer an alternative interpretation that stressed not 'realism', but the decadent pleasures of pomp and artifice in the painting of Van Eyck.

Haskell is right in pointing to the paradigmatic importance of this evaluation, but need we stop here? Need we accept the biological concept of decadence which Huizinga uses? The technical progress achieved by the Van Eycks in the rendering of the visible world is undeniable.[11] Need it conflict with forms of society which proved unable to stand up to other technological developments, just as the norms of chivalry succumbed to the development of gunpowder?

No wonder that by the time Huizinga wrote, art historians had tried to struggle free from the compulsion of labelling any change of style as either progressive or decadent. This is a development that lies outside Haskell's book, but that has an undeniable bearing on the problems of method with which he is concerned. I am thinking of successive efforts to rehabilitate certain styles of the past, and to free them from the stigma of decline.

The first wave of this evaluation dates back to the Romantic movement that angrily rejected Vasari's identification of 'Gothic' with 'barbaric'. The next may be said to have begun in the middle of the nineteenth century, when Jacob Burckhardt ceased to equate 'baroque' with decadence, a shift of taste that culminated in Heinrich Wölfflin's ground-breaking book *Renaissance and Baroque* of 1888. It was soon the turn of Roman art, which Franz Wickhoff showed in a new light in his book on the Vienna Genesis (later published as *Römische Kunst*). He was followed by another Viennese art historian, Alois Riegl, whose modest title *The Industrial Art of Late Antiquity* (1902) concealed the radical proposal to banish the term 'decline', even from the treatment of late antique styles, and to view all artistic development as the result of novel 'intentions'.

These were the years when the intrinsic values of 'primitive art' were discovered by the radical movements of the twentieth century, which also

enabled Max Dvořák (Wickhoff's successor in Vienna) to commend the previously derided tendencies of Italian Mannerism to his Expressionist contemporaries (1920). In the post-war years, Millard Meiss entered a plea for the retrograde tendencies of the Italian trecento, till in the end even the Salon painters of the nineteenth century found their champions, a development in which Francis Haskell himself was also involved.

Thus, slowly but surely, the traditional notions of progress and decline were rendered meaningless, and with them the technological view of the history of art that had provided the framework for Vasari, no less than for the ancients. To be sure, their yardsticks were sometimes crude, but their account of the history of image mastery as the slow acquisition of mimetic skill made some rational sense. But, if we are no longer allowed to speak in terms of means and ends, all images embody the intention of their creators and we must find another explanation of stylistic change.

If the rendering of nature changes in the course of history, who knows if nature was not seen differently at different periods? And could not this difference have been due to the transformations mankind had undergone in the course of its evolution? Clearly, in thus attempting to become more scientific, art history had surrendered all objective standards. Largely inspired by developments in contemporary art, it fell back on the Hegelian dogma that changes of style manifest not a change in skill but a change in will, expressing a different 'world view', or collective spirit. What secured the spectacular success of this approach, which was taken by such influential writers as William Worringer, is the fact that 'expression' is a characteristic shared by all visual configurations. No wonder it suddenly looked as if a master key had been found to the essence of all ages: surrender to the expressive value of any image and it will lead you to the innermost core of mankind's past. This of course was the very promise that had aroused the anger of a real scholar such as Ernst Robert Curtius.

It is merciful that Haskell has spared us the analysis of this kind of pseudo-history. Even so one might regret that he left on one side the new access to the art of the past that so favoured the spread of this heresy: the vogue for art books and the skill with which photographers could approximate the art of the past to the taste of our century. It was André Malraux who became intoxicated with this capacity of what he called the 'Museum without Walls'[12] to turn the past into myth. Though Haskell might have some sympathy with this conclusion, he would never endorse such a blanket verdict. For is it all a myth? Does it not rather depend on the type of question we ask, and on the type of answers we seek? Art does not reflect the spirit of the age, for the notion is much too vague to be of

any use. But why should not artists have shared the values and aspirations of their culture and society? Their sense of decorum, or their cult of anti-decorum, their heroic ideals or their love of refinement? Maybe the historian of art cannot tell the historian much that he could not also have gathered from other sources, but surely the historian can still assist the historian of art in interpreting the art of the past in the light of textual evidence. If anybody has demonstrated this possibility, it is Francis Haskell.

Notes

Works by E.H. Gombrich cited in the notes

The Story of Art (London: Phaidon, 1950; 16th edition, 1995, reprinted, 1996, 1997, 1998)

Art and Illusion: a Study in the Psychology of Pictorial Representation (London: Phaidon; Princeton: Princeton University Press, 1960; 5th edition, 1977, latest reprint 1996)

Meditations on a Hobby Horse and Other Essays on the Theory of Art (London: Phaidon, 1963; 4th edition, 1985, reprinted 1994)

Norm and Form: Studies in the Art of the Renaissance I (London: Phaidon, 1966; 4th edition 1985, reprinted 1993, 1996, 1998)

Aby Warburg: an Intellectual Biography (London: Warburg Institute, 1970; 2nd edition, Oxford: Phaidon, 1986)

Symbolic Images: Studies in the Art of the Renaissance II (London: Phaidon, 1972; 3rd edition, 1985, reprinted 1993)

The Heritage of Apelles: Studies in the Art of the Renaissance III (Oxford, Phaidon: 1976; reprinted 1993)

Ideals and Idols: Essays on Values in History and in Art (Oxford: Phaidon, 1979; reprinted 1994, 1998)

The Sense of Order: a Study in the Psychology of Decorative Art (Oxford: Phaidon, 1979; 2nd edition, 1984, reprinted 1992, 1994, 1998)

The Image and the Eye: Further Studies in the Psychology of Pictorial

Representation (Oxford: Phaidon, 1982; reprinted 1994)

Tributes: Interpreters of our Cultural Tradition (Oxford: Phaidon, 1984)

New Light on Old Masters: Studies in the Art of the Renaissance iv (Oxford: Phaidon, 1986; reprinted 1993, 1998)

Reflections on the History of Art: Views and Reviews, ed. Richard Woodfield (Oxford: Phaidon, 1987)

Topics of our Time: Twentieth Century Issues in Art and in Culture (London: Phaidon, 1991; reprinted 1992, 1994)

The four volumes of *Studies in the Art of the Renaissance* were reissued as a boxed set under the general title *Gombrich on the Renaissance* (London: Phaidon, 1993)

A representative selection of E.H. Gombrich's essays is published in *The Essential Gombrich,* ed. Richard Woodfield (London: Phaidon, 1996)

Introduction

1 Reported by Heinrich Wölfflin in *Gedanken zur Kunstgeschichte* (Basle, 1941), p. 143.
2 'Die Sammler', 'Das Altarbild', 'Das Porträt', collected in *Beiträge zur Kunstgeschichte von Italien* (Basle, 1898); cf. *Gesamtausgabe*, ed. Hans Trog and Emil Dürr, vol. 12 (Berlin, 1930). The second essay has been translated and edited by Peter Humfrey, *The Altarpiece in Renaissance Italy* (Oxford, 1988).
3 The classic account is Helmut Gernsheim, *The History of Photography from the Earliest Use of the Camera Obscura in the Eleventh Century up to 1914* (Oxford, 1955).
4 See J. Mordaunt Crook, *The Dilemma of Style: Architectural Ideas from the Picturesque to the Post-Modern* (London, 1987), pp. 232–71.
5 See E. Kris and E.H. Gombrich, 'The Principles of Caricature', *British Journal of Medical Psychology,* 17 (1938); and *Art and Illusion,* ch. vii. See also R. Godfrey, ed., *English Caricature, 1620 to the Present* (exh. cat., London: Victoria and Albert Museum, 1984).
6 The term was first used by Filippo Baldinucci, *Vocabolario toscano dell'arte del disegno* (Florence, 1681), p. 29.
7 Giovanni Pietro Bellori, *Le vite de' pittori, scultori ed architetti moderni*

(Rome, 1672), p. 75.

8 Letter from Gaetano Berenstat to Ghezzi, 17 February 1729, quoted in Anthony Blunt and Edward Croft-Murray, *Venetian Drawings of the XVII and XVIII Centuries in the Collection of Her Majesty the Queen at Windsor Castle* (London, 1957), p. 140.

9 Dorothy George, *English Political Caricature* (Oxford, 1959).

Chapter 1: Paintings on Walls

1 See also my Romanes Lecture, *Art History and the Social Sciences* (Oxford, 1975), reprinted in *Ideals and Idols*, pp. 131–66.

2 See Mauro Matteini and Archangelo Moles, 'A Preliminary Investigation of the Unusual Technique of Leonardo's Mural *The Last Supper*', *Studies in Conservation*, 24 (1979), pp. 125–33.

3 Aby Warburg, 'Domenico Ghirlandajo in Santa Trinità: Die Bildnisse des Lorenzo de' Medici und seiner Angehorigen', and 'Francesco Sassettis Letzwillige Verfugung', in *Gesammelte Schriften* (Berlin, 1932), pp. 95–126, 129–58. For Vasari's original text, see *Le vite de' più eccellenti pittori, scultori e architettori*, ed. Gaetano Milanesi (Florence 1878–85), vol. 3, pp. 260–8.

4 Leonardo da Vinci, *Treatise on Painting*, ed. A. Philip McMahon (Princeton, NJ, 1956), no. 265 (Cod. Urb. 47r & v). Translations in the text are mine.

5 Ed. cit., no. 418 (Cod. Urb. 108).

6 Eve Borsook, *Mural Painters of Tuscany* (London, 1960).

7 Ed. cit., no. 265 (Cod. Urb. 47v).

8 Ed. cit., no. 267 (Cod. Urb. 61r).

9 Vasari, ed. Milanesi, vol. 4 (1879), p. 30.

10 *Art and Illusion*, pp. 99–125.

11 Emanuel Löwy, *Polygnot: Ein Buch von Griechischer Malerei* (Vienna, 1929).

12 Pausanias, x.ii.25–31.

13 J.W. von Goethe, *Uber Polygnots Gemälde in der Lesche zu Delphi* (1803).

14 Ernst Pfuhl, *Malerei und Zeichnung der Griechen*, 3 vols. (Munich, 1923), vol. 2, pp. 883–6, 890–1; vol. 3, pls. 721–2.

15 F.C. Bartlett, *Remembering: A Study in Experimental and Social Psychology* (Cambridge, 1932), p. 180.

16 Decio Gioseffi, *Perspective artificialis* (Trieste, 1957).

17 Vitruvius, *On Architecture*, VII.v.

18 See *Norm and Form*, pp. 83–6.

19 Giacomo Grimaldi, *Descrizione della Basilica di S. Pietro in Vaticano: Codice Barberini Latino 2733*, ed. Reto Niggl (Vatican City, 1972); see also

J. Garber, *Wirkungen der frühchristlichen Gemäldezyklen der alten Peters und Pauls Basilika in Rom* (Berlin and Vienna, 1918).

20 I refer especially to the seated woman in the scene of the Adoration of the Magi who has been interpreted as Ecclesia or as Divine Wisdom.

21 Otto Demus, *Romanesque Mural Painting* (New York and London, 1970), pp. 478–9, pls. 204–5.

22 Émile Mâle, *L'Art religieux de la fin du Moyen Age en France* (Paris, 1908), especially pp. 27–34, 35–66.

23 *The Mirrour of the Blessed Lyfe of Jesu Christ*, ed. Lawrence F. Powell (Oxford, 1908), pp. 55–6.

24 See 'Action and Expression in Western Art', in *The Image and the Eye*, pp. 78–104, and 'The Leaven of Criticism in Renaissance Art', in *The Heritage of Apelles*, pp. 111–31.

25 See 'Introduction: Aims and Limits of Iconology', in *Symbolic Images*, pp. 1–25, especially pp. 15–16.

26 Sven Sandström, *Levels of Unreality* (Uppsala, 1963); for the status of personifications, see *Symbolic Images*.

27 L.B. Alberti, *On Painting and On Sculpture: The Latin Texts of De Pictura and De Statua*, ed. C. Grayson (London, 1972), p. 49.

28 Catherine Dumont, *Francesco Salviati au Palais Sacchetti de Rome et la décoration murale italienne (1520-1560)* (Geneva, 1973), which also contains a full bibliography.

29 See my Romanes lecture cited above (note 1).

30 A. Blunt, 'Illusionist Decoration in Central Italian Painting of the Renaissance', *Journal of the Royal Society of Arts*, 107 (1958–9), pp. 309–26.

31 See 'Icones Symbolicae', in *Symbolic Images*, especially pp. 153–6.

32 *Lectures on Painting by the Royal Academicians*, ed. R.N. Wornum (London, 1889), p. 355. The famous antiquarian, the Comte de Caylus, had published a 'Description de deux tableaux de Polygnote donnée par Pausanias', *Histoire de l'Académie Royale des Inscriptions et Belles Lettres*, (1761), pp. 34–55, for which Le Lorrain had provided pictorial illustrations. These had given Etienne Falconet, in his translation of Pliny (*Traduction des XXXIV, XXXV, et XXXVI livres de Pline l'ancien*, 2nd edn., The Hague, 1773, vol. 1, p. 248), another opportunity of venting his spite on the ancients he considered much overrated. I am indebted for this explanation of Fuseli's remark to Dr Alex Potts.

33 A. Boe, *From Gothic Revival to Functional Form: A Study in Victorian Theories of Design* (Oslo, 1957; 2nd edn., 1997).

34 *Department of Practical Art: Catalogue of the Articles of Ornamental Art* (London, 1852), Appendix, no. 23.

35 'S'il se f… de la muraille … la muraille le vomira', quoted in Marius Vachon, *Puvis de Chavannes* (Paris, 1895), p. 115.

36 Hodler's lecture 'Die Sendung des Künstlers' is reprinted in *Die Krise der Kunst*, ed. S. Rudolph (Stuttgart, 1948).

Chapter 2: Paintings for Altars

1 Thomas Munro, *Evolution in the Arts and other Theories of Cultural History* (Cleveland, 1963).

2 *The British Journal of Aesthetics*, 4 (1964), pp. 263–70.

3 *L'Écologie des images* (Paris, 1983).

4 See my essay on Hegel in *Tributes*, pp. 64ff.

5 *Art and Illusion*, chapter IV, pp. 99–125.

6 See *The Image and the Eye*, s.v. in Index.

7 'ut hi qui litteras nesciunt, saltem in parietibus videndo legant quae legere in codicibus non valent', *Sancti Gregorii Epistolae*, lib. IX, epist. 105, in Migne, *Patrologiae Cursus Completus*, vol. 77 (Paris, 1849), cols. 1027–8; 'Nam quod legentibus scriptura, hoc idiotis praestat pictura cernentibus', ibid., lib. XI, epist. 13, col. 1128.

8 For dating and bibliography, see the exhibition catalogue *Lanfranco e Wiligelmo: Il Duomo di Modena*, ed. Enrico Castelnuovo *et al.* (Modena, 1984), pp. 560–3.

9 Ernst Schubert, *Der Naumburger Dom* (Berlin, 1968).

10 Émile Mâle, *L'Art religieux de la fin du Moyen-Age en France* (Paris, 1908). See also p. 29 above.

11 The masterly essay by Jacob Burckhardt, 'Das Altarbild', in *Beitrage zur Kunstgeschichte von Italien*, published posthumously in 1898 (*Gesamtausgabe*, 12 (1930)) has never been superseded, but it only deals with one period and school; for the English translation see ch. 1, n. 2.

12 For this and the following, see Helmut Hager, *Die Anfänge des italienischen Altarbildes: Untersuchungen zur Entstehungsgeschichte des toskanischen Hochaltar retabels*, Veröffentlichungen des Biblioteca Hertziana (Munich, 1962).

13 See Hager, op. cit., pp. 66–74.

14 Among recent discussions of this complex connection, see Kurt Weitzmann, 'Crusader Icons and the Maniera Greca', in Irmgard Hutter, ed., *Byzanz und der Westen: Studien zur Kunst des europäischen Mittelalters*, Sitzungsberichte der Österr. Akademie der Wissenschaften, Phil.-Hist. Klasse, 432 (Vienna, 1984), pp. 143–70; Ernst Kitzinger, 'The Byzantine Contribution to Western Art of the Twelfth and Thirteenth Centuries', in his *The Art of Byzantium and the Medieval West*

(Bloomington, Ind., 1976), pp. 357–78; and Otto Demus, *Byzantine Art and the West* (New York, 1970), all with further bibliography.

15 Vasari, ed. Milanesi, vol. 1, pp. 247–8.

16 Demus, *Byzantine Art*, p. 212.

17 Hugh Brigstocke, *Italian and Spanish Paintings in the National Gallery of Scotland*, 2nd edn. (Edinburgh, 1993), pp. 205–6.

18 Millard Meiss, *Painting in Florence and Siena after the Black Death* (Princeton, NJ, 1951), pp. 9–16.

19 See Rona Goffen, '*Nostra Conversatio in Caelis est*. Observations on the *Sacra Conversazione* in the Trecento', *Art Bulletin*, 61 (1979), pp. 198–222.

20 *New Light on Old Masters*, p. 102.

21 *Symbolic Images*, p. 16.

22 Vasari, ed. Milanesi, vol. 4, pp. 38–9.

23 The relevant documents are most easily available in Adolfo Venturi, *Storia dell'arte italiana*, XI.iii (Milan, 1928), pp. 111–14. I am indebted to Charles Hope for discussing this correspondence with me.

24 Demus, *Byzantine Art*, p. 205.

Chapter 3: Images as Luxury Objects

1 Erwin Panofsky, *Early Netherlandish Painting: Its Origins and Character*, 2 vols. (Cambridge, Mass., 1964), I, pp. 51–74 (p. 67).

2 Otto Pächt, 'Early Italian Nature Studies and the Early Calendar Landscape', *Journal of the Warburg and Courtauld Institutes*, 13 (1950), pp.13–47; Millard Meiss, *French Painting in the Time of Jean de Berry*, 2 vols. (London, 1967, 1968); Robert W.H.P. Scheller, *A Survey of Medieval Model Books* (Haarlem, 1963), revised as *Exemplum: Model-Book Drawings and the Practice of Artistic Transmission in the Middle Ages, c.900–c.1470* (Amsterdam, 1995).

3 Francis Wormald, 'The Wilton Diptych', *Journal of the Warburg and Courtauld Institutes*, 17 (1954), pp. 191–203. See also Dillian Gordon, *Making and Meaning: The Wilton Diptych* (London, 1993), especially p. 66, n. 112 with further references; and *The Regal Image of Richard II and the Wilton Diptych*, ed. Dillian Gordon *et al.* (London, 1997).

4 Gordon argues (p. 21) that 'it seems therefore legitimate to interpret the composition of the diptych as reading from left to right: the king will eventually be transferred from the wasteland in which he kneels to the flowery meadow, having been redeemed by Christ's Passion and Resurrection'.

5 See Keith Christiansen, *Gentile da Fabriano* (London, 1982), especially pp. 23–33.

6 J. Lognon and R. Lazeller, *Les Très Riches Heures du duc de Berry: Introduction and Legend*, with an introduction by Millard Meiss (London, 1969).

7 Enrico Castelnuovo, *I Mesi di Trento: Gli affreschi di Torre dell'Aquila e il Gotico Internazionale* (Trento, 1986).

8 Castelnuovo, op. cit., pp. 50–2.

9 J. Huizinga, *The Waning of the Middle Ages* (New York, 1954).

10 Barbara Tuchman, *A Distant Mirror: The Calamitous Fourteenth Century* (London, 1979).

11 See my lecture 'In Search of Cultural History', in *Ideals and Idols*, pp. 24–59.

12 K.R. Popper, *The Poverty of Historicism* (London, 1959), pp. 149ff.

13 'The Logic of Vanity Fair: Alternatives to Historicism in the Study of Fashions, Style and Taste', in *Ideals and Idols*, pp. 60–9.

14 Thorsten Veblen, *The Theory of the Leisure Class: An Economic Study in the Evolution of Institutions* (New York, 1899), especially pp. 96–101.

15 Theodor Müller and Erich Steingräber, 'Die französische Goldemailplastik um 1400', *Münchener Jahrbuch der bildenden Kunst* (1954), pp. 29–79 (69–70). See also the exhibition catalogue *Das Goldene Rössl: Ein Meisterwerk der Pariser Hofkunst um 1400*, ed. Reinhold Baumstark (Munich, 1995).

16 *Purgatorio* XI, 73–90. I have commented on this passage in 'Giotto's Portrait of Dante?', *New Light on Old Masters*, pp. 11–31.

17 Charles Osgood *et al.*, *The Measurement of Meaning* (Urbana, 1957).

18 G. Boccaccio, *Il Decamerone*, Giornata VI, Novella 5.

19 Vasari, ed. Milanesi, vol. 1, pp. 370–1.

20 Otto Pächt, loc. cit.

21 Millard Meiss and E.W. Kiral, *The Visconti Hours* (London, 1972).

22 *Art and Illusion*.

23 Julius von Schlosser, 'Zur Kenntnis der künstlerischen Überlieferung im späten Mittelalter', and 'Vademecum eines fahrenden Malergesellen', *Jahrbuch der Kunsthistorischen Sammlungen in Wien*, 23 (1902), pp. 279–313, 314–26.

24 'Ideal and type in Italian Renaissance Painting', in *New Light on Old Masters*, pp. 89–124.

25 Pietro Toesca, *La Pittura e la miniatura in Lombardia* (Milan, 1912). The full text (with introduction) is printed in Mrs Merrifield, *Original Treatises … on the Art of Painting*, 2 vols. (London, 1849), vol. 1, pp. 259–321.

26 Patrick de Winter, *La Bibliothèque de Philippe le Hardi duc de Bourgogne 1364–1407* (Paris, 1985).

27 F. Wormald, loc. cit.

28 E. Castelnuovo, loc. cit.

29 Cicero, *De Oratore*, III. 98–9.

30 L.B. Alberti, *On Painting*, ed. C. Grayson (Oxford, 1972), p. 93.

31 E. Panofsky, op. cit., pp. 69–70.

Chapter 4: Pictures for the Home

1 The pioneering study in this field is Mario Praz, *An Illustrated History of Interior Decoration from Pompeii to Art Nouveau* (London, 1964). Of later works, Peter Thornton's *Authentic Décor: The Domestic Interior, 1620-1920* (London, 1984) is extremely useful. Among many books on nineteenth-century interior decoration may be mentioned Ralph Dutton, *The Victorian Home* (London, 1954); Susan Lasdun, *Victorians at Home* (London, 1981); and Charlotte Gere, *Nineteenth-Century Decoration: The Art of the Interior* (London, 1989).

2 Extracts from the inventory of 1498 are given in Ronald Lightbown, *Sandro Botticelli: Life and Work*, 2 vols. (London, 1978), vol. 2, pp. 51–3.

3 *The Sense of Order*, pp. 95–116.

4 See *Georg Baselitz* (Cologne, 1990).

5 As Christopher Brown has noted in the exhibition catalogue, *Van Dyck* (1990–1), p. 44, n. 7, Van Dyck's paintings were originally intended for other rooms, and not moved into the Double Cube until *c.*1680.

6 *The Sense of Order*, p. 80.

7 It was apparently not until the 1870s that the architect came to the aid of the picture lover and provided him with the familiar wooden picture rail, though in the previous century, iron, and later brass, cornice poles had fulfilled a similar function. I am grateful to Dr Clive Wainwright for this information.

8 As Bruno Pons has demonstrated in his book *Grands Décors français, 1650-1800, reconstitués en Angleterre, aux Etats-Unis, en Amérique du Sud et en France* (Dijon, 1995).

9 See, for example, Vivien Greene, *English Dolls' Houses of the Eighteenth and Nineteenth Centuries* (London, 1955; new edn., 1979); and Leoni von Wilckens, *Tageslauf im Puppenhaus: Bürgerliches Leben vor dreihundert Jahren* (Munich, 1955).

10 Hans Floerke, *Studien zur Niederländischen Kunst- und Kulturgeschichte: Die Formen des Kunsthandels, das Atelier, und die Sammler in den Niederlanden von 15.-18. Jahrhundert* (Munich and Leipzig, 1905), p. 171; cf. Jan Denucé, *De Antwerpsche 'Konstkamers': Inventarissen van kunstverzamelingen te Antwerpen in de 16e und 17e eeuwen* (The Hague,

1932), pp. 14–56. For a recent interpretation of this material, see Z.Z. Filipczak, *Picturing Art in Antwerp, 1550-1700* (Princeton, 1987), especially ch. 7, pp. 58–72.

11 Plato, *Sophist*, 23, 263.

12 *The Diary of John Evelyn*, ed. E.S. de Beer, 6 vols. (Oxford, 1955), vol. 2, p. 39.

13 On picture frames, see P.J.J. van Thiel and C.J. de Bruyn Kops, *Framing in the Golden Age: Picture and Frame in Seventeenth Century Holland* (Amsterdam and Zwolle, 1995); Franco Sabatelli, ed., *La cornice italiana dal Rinascimento al Neoclassico* (Milan, 1992); Jacob Simon, *The Art of the Picture Frame: Artists, Patrons, and the Framing of Portraits in Britain* (London, 1996); Eva Mendgen *et al.*, *In Perfect Harmony: Picture and Frame, 1850-1920* (Zwolle, 1995); and Paul Mitchell and Lynn Roberts, *Frameworks: Form, Function and Ornament in European Picture Frames* (London, 1996) and *A History of European Picture Frames* (London, 1996).

14 Frederick Hartt, *Giulio Romano*, 2 vols. (New Haven, 1958), vol. 1, p. 267, document 135.

15 On this tendency, see Peter Thornton, *Seventeenth-Century Interior Decoration in England, France and Holland* (New Haven and London, 1978), p. 254, quoting an artist's handbook of 1675.

16 The early stages of this competition are discussed in David Landau and Peter Parshall, *The Renaissance Print 1470–1550* (New Haven and London, 1994), especially pp. 81–8, 231–7.

17 C.F. Joullain, *Réflexions sur la peinture et la gravure, accompagnées d'une courte dissertation sur le commerce de la curiosité, et les ventes en général* (Paris and Metz, 1786), p. 146.

18 See Timothy Clayton, *The English Print 1688-1802* (New Haven and London, 1977), pp. 86-9.

19 Antony Griffiths, 'Prints after Reynolds and Gainsborough', *Gainsborough and Reynolds in the British Museum* (London, 1978), pp. 29–56; and *Reynolds*, ed. Nicholas Penny (exh. cat., London, Royal Academy, 1986).

20 Goethe, *Aus meinem Leben: Dichtung und Wahrheit*. The inventory of Goethe's own house drawn up by C. Schuchardt, *Goethes Kunstsammlungen*, 3 vols. (Jena, 1848), includes hundreds of engravings reproducing famous paintings and views.

21 On the Arundel Society, see Christopher Lloyd and Tanya Ledger, *Art and its Images* (Oxford, 1975), pp. 121–33, and Tanya Ledger, 'A Study of the Arundel Society, 1848–1897' (unpublished dissertation, Oxford, 1978). See also Susan Lambert, *The Image Multiplied: Five Centuries of Printed Reproductions of Paintings and Drawings* (London, 1987).

22 C.S. Lewis, *De Descriptione Temporum, an Inaugural Lecture* (Cambridge, 1955), pp. 20–1.

Chapter 5: Sculpture for Outdoors

1 Charles Baudelaire, *Curiosités esthétiques: L'Art romantique et autres œuvres critiques*, ed. Henri Lemaitre (Paris, 1962), pp. 187–91.

2 *Meditations on a Hobby Horse*, pp. 1–11.

3 Pauline Cockrill, *The Teddy Bear Encyclopaedia* (London, 1993).

4 Quoted in *Aby Warburg*, p. 71.

5 Quoted in *The Sense of Order*, p. 257.

6 E.g. Pausanias, I.xxii.

7 Cicero, *Epistulae ad familiares*, VIII.23, ed. D.R. Shackleton Bailey (Cambridge, 1977), vol. 2, p. 53

8 J. Pope-Hennessy, *Donatello Sculptor* (New York, 1993), pp. 20-8.

9 In addition to the following example, we may mention the two *cantorie* by Donatello and Luca della Robbia: see Richard Krautheimer, *Lorenzo Ghiberti* (Princeton, 1956), pp. 31ff.

10 See H.W. Janson, *The Sculpure of Donatello* (Princeton, 1963), p. 198.

11 Vasari, ed. Milanesi, vol. 6, pp. 154–7.

12 See Kathleen Weil-Garris, 'On Pedestals: Michelangelo's *David*, Bandinelli's *Hercules and Cacus* and the Sculpture of the Piazza della Signoria', *Römisches Jahrbuch für Kunstgeschichte*, 20 (1983), pp. 378–415.

13 *London*, ed. Charles Knight, vol. 6 (London, 1844), ch. CXXX, pp. 78–9.

14 M. Trachtenberg, *The Statue of Liberty* (New York, 1976).

15 Henry Lydiate, 'The Case for the One Percent: Securing Patronage for Public Art', *Art within Reach: Artists and Craftworkers, Architects and Patrons in the Making of Public Art*, ed. Peter Townsend (London, 1984), pp. 95–100.

Chapter 6: The Dream of Reason

I originally took up this subject when I came across the popular book by E.F. Henderson, *Symbol and Satire in the French Revolution* (New York and London, 1912). Apart from other publications listed in the notes I should like to refer to the catalogue of the exhibition *L'Art de l'estampe et la Révolution française* (Paris, Musée Carnavalet, 1977), to which Dr Richard Wrigley has kindly drawn my attention; and Mark Jones, *Medals of the French Revolution*, British Museum Keys to the Past (London, 1977), with further bibliography. Among printed sources I have used the large French Revolution Collection in the British Library, originally catalogued by G.K. Fortescue and described in an article by A.C. Broadhurst in the *British*

Library Journal, 2, no. 2 (1972), pp. 138–58. References to that material are given by the pressmark preceded by B.L. (British Library).

1 For this and the following, see F.-A. Aulard, *Le Culte de la raison et le culte de l'esprit suprême* (Paris, 1892; repr. Aalen, 1975), pp. 52ff.

2 M.-A. Thiers, *Histoire de la Révolution française (1793-1794): Essai historique*, vol. 1 (Brussels, 1845), ch. 30, p. 449.

3 Aulard, p. 83.

4 Aulard, p. 88.

5 Aulard, p. 87.

6 Aulard, pp. 88ff.

7 Aulard, p. 284.

8 *Détails exacts des cérémonies et de l'ordre à observer dans la Fête de l'Etre Suprême*, 1794. B.L. R 182/3.

9 'Rapport fait à la Convention Nationale dans la séance du second mois de la seconde année de la République Française au nom de la Commission chargée de la confection du calendrier'. B.L. F.R., 370, 1.

10 J. Thurber, *The Wonderful O* (London, 1958).

11 See *Art and Illusion*, ch. XI.

12 'Confédération Nationale du 14 juillet 1790: Description fidèle de tout ce qui a précédé, accompagné et suivi cette auguste cérémonie'. B.L. R 180, 9.

13 I have discussed germane aspects of visual sybolism and propaganda in 'The Cartoonist's Armoury' and 'Visual Metaphors of Value in Art', in *Meditations on a Hobby Horse*; 'The Use of Art for the Study of Symbols', in *The Essential Gombrich*; 'Icones Symbolicae', in *Symbolic Images*; 'The Visual Image', in *The Image and the Eye*; and 'Myth and Reality in German Wartime Broadcasts', in *Ideals and Idols*.

14 Charles E. Osgood, *The Measurement of Meaning* (Urbana, 1957).

15 The ceiling is illustrated in *Meditations on a Hobby Horse*, fig. 109.

16 The symbolism of this composition is strikingly anticipated in Streater's ceiling painting of the Sheldonian Theatre in Oxford of 1668.

17 Illustrated in Dorothy George, *English Political Caricature* (Oxford, 1959), vol. 1, pl. 36.

18 I am grateful to Dr Richard Wrigley for his advice and criticism relative to the history of the *bonnet rouge*.

19 *Révolution française ou analyse complète et impartiale du Moniteur suivie d'une table alphabétique des personnes et des choses.* A Paris, chez Girasin, 1801. B.L. 181 g. 2.

20 *Gazette universelle*, 22 March 1792 (B.L. F. 121); *Journal des débats de la société des Jacobins*, 21 March 1792; *Bibliothèque historique de la Révolution* (B.L. F. 89* and 90*).

21 David Lloyd Dowd, *Pageant-Master of the Republic: Jacques-Louis David and the French Revolution* (Lincoln, Nebraska, 1948), pp. 55–61.

22 *Journal des débats*, 21 June 1792.

23 M.A. Thiers, vol. 1, ch. 9, p. 127.

24 Albert Matthiez, *Les Origines des cultes révolutionnaires 1789-1792* (Paris, 1904; repr. Geneva, 1977), pp. 32–3.

25 Harper's *Encyclopedia of United States History* (New York & London, 1902), s.v. 'Liberty poles'.

26 J.-J. Rousseau, *Oeuvres complètes*, vol. 16 (Paris, 1791), p. 259.

27 Cf. note 21.

28 See *Symbolic Images*, pp. 158ff.

29 Georg Stuhlfaut, *Das Dreieck, Geschichte eines religiösen Symbols* (Stuttgart, 1937).

30 Dorothy George, op. cit.

31 *Encyclopedia Americana*, vol. 13 (1957), p. 362.

32 A. Boppe, *Les Vignettes emblématiques sous la Révolution* (Paris, 1911), p. 7, n. 1. The 'mountain' here refers to the seats of the Jacobins in their assembly.

33 E.F. Henderson, *Symbol and Satire in the French Revolution* (New York and London, 1912), shows on pl. 59 the personification of France making her children clasp hands, labelled *Fraternité*, but I know of no personification of that concept as such.

34 *Médailles sur les principaux événements du règne de Louis le Grand* (Paris, 1702), pp. 110, 213.

35 *Les Franc-maçons écrasés* (Amsterdam, 1747), p. 348.

36 Aulard, as in note 1.

37 Illustrated in Draper Hill, *Mr Gillray the Caricaturist* (London, 1965), pl. 52.

Chapter 7: Magic, Myth and Metaphor

1 *Luther Studien, Luthers Kampfbilder*, ed. Hartman Grisar, S.J., I-III (Freiburg, 1923).

2 Miroslav Hrock and Anna Skybova, *Die Inquisition im Zeitalter der Gegenreformation* (Leipzig, 1985), illustrate relevant engravings but on pp. 121–37 express doubts concerning their documentary value.

3 K.C. Cameron, 'Henri III, a Maligned or Malignant King?: Aspects of the Satirical Iconography of Henri de Valois', University of Exeter, 1978.

4 See Dorothy M. George, *English Political Caricature to 1792* (Oxford, 1959), pp. 15f.

5 D.P. Walker, *The Decline of Hell* (London, 1964).

6 I have discussed Freud's theory of verbal wit in *Tributes*, pp. 93–115. The

285

same volume also contains an account of my collaboration with Ernst Kris, pp. 221–33.

7 Our ideas were summarized in a joint article, 'The Principles of Caricature', *British Journal of Medical Psychology*, 17 (1938), pp. 319–42, and in the King Penguin book *Caricature* (Harmondsworth, 1940).

8 In incorporating our joint article from the *British Journal of Medical Psychology* in his *Psychoanalytic Explorations in Art* (New York, 1952), Kris added the note on p. 200: 'On reconsidering this passage written some fifteen years ago, we now (1951) find our ideas incomplete. A good deal of further investigation concerned with the relation of word and image in ontogenetic development and in historical contexts may prove rewarding. We hope to return to this question jointly.' Unhappily this hope never materialized.

9 See my address to the Seventh International Congress of Germanic Studies in Göttingen, 1985, '"Sind eben alles Menschen gewesen": Zum Kulturrelativismus in den Geisteswissenschaften', *Acts of the Congress*, vol. 1 (Tübingen, 1986), pp. 17–28; English translation in *Topics of Our Time*, pp. 36-46.

10 19 July 1989.

11 27 July 1989.

12 Samuel Edgerton, *Painting and Punishment in Tuscany* (Ithaca and London, 1985). See also David Freedberg, *The Power of the Image* (Chicago and London, 1989), ch. 10, with many bibliographical references.

13 Reprinted in *Meditations on a Hobby Horse*.

14 Hans Vaihinger, *Die Philosophie des Als-Ob*, 2nd edn. (Berlin, 1913).

15 *Bild als Waffe: Mittel und Motive der Karikatur in fünf Jahrhunderten*, ed. Gerhard Langemeyer, Gerd Unverfehrt, Herwig Guratzsch and Christoph Stölzl (Munich 1984).

16 Reprinted in *Meditations on a Hobby Horse*.

17 A. Warburg, 'Heidnisch-Antike Weissagung in Wort und Bild zu Luthers Zeiten', *Gesammelte Schriften*, vol. 2 (Leipzig, 1932).

18 For a discussion of the picture's relation to the biblical text, see *French Caricature and the French Revolution 1789-1799*, exhibition catalogue by Cynthia Burlingham and James Cuno, Grunwald Center for the Graphic Arts, Wight Art Gallery, University of California, Los Angeles (Chicago, 1988), p. 98.

19 The publisher, A. Allard, was neither the first nor the last to adapt earlier compositions for satirical purposes: a print after Titian's *Diana and Callisto* was changed by Pieter van der Heyden in *c*.1585 into *Queen Elizabeth I discovering the Lewdness of the Papacy*; cf. David Kunzle, *The*

Early Comic Strip (Berkeley and Los Angeles, 1973), p. 122, and *Bild als Waffe*, pp. 266–74.

20 Petrus Ansolini da Ebulo, *De rebus siculis carmen*, ed. Ettore Rota (Rerum Italicarum Scriptores, ed. L.A. Muratori, xxxi) (Città di Castello, 1904).

21 Mirjam Bohatcova, *Irrgarten des Schicksals, Einblattdrucke vom Anfange des dreissig-jährigen Krieges* (Prague, 1966).

22 The historian might do well, however, to remember the response by Ridolfo Varano to his *pittura infamante* as told by Edgerton (see note 12), pp. 85–7: the Condottiere refused to feel disgraced, replied in kind, and finally made it up with his detractors.

23 Draper Hill, *Mr Gillray the Caricaturist* (London, 1965), pp. 58–63.

24 The conversation with Frank Whitford was broadcast on BBC Radio 3 on 1 April 1989. I am greatly obliged to the artist for allowing me to quote his words.

Chapter 8: Pleasures of Boredom

1 *Le vite de' più eccellenti pittori, scultori ed architetti*, ed. G. Milanesi, vol. 1 (Florence, 1878), p. 248. Ernst Kris and Otto Kurz, in *Legend, Myth and Magic in the Image of the Artist* (New Haven and London, 1979), p. 28, have shown that the same anecdote is told of several other artists.

2 In chapter 10 of his great book *Homo Ludens* (London, 1949), Johan Huizinga deals with play-forms in art, and also inserts a vivid description of 'doodling', but minimizes its connection with the practice of art.

3 Colette Sirat, 'Scrivere per diletto', *Piaceri di noia*, pp. 19–32.

4 *Art and Illusion*, pp. 284–8. See also the comprehensive study by Lucien Boissonnas, *Wolfgang-Adam Töpffer* (Lausanne, 1995).

5 Rodolphe Töpffer, *Essai de physiognomie* (Geneva, 1845).

6 The most 'finished' images occur among the representations of flowers and embroidery motifs, e.g., 1776/1780, mat. ex. 686.

7 A rough count reveals that among the human figures, 21 are *en face* and 59 in profile, of which 53 turn left.

8 *Treatise on Painting*, ed. A. Philip McMahon (Princeton, 1956), Cod. Urb., fol. 35v.

9 Martin Kemp in the exhibition catalogue, *Leonardo da Vinci* (London, 1989), p. 12.

10 Martin Kemp, *Leonardo da Vinci: The Marvellous Works of Nature and Man* (Cambridge, 1981), pp. 296–7.

11 Ed. cit., Cod. Urb., 62r and 35v. See 'Leonardo's Method for Working out Compositions', in *Norm and Form*, pp. 58–64, reprinted in *The Essential Gombrich*, pp. 211–21.

12 See 'Leonardo's Grotesque Heads', in *The Heritage of Apelles*, pp. 57–75.

13 See *The Sense of Order*, pp. 251–84.

14 André Chastel, *La Grottesque* (Paris, 1988); cf. 'Leonardo's Method for Working out Compositions' (cited in note 11).

15 See John MacGregor, *The Discovery of the Art of the Insane* (Princeton, 1989), pp. 275–6.

16 Paul Klee, *On Modern Art* (London, 1948).

17 Russell M. Arundel, *Everybody's Pixillated: A Book of Doodles* (Boston, 1937).

18 Ernst Kris, *Psychoanalytic Explorations in Art* (New York, 1952), pp. 90–1 (with further bibliographical references).

19 Ibid., p. 307.

20 Desmond Morris, *Manwatching* (London, 1977), pp. 179–81.

21 Ulric Neisser, *Cognitive Psychology* (New York, 1967), asks many of the relevant questions.

22 This does not necessarily apply to all the material in this volume: e.g., 1760, mat. 142: 'Chi legge questo e uno ciuccio e chi la fatte e uno animale' recalls the tone of graffiti.

Chapter 9: Pictorial Instructions

1 An example is a view of Breslau after F.B. Werner, *c*.1750, in Heinrich Höhn, *Alte deutsche Städte* (Leipzig, 1935).

2 *What to do in an Emergency* (Reader's Digest, 1986).

3 *Sancti Gregorii Magni Epistolae*, lib. XI, epist. 13, in Migne, *Patrologiae Cursus Completus*, vol. 77, col. 1128.

4 See, for example, Claus Nissen, *Die botanische Buchillustration*, 2 vols. (Stuttgart, 1951); and Wilfred Blunt, *The Art of Botanical Illustration* (London, 1950; rev. edn., Woodbridge, 1994).

5 Now in the Louvre; see Wilhelm Gundel, *Dekane und Dekansternbilder* (Hamburg, 1936), pl. XL.

6 Loren Mackinney, *Medical Illustrations in Medieval Manuscripts*, Wellcome History of Medicine Library (London, 1965), ch. VL, pp. 48–50.

7 Translated and edited by Casey Wood and F. Marjorie Fyfe (Stamford and Oxford, 1943).

8 Leo Bagrow, *History of Cartography*, ed. R.A. Skelton (London, 1964).

9 Windsor, Royal Library, 12883, 12277, 12278; see A.E. Popham, *The Drawings of Leonardo da Vinci* (London, 1946), pp. 264–6.

10 R. Herrlinger, *History of Medical Illustration from Antiquity to AD 1600*, trans. G. Fulton-Smith (Nijkerk, 1970), pp. 54–60.

11 Compare his muscle studies (Windsor, R.L. 12640; Popham, p. 237), or his

many studies of wave motions illustrated in *The Heritage of Apelles*, especially fig. 86.

12 Hellmut Lehmann-Haupt, *The Göttingen Model Book* (Columbia, 1972). I owe the knowledge of this interesting manual to Dr Michael Evans of the Warburg Institute.

13 See Gerardus Mercator, *On the Lettering of Maps*, illustrated in Svetlana Alpers, *The Art of Describing* (Chicago, 1983), fig. 80.

14 Carlo Bascetta, *Sport e giuochi: Trattati e scritti del 15 al 18 secolo*, 2 vols. (Milan, 1978).

15 Thoinot Arbeau, *Orchéosographie* (1589), trans. and ed. Julia Sutton (New York, 1967).

16 A facsimile of the English edition is included in Nicholas Orme, *Early British Swimming, 55 BC to AD 1719* (Exeter, 1983).

17 Compare Giulio Facciolo, *Arte della cucina: Libri di ricette dal 14–19 secolo*, 2 vols. (Milan, 1966).

18 See, for example, Stephen Werner, *Blueprint: A Study of Diderot and the Encyclopédie Plates* (Birmingham, Alabama, 1993).

Chapter 10: Styles of Art and Styles of Life

1 Osbert Lancaster, *Here, of all Places: The Pocket Lamp of Architecture* (London, 1959), pp. 52–3, 168–9.

2 See especially 'In Search of Cultural History', in *Ideals and Idols*, pp.24–59; 'The Psychology of Styles', in *The Sense of Order*, pp. 195–216; and 'From the Revival of Letters to the Reform of the Arts: Niccolò Niccoli and Filippo Brunelleschi', in *The Heritage of Apelles*, pp. 93–110. The bulky German anthology compiled by Peter Por and Sandor Radnoti, *Stilepoche, Theorie und Diskussion* (Frankfurt-am-Main, 1990), also included one of my contributions to this debate.

3 See 'Four Theories of Artistic Expression', *Architectural Association Quarterly*, 12, no. 4 (1980), pp. 14–19.

4 Seneca, *Epistulae Morales ad Lucilium*, CXIV, English translation as *Letters from a Stoic*, selected and translated by Robin Campbell (Harmondsworth, 1969), pp. 212–20.

5 Sir Joshua Reynolds, *Discourses on Art*, ed. Robert R. Wark (San Marino, 1959), p. 89.

6 Ed. cit., p. 171.

7 Jean Locquin, *La Peinture d'histoire en France de 1747-1785* (Paris, 1912), where Berthélemy's painting of 1785, *Manlius Torquatus Condemning his Son to Death*, is illustrated.

8 Ed. cit., p. 277.

9 James Harris, *Philological Inquiries* (London, 1781), vol. 2, p. 234. Only the entire passage from which Reynolds quoted brings home to the modern reader the degree to which the task of the critic was seen to be like that of a nanny trying to coax a recalcitrant child into eating a wholesome but unloved dish: 'if, while we peruse some Author of high rank, we perceive we don't instantly relish him, let us not be disheartened – let us even FEIGN *a Relish, till we find a Relish come*. A *morsel* perhaps pleases us – Let us cherish it – *Another Morsel*, strikes us – let us cherish this also. – Let us thus proceed, and steadily persevere, till we find we can relish, not *Morsels*, but *Wholes*; and feel that, what began *in* FICTION, terminates in REALITY. The Film being in this way removed, we shall discover *beauties*, which we never imagined; and contemn for *Puerilities*, what we once *foolishly* admired.'

10 See 'Reynolds's Theory and Practice of Imitation', in *Norm and Form*, pp. 129–34.

11 Ed. cit., p. 98.

12 Lionel Trilling, *Sincerity and Authenticity* (London, 1972).

13 M.H. Abrams, *The Mirror and the Lamp* (New York, 1958).

14 William Wordsworth, *The Poetical Works* (London, 1859), vol. 2, pp. 324, 329.

15 John Ruskin, *The Works*, ed. E.T. Cook and A. Wedderburn (London and New York, 1903–12), vol. 3, p. 191.

16 Edinburgh Lecture, ed. cit., vol. 12, p. 158.

17 Lord Lindsay, *Sketches of the History of Christian Art* (London, 1846), Letter IV, p. 162.

18 George Boas, 'Il faut être de son temps', *The Journal of Aesthetics and Art Criticism* (spring 1941), pp. 52–65.

19 Charles Baudelaire, *The Painter of Modern Life*, translated and edited by Jonathan Mayne (London, 1964).

20 Open letter to a group of prospective students, 1861, quoted in Robert Goldwater and Marco Treves, *Artists on Art* (New York, 1945), p. 296.

21 K.R. Popper, *The Poverty of Historicism* (London, 1957).

22 David S. Andrew, *Louis Sullivan and the Polemics of Modern Architecture* (Urbana and Chicago, 1985), p. 58.

23 *The Observer*, 29 September 1990.

24 Igor Golomstock, *Totalitarian Art* (London, 1990).

25 Werner Haftmann, *Banned and Persecuted: Dictatorship of Art under Hitler* (Cologne, 1986).

26 Daniel Pick, *Faces of Degeneration: A European Disorder, c.1848-1918* (Cambridge, 1989).

27 English translation as *Degeneration* (New York, 1985). For the influence of Nordau, see John M. MacGregor, *The Discovery of the Art of the Insane* (Princeton, 1989), pp. 238–43.

28 Op. cit., p. 27.

29 Pierre Bourdieu, *La Distinction: Critique sociale du jugement* (Paris, 1979).

30 The possibility of interpreting national styles as the expression of national character was taken for granted by writers as diverse as J.J. Winckelmann, John Ruskin, Heinrich Wölfflin, and Nikolaus Pevsner. For an alternative approach to the whole question, see Benedict Anderson, *Imagined Communities: Reflections on the Origins and Spread of Nationalism* (London, 1983).

31 *Ideals and Idols*, pp. 60–92.

32 G.K. Chesterton, *G.F. Watts* (London, 1904), p. 3.

33 Frank Rutter, *Evolution in Modern Art* (London, 1926).

34 Op. cit., p. 83.

35 See my article 'From Careggi to Montmartre', in *Il se rendit en Italie: Études offertes à André Chastel* (Paris, 1987), pp. 667–77, reprinted as 'Plato in Modern Dress' in *Topics of Our Time*, pp. 131-141.

36 Op. cit., p. 282.

37 See above, ch. 7, n. 9.

38 The expression is due to Georges Clemenceau.

Chapter 11: What Art Tells Us

1 A reprint of this work, edited by Friedrich Piel and with an informative introduction by Horst Bredekamp, was published by Mander Kunstverlag, Mittenwald, 1978.

2 For the bibliography and the implications of this discovery, see Lynn White, Jr., *Mediaeval Technology and Social Change* (Oxford, 1962), pp. 59ff.

3 *The Works of John Ruskin*, ed. F.T. Cook and A. Wedderburn, vol. 14 (London, 1906), p. 203.

4 Quoted in 'In Search of Cultural History', in *Ideals and Idols*, p. 34.

5 The extract, together with other supporting material, has been published in Dieter Wuttke, *Kosmopolis der Wissenschaft: E.R. Curtius und das Warburg Institute* (Baden-Baden, 1989), appendix xv.

6 In my address to the American Academy of Arts and Sciences in May 1981, republished as 'Focus on the Arts and Humanities', in *Tributes*, pp. 11–27.

7 Wuttke, *Kosmopolis der Wissenschaft*, pp. 177ff.

8 Goethe, *Sämtliche Werke* (Stuttgart, 1972), vol. 11, pp. 332–3.

9 M.H. Abrams, 'Art-as-such: The Sociology of Modern Aesthetics', in

Doing Things with Texts: Essays in Criticism and Critical Theory (New York, 1989), pp. 135–58.

10 K.R. Popper, *The Poverty of Historicism* (London, 1957).

11 In a recent paper on 'Late Medieval Optics and Early Renaissance Painting', *Sartoniana*, 9 (1996), pp. 143–75, Marc de Mey has suggested that both the interest of the Van Eycks in reflection and that of the Florentines in perspective derived from the tradition of scientific optics that reached the Western world through the Arabs. This interesting hypothesis would, of course, run counter to Huizinga's interpretation.

12 See also my review article on 'André Malraux and the Crisis of Expressionism', in *Meditations on a Hobby Horse*, pp. 11–27.

Index

Photographic Acknowledgements

AKG, London: 195, 199; Alinari, Florence: 6, 8, 9, 16, 17, 24, 29, 31 33, 34, 35, 36, 41, 43, 61, 64, 65, 66, 69, 70, 71, 74, 75, 79, 80, 84, 90, 103, 104, 106, 138, 142, 144, 173, 185, 186, 187, 204, 205, 206, 209, 211, 267, 339, 344; Jo Bacon, London: 222; Baltimore Museum of Art, Cone Archives: 150; Barnaby's Picture Library, London: 196, 213, 216; Biblioteca Apostolica Vaticana, Rome: 20; Bibliothèque Nationale, Paris: 136, 223, 227, 241, 242, 243, 244, 245, 246, 248, 226, 229, 230, 231; Biblioteca Nazionale Centrale, Florence, photo Alberto Scardigli: 114; Bildarchiv Foto Marburg: 55, 59, 108; Bildarchiv Preussischer Kulturbesitz, Berlin: 51, 73, 92, 164, 171, 288; Dr. Christian Brandstätter, Vienna: 47; Bridgeman Art Library, London: 148; British Library Newspaper Library, London: 351; British Library, London: 58; British Museum, London: 2, 3, 271, 275, 280, 282, 292, 294, 306; Brooklyn Museum of Art, New York: 238; Burgerbibliothek, Berne: 277, 278, 283, 285, 289, 291; Martin Charles, London: 189; Jean-Loup Charmet, Paris: 323; Sioban Coppinger, Lambourne: 221; Fabio Donato, Naples: 297, 298, 299, 301, 302, 303, 308, 309; Ursula Edelmann, Frankfurt am Main: 93, 140; Fitzwilliam Museum, Cambridge: 72; Fotografia Lensini Fabio, Siena: 30; Foto Roncaglia, Modena: 54; Foto Saporetti, Milan: 109; Fremdenverkehrsverein Göttingen: 215; Galleria degli Uffizi, Florence: 76; Germanisches Nationalmuseum, Nuremberg: 166; Giraudon, Paris: 45, 100, 107, 110, 116, 141, 170; Graphische Sammlung Albertina, Vienna: 111, 129; Hamburger Kunsthalle, Hamburg: 234; Harlow Art Trust: 218; Harvard University Art Museum, Cambridge, MA: 133, 135; Hellenic Republic Ministry of Culture, Athens: 50; Hessisches Landesmuseum, Darmstadt: 163; Hirmer Fotoarchiv, Munich: 49; Hulton Deutsch, London: 214, 350; Istituto Centrale per il Catalogo e la Documentazione, Rome: 40; Istituto Suore Benedettine di Priscilla, Rome: 18, 19; A.F. Kersting, London: 44, 151; Kunsthistorisches Museum, Vienna: 127, 128, 130, 132, 134, 168; Kunstsammlungen der Veste Coburg: 290; Leuvehaven, Rotterdam: 217; Liliane Lijn, London: 219; Metropolitan Museum of Art, New York: 10, 67, 162; Museu Nacional d'Art de Catalunya, Barcelona: 22; Musée National

Suisse, Zurich: 46; National Gallery of Scotland, Edinburgh: 68; National Gallery, London: 60, 81, 87, 96, 119, 146, 175, 176, 180; National Portrait Gallery, London: 4; Öffentliche Kunstsammlung, Basle: 181; Opificio delle Pietre Dure Gabinetto Fotografico, Florence: 115, 117, 118; Österreichische Nationalbibliothek, Vienna: 124, 137, 139; Paul-Klee Stiftung, Berne: 310; Peggy Guggenheim Collection, Venice: 346; Pepys Library, Cambridge: 125, 126; Peterborough Sculpture Trust: 220; Philadelphia Museum of Art: 77; Photographie Bulloz, Paris: 53, 121, 143, 177, 224, 258, 262; Phototheque des Musée de la Ville de Paris: 226, 235, 236, 237, 247; Rijksmuseum, Amsterdam: 82, 159, 165, 167, 169, 276; RMN, Paris: 57, 113, 158; Roger-Viollet, Paris: 174, 212, 349; Royal Academy of Arts, London: 341, 347, 348; Royal Museums of Fine Art, Brussels: 192; Scala, Florence: 37, 354; Sinai Archive, University of Michigan: 62; Spectrum Colour Library, London: 123, 198; Staatliche Kunstsammlungen, Dresden: 188; Staatsgemälde-sammlungen, Munich: 147; Stadt- und Universitätsbibliothek, Frankfurt am Main: 56; Statens Museum for Kunst, Copenhagen: 345; Tate Gallery, London: 353; Uppsala University Library: 105; Victoria and Albert Museum, © The Board of Trustees, London: 112; Wallace Collection, London: 172; Warburg Institute, University of London: 153, 154, 157, 201, 249, 321, 325, 326, 327, 328; Werner Forman Archive, London: 200; Witt Library, Courtauld Institute of Art: 210; Yale Center for British Art, New Haven: 155, 156; York City Art Gallery: 343.